T0200687

Stereophonica

Stereophonica

Sound and Space in Science, Technology, and the Arts

Gascia Ouzounian

The MIT Press
Cambridge, Massachusetts
London, England

© 2020 Massachusetts Institute of Technology

All rights reserved. No part of this book may be reproduced in any form by any electronic or mechanical means (including photocopying, recording, or information storage and retrieval) without permission in writing from the publisher.

This book was set in ITC Stone Serif Std and ITC Stone Sans Std by New Best-set Typesetters Ltd. Printed and bound in the United States of America.

Library of Congress Cataloging-in-Publication Data

Names: Ouzounian, Gascia, author.
Title: Stereophonica : sound and space in science, technology, and the arts / Gascia Ouzounian.
Description: Cambridge, Massachusetts : The MIT Press, 2020. | Includes bibliographical references and index.
Identifiers: LCCN 2020003270 | ISBN 9780262044783 (hardcover)
Subjects: LCSH: Sound—History. | Sounds—History. | Acoustical engineering—History. | Music—History and criticism. | Sound in art—History.
Classification: LCC QC220 .O99 2020 | DDC 534.09—dc23
LC record available at https://lccn.loc.gov/2020003270

10 9 8 7 6 5 4 3 2 1

To Denise Lupien, who helped me imagine a life in music and sound; and to Gerard Gormley, for sharing that life with me.

All sounds (whatsoever) move round, that is to Say, On all sides, Upwards, Downwards, Forewards and Backwards: This appeareth in all Instances.
—Francis Bacon, *Sylva Sylvarum* (1627)

Music will eventually engulf and surround you.
—Edgard Varèse (1936)

Contents

Acknowledgments

This project has been supported by many people over many years. I'm indebted to Doug Sery at the MIT Press for being a supportive and generous editor; Noah J. Springer for his advice throughout the publication process; Kathleen A. Caruso for her careful editorial work and guidance; Julia Collins for her meticulous copyediting; and Emily Gutheinz and Sean Reilly for their wonderful work on the design and art package.

Librarians and staff at a number of archives provided crucial support with research. My thanks go to Sheldon H. Hochheiser and Melissa Wasson at the AT&T Archives and History Center; Ted Houghtaling and Leah Loscutoff at the Samuel C. Williams Library at the Stevens Institute of Technology; Barry Truax of the World Soundscape Project; Tori Owen and Eleanor James at Arcana Editions; Cate Watson at The Science Museum Library & Archives at Wroughton; Natasha Swainston at the Churchill Archives Centre at Cambridge University; Andrew Hennan at the Banff Centre for Arts and Creativity; and staff at the libraries of McGill University, University of California San Diego, Stanford University, and the University of Oxford.

The Faculty of Music at the University of Oxford and Lady Margaret Hall supported this work through a period of research leave, and my colleagues and students brought much joy to the work. I'm grateful in particular to Georgina Born for her generous advice and collaborative spirit; Joe Davies for his kindness, friendship, and unparalleled support of our community; Sanja Bogojevic and Christina Goldschmidt for their willingness to read the manuscript, even though one is a lawyer and the other a mathematician; Alan Rusbridger, Lindsay Mackie, Jo Murray, and Helen Barr for creating a warm and vibrant college atmosphere; Susan Wollenberg for her inspiring presence; and my colleagues in the Faculty of Music for fostering a genuinely stimulating research culture.

Artists, composers, and curators generously shared their work, ideas, and time. It is a pleasure to thank Amanda Abi Khalil, Sam Auinger, Joan Baz, Steve Chance, Heidi Fast, Anna Friz, Nathalie Harb, Vijay Iyer, Christina Kubisch, Una Lee, Signe Líden, kara lynch,

Omaya Malaeb, Matilde Meireles, Nadim Mishlawi, Joe Namy, Mendi+Keith Obadike, Marianthi Papalexandri-Alexandri, Jen Reimer, Merijn Royaards, Youmna Saba, Mhamad Safa, Carsten Seiffarth, Carsten Stabenow, Markus Steffens, Max Stein, Julian Stein, and Cynthia Zaven.

Many others have supported this work through their encouragement and interest. I warmly acknowledge the support of Carolyn Birdsall, Zeynep Bulut, Eric Clarke, Seth Cluett, Marcel Cobussen, Charles Curtis, Peter Cusack, Paul DeMarinis, R. Luke DuBois, Ellen Flügge, Michael Gandy, Patrick Grealey, David Gutnik, Elizabeth Hoffman, Adriene Jenik, Douglas Kahn, Ben Knapp, Melle Kromhout, Anahid Kassabian, Fanny Louvier, Eric Lyon, Emily Mac-Gregor, Lev Manovich, James Mansell, Miya Masaoka, Conor McCafferty, Andra McCartney, Mara Mills, Melissa Morton, Úna Monaghan, Rachel O'Grady, Jonathan Packham, Colin Ripley, Jan Smaczny, Jason Stanyek, Paul Stapleton, Jonathan Sterne, Christabel Stirling, Atau Tanaka, Spencer Topel, Justinien Tribillon, David Trippett, Eric de Visscher, Salomé Voegelin, and Ellen Waterman.

I'm indebted to Joe Davies, Christopher Haworth, and Guy Veale for their valuable feedback on the manuscript; Melissa van Drie for her careful reading, generosity, and many insights; Sarah Lappin and John Bingham-Hall for being brilliant collaborators; Sumanth Gopinath for support at an early stage; Eric Lewis and Piers Hellawell for support at a late one; and Richard Sennett for the warm welcome to Theatrum Mundi.

George Lewis was a formidable PhD supervisor who diligently advised students like myself while seemingly reforming an entire discipline. His work fuels mine in every respect. Jann Pasler inspired many of us in the Critical Studies & Experimental Practices program at the University of California San Diego. I'm grateful to them for creating an environment in which experimental work could thrive, and for continuing to do such transformative, rigorous work.

I'm thankful for the many friends who supported this project, in particular the Allen family, Drew Boles, Fernanda Carniero and Alexandre Lopes Rocha Lima, Maïa Cybelle Carpenter, Michael J. Daly and Conan McIvor, Emily DeDakis, Eve Egoyan and David Rokeby, Elinor Frey and Maxime McKinley, Chloé Griffin, the Griffins, the Hellawells, the Hickeys, Kelly Hennigan, KP Holland, Rich Tayloe and Doug Cordes, and Lauren Wooley. Eve, Elinor, Chloé, I'm so grateful for our collaborations and your presence in my life.

My family has been wonderfully supportive throughout. My sisters, Maral and Karen, inspire me with their dedication to their craft and the time they give to others; their husbands bring laughter to our lives, as do our nephews; my mother uplifts us with her boundless energy and zest for life; my grandmother brightens our lives daily; and my father did the hard work of reading chapters but also celebrating good times in various corners of the world. I'm deeply indebted to them, and to my new family, the Gormleys, for their support.

The book is dedicated to Denise Lupien, an extraordinary violinist and educator. I was enormously fortunate to study with her at McGill University, where she was a professor of violin while also serving as concertmaster of the Orchestre Métropolitain and as first violinist of Quatuor Morency. She and her partner, the wonderful luthier Denis Cormier, gave freely of their time and built a community around art, music, philosophy, and friendship. They inspire me still.

The book is also dedicated to Ger, for his kindness, intelligence, warmth, musicality, humor, patience, and love.

Illustrations

1 Introduction

1.1 Profusions

Contemporary art is replete with works that explore the relationships between sound and space, with "space" understood in physical, sensorial, geographical, social, and political terms. Today I can plug my headphones into the façade of a building in Berlin to hear how its materiality, made audible through the use of seismic sensors embedded into the building's infrastructure, changes over time and in response to variations in atmospheric pressure, weather, and other environmental factors. In other words, I can listen to a building as it evolves over time and in relation to its surroundings. In suburban London I can visit a building whose spiraling form is inspired by the music of Erik Satie and the chance methods of John Cage. Electronic music, projected over loudspeakers, is played throughout the building. The music is created from sounds that were recorded during the making of the building itself: the sounds of breaking ground, of pouring concrete. This literal *musique concrète* is lush and surprisingly beautiful. And, it is impossible to say where music begins and architecture ends. In 2017 I could visit an acoustic refuge in a low-income neighborhood in Beirut. This temporary structure, erected in a parking lot close to a highway, used acoustic paneling to reduce environmental noise, but it also featured a quiet, meditative soundtrack composed of everyday city sounds. The designer wanted to draw attention to the uneven ways in which noise affects rich and poor inhabitants of the city—how a politics of noise shapes the city and differently impacts upon the lives of its residents.[1]

While these particular projects are formed at the intersection of music, art, architecture, and urban design, many others take the form of sound recordings, compositions, performances, films, installations, sculptures, radio works, websites, and much more. I can listen to a "sound essay" that makes audible the subterranean crypts, caverns, and cisterns of Cagliari by an artist who "spent weeks listening to the changing echoes while descending down into the dark and recording the city filtered through its cavities" (Lidén 2015). I can

take a listening tour of Bonn, following a map of unique acoustic features of the city created by Bonn's "City Sound Artist" in 2010. Or, I can take an "electrical walk" in any number of cities while wearing specially designed headphones that make audible normally inaudible elements of the urban infrastructure. During my walk, what were formerly silent objects like surveillance cameras, ATMs, and transportation infrastructures beat and resonate with the pulses and tones of electromagnetic energy.[2]

In parallel to this proliferation of artworks that explore the relationships between sound and space, contemporary scholarship on sound is replete with spatial concepts—concepts that likewise traverse physical, sensorial, geographical, social, and political realms. It is common to read about "acoustic spaces," "soundscapes," "aural architectures," "auditory perspective," "acoustic communities," and "acoustic territories," to give only a few examples.[3] Such concepts have been defined and redefined, theorized and problematized. They are laden with meaning—and in some cases multiple and conflicting meanings—and they form, in a foundational sense, the ground of sound studies. As Andrew Eisenberg writes, "It is difficult to identify any work of sound studies that does *not* deal in some way with space" (Eisenberg 2015, 195).

Despite this striking "profusion of research" (Born 2013, 5)—what Georgina Born describes as "a veritable avalanche of scholarship devoted to the interconnections between sound and space" (5)—our historical understanding of how sound came to be understood as spatial nevertheless remains lacking. Today we take for granted that sound is spatial, and that hearing is spatial, too: that it is possible to hear where sounds come from and how far away or close they are. However, as recently as 1900, a popular scientific view held that sound itself could not relay "spatial attributes," and that the human ear had physiological limitations that prevented it from receiving spatial information. Many psychologists believed it was through reasoning, or else through visual or haptic sensations, that an "auditory space" was constructed (Pierce 1901). In order to explore such striking shifts in perspective, *Stereophonica* will trace a history of thought and practice related to acoustic and auditory spatiality as they emerge in connection to such fields as philosophy, physics, physiology, psychology, music, architecture, and urban studies. I track evolving ideas of acoustic and auditory spatiality (the spatiality of sound and hearing); and, equally, ideas that emerged in connection to particular *kinds* of spaces, acoustic and auditory technologies, musical and sonic cultures, experiences of hearing, and practices of listening. My discussion begins in the nineteenth century, a century that marks a "transition from sound and listening as non-spatial phenomena to fundamentally spatial phenomena" (Théberge, Devine, and Everrett 2015, 15). It extends to the present day, when artists seek to reconfigure entire cities through sound, and the concept of "sonic urbanism" circulates within and across the worlds of architecture, urban studies, and sound studies (Kafka, Lovell, and Shipwright 2019).

Rather than revisit recent academic debates on sound and space, which are deftly unpacked by Born and others, in this introductory chapter I look back to spatial conceptions of sound that circulated prior to the nineteenth century. This is in order to situate the discussion that follows within even longer trajectories of thought that continue to resonate in various scientific, musical, artistic, and intellectual traditions today. In the following passages I turn to three recurring figures of acoustic spatiality: (1) propagation, which pertains to the *inherent* ability of sound to pass through a medium and traverse space—an idea encapsulated by the common refrain "sound travels"; (2) reflection, whereby sound is understood in relation to its *interactions* with objects and environments; and (3) projection, which denotes the movement of sound across a distance, implies that something is done *to* sound, and is typically associated with some kind of technological mediation (e.g., sound projected via an apparatus, whether a loudspeaker, a trumpet, or a mouth). By showing how these figures emerged at the intersection of historically situated scientific, technological, philosophical, and musical cultures, this brief introduction serves as a microcosm of the book, which makes the case that a properly historicized account of the understanding of the relationships between sound and space can help us to better appreciate the myriad creative practices and theoretical discourses that give form and sense to those relationships today.

1.2 Propagations

By the nineteenth century there were already numerous treatises on the propagation of sound in the scientific literature. In "A Catalogue of Works Relating to Sound" (Peirce 1836), a bibliography that attempted to collect all known philosophical and scientific writings on sound to date,[4] we find an impressive list of titles on propagation arranged into six categories: Propagation of Sound in General (sixteen entries), Propagation of Sound in Air (forty-nine entries), Propagation of Sound in Gases and Vapors (ten entries), Propagation of Sound through Liquids (nine entries), Propagation of Sound in Solids and Mixed Media (twenty entries, including an essay on hearing by the teeth), and Mathematical Theory of Propagation of Sound (thirty-five entries, beginning with Newton's *Principia*).[5]

Theories on the propagation of sound were established through extensive and sometimes remarkable experiments that aimed to determine such factors as: the material nature of the propagation (did sound propagate as a wave? a pulse? as rays? particles? a combination of these?); its form (were the waves concentric? did the rays radiate outward from a source?); its speed (did sound propagate more quickly in air or water? was it the medium's density or its elasticity that determined how quickly sound propagated through it?); and the conditions required for propagation to occur (could sound propagate in *any* medium? could it propagate in a vacuum?).

While such questions may seem straightforward, the experimental methods they inspired were not. In 1808 the French physicist Jean-Baptiste Biot descended into the subterranean quarries of Paris, where he held conversations in hushed tones through empty cast-iron tubes that normally delivered water throughout the metropolis. He found that the quietest whispers could be clearly heard through an iron tube 3,120 feet long, while a pistol fired at one end of that tube could extinguish a candle at the other (see Tyndall 1867, 13). Thus, not only could sound propagate over long distances, its propagations could produce distinct effects—and not only sonic ones. Another experimenter required three auditors to strip naked and dive under water. While submerged, they listened as the experimenter yelled at them, discharged a pistol, and finally exploded a grenade, all in an attempt to better understand the propagation of sound in water (see Herschel 1830, 767). The German physicist and musician Ernst Chladni reported on experiments by the Danish scientists Johann David Herholdt and Carl Gottlob Rafn in which a 600-foot-long metal wire was stretched between a metal plate, suspended in air, and an auditor who held the wire between his teeth. In this precarious position the auditor heard not one but two distinct sounds whenever the plate was struck. He heard the first sound, which was conducted through the wire, almost instantaneously. The second sound, which was conducted through the air, arrived later (Herschel 1830, 772).

Theories of sound propagation informed, if not engendered, spatial conceptions of sound. If sound is imagined as a vibration (e.g., an oscillation) that propagates as a wave (e.g., an audible wave of pressure) then it is by definition spatial; and if it is imagined as propagating through air and other mediums, then through its propagations it is effectively "spatialized."[6] However, the ability of sound to propagate in, and just as important, *through*, any medium—whether air, solids, liquids, gases, or vapors—further conferred upon sound distinct powers, both real and imagined. The French naturalist Jean-Baptiste Lamarck, for example, was inspired to study the propagation of sound following an enormous explosion at the Grenelle gunpowder factory in Paris. On the morning of August 31, 1794, approximately sixty-five thousand pounds of gunpowder exploded in the factory, killing over a thousand workers (see figure 1.1). The explosion was so loud that it was reportedly heard at Fontainebleau, around seventy kilometers away. The air was very still that day, so much so that leaves on trees did not rustle. Even so, the sound of the explosion was so forceful that Lamarck believed it had caused distant windows to break, ceilings to crack, and even ice cubes inside people's homes to fracture.

Lamarck's views on sound contained what we now know to be fallacies. Shock waves, and not sound waves, would have caused the destruction that he and others witnessed that day; and sound is not an invisible fluid that "immerses" the listener, as he also proposed.[7] Still, these views spoke to the idea that sound, as something that could cross vast distances, breach any physical boundary, and permeate any medium, was possessed of great power, even great

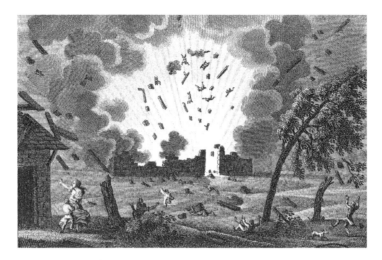

Figure 1.1
Copper engraving by François-Louis Couché depicting the explosion of the gunpowder factory at Grenelle on August 31, 1794.

powers of destruction, precisely because of its propensity to be reflected and its ability to propagate through space.

1.3 Reflections

At the same time, these propensities rendered sound mercurial: a wavering, trembling, quavering substance whose reflections and propagations could hardly be well controlled.[8] "Echo is a capricious being, whose caprices are not easily divined," wrote the Prussian astronomer and mathematician Rodolphe Radau (1870, 88). In *Wonders of Acoustics* (1870) Radau collected marvelous and sensational stories of sound, drawing from well-known historical sources like Athanasius Kircher's *Musurgia Universalis* (1650) and *Phonurgia Nova* (1673), as well as from the contemporary scientific literature, notably the writings of Ernst Chladni, Charles Wheatstone, and Hermann von Helmholtz, which I return to later. One story recounted the fate of an Englishman who had embarked on a doomed project to capture an echo. It was a cautionary tale:

> An Englishman, traveling in Italy, met with an echo so beautiful that he determined to buy it. It was produced by a detached house. This was taken down, carried to England, and reconstructed on one of his estates, exactly on its original plan—a place having been chosen for it at exactly the same distance from his dwelling as it stood, in Italy, from the place whence the echo was most distinctly heard. To test the echo he sent for a box of pistols, charged both the weapons, went to the window,

and fired—no sound was returned; drawing the trigger of the second, he shot himself through the brain! It was never known what defect in the construction was the cause of this lamentable disappointment. (Radau 1870, 88)

The reader, of course, wondered if there was any defect at all in the construction of the house, or whether the defect lay in the crude project of trying to trap, indeed purchase, something as sublime and elusive as an echo—a figure that for many philosophers symbolized *that which can never be apprehended*, since an echo is always and only ever sensed through reflections. After all, the echo is not the voice, but the "image of the voice," as the French Minim friar and mathematician Marin Mersenne wrote in *Harmonie universelle* (Mersenne 1636, book 1, 51, my translation). Echo was a fugitive Nymph; the "daughter of the air"; a "vagabond" (54).

Echoes—a particular species of acoustic reflection wherein the reflected sound is delayed enough that it is perceived as a distinct sound—not only conjured ideas of sound's ephemerality and ineffability; they were also rich with spiritual and religious resonances. In *Sylva Sylvarum* (1627), a ten-volume study of the natural world by the English philosopher Francis Bacon, we find an intriguing passage in which Bacon recounts a spiritual encounter with an echo. Upon visiting Charenton-le-Pont, a town near Paris, Bacon stumbled upon a ruined chapel that produced fantastic "Super-Reflexions," what he called the echoes of echoes. The four walls of the chapel were still intact but its roof was completely missing. Speaking at one end of the chapel one afternoon, Bacon heard his voice returned to him thirteen times. He learned that others who had spoken in the same chapel in the evenings, when the air was thicker, could hear their voices returned to them up to sixteen times. The echoes, however, did not return all the words that had been spoken equally well. In particular they could hardly express the letter "s" (Bacon 1627, III.251, 58). Invited to do so by a man who believed that the echoes were the work of good spirits, Bacon called out the name "Satan." What the echoes returned was *"va t'en,"* a French expression that roughly translates as "go away," or, in this context, "be done with you." This encapsulated Bacon's idea that echoes represented the *"Spiritual Essence"* of sounds (III.287, 62; emphasis in original).[9] For, if echoes did not have a spiritual basis, the words should all be returned alike and should not be so inexplicably, and so perfectly, transformed.

While accounts like Mersenne's and Bacon's might strike the modern reader as mannered, even sober accounts in eighteenth- and nineteenth-century mathematical treatises on acoustics often included passages on the phenomenal nature of remarkable echoes. Chladni cited an echo that was said to change the voice in different ways, another that could repeat a word forty times, and even one that could repeat the first verse of the *Aeneid* eight times (Chladni [1809] 2015, 158). He also recalled a church in which a hidden orchestra, seated behind boards in an alcove near the church's ceiling, produced music that was heard only through

its reflections. Beautiful tones seemed to pour out from the top of a tableau that depicted angels announcing the birth of Christ (160).

Such rapturous echoes and acoustic reflections were a testament to the infinite variety of forms that sound could take when it came into contact with the world; and equally, to the infinite variety of ways in which sound could reshape the world in its "image." Although Mersenne never met the vagabond nymph, leaving the project to "another Pan," he took solace in knowing that echoes were "the Creator's way of giving language to the woods, to rivers and mountains," and thereby creating in nature a kind of "ravishing harmony" that all the great works of human invention tried to imitate (Mersenne 1636, book 1, 56; my translation).

The propagations and reflections of sound thus rendered it simultaneously powerful and fragile in the minds of philosophers and physicists. As energy or matter in motion, sound could move through a void, permeate a medium, and penetrate, corrupt, and even destroy objects. Its fluctuating movements, however, rendered it paradoxically unstable: vacillating, oscillating, undulating, fluttering, trembling, quavering. The propagations of sound thus complicated questions about its nature, distinguishing it as a phenomenon that could occupy and simultaneously transform a medium. Bacon distinguished visible from audible phenomena, for example, by suggesting that *"Visibles"* did not have the power to "mingle" in a medium like water or air, whereas *"Audibles"* did (Bacon 1627, III.224, 53; emphasis in original). In contrast to light, sound could *disturb* a medium and produce changes in it, even if those changes were minor or temporary. Indeed, sound was uniquely believed to possess the power to reconfigure the physical world, as well as spiritual and psychical worlds, through its spatial effects. To gain control over these effects, then, would be to gain control over these other domains as well.

1.4 Projections

The stories of the explosion at the gunpowder factory, the thwarted Englishman, and the chapel at Charenton-le-Pont variously describe the spatial effects of sound as mystifying, terrifying, and mesmerizing. Such effects were exploited to a spectacular degree by twentieth-century composers who used electroacoustic technologies to create "spatial music" that evoked these very same qualities. Spatial effects had certainly been heard in diverse musical traditions prior to the twentieth century. Well-known examples include the antiphonal singing of *cori spezzati* (spatially separated choirs) in Renaissance Venice, or the antiphony underlying African American musical traditions (Lornell 2012).[10] The mid-twentieth century was a turning point in this history, however, in that composers now had at their disposal electroacoustic technologies (such as multitrack sound recording and reproduction systems,

discussed in chapter 4) that enabled them to control multiple "channels" of sound at once, thus making it possible to foreground the location and movement of sounds as compositional parameters.[11] As the French-born, U.S.-based composer Edgard Varèse would say about *Poème électronique* (1958), an eight-minute electroacoustic composition projected over hundreds of loudspeakers inside the Philips Pavilion at the 1958 World's Fair in Brussels, "The music was distributed by 425 loudspeakers. . . . The loudspeakers were mounted in groups and in what is called 'sound routes' to achieve various effects such as that of the music running around the pavilion, as well as coming from different directions, reverberations, etc. For the first time I heard my music literally projected into space" (Varèse [1959] 1998, 170).

What Varèse called "spatial music" had antecedents not only in earlier musical traditions, however, but equally in the scientific practices of earlier eras. Varèse himself was inspired by the writings of Hermann von Helmholtz, which led him to experiment with sirens to create "parabolic and hyperbolic trajectories of sound" in works like *Amériques* (1918–1921; revised 1927) and *Ionisation* (1929–1931), giving form to what he called "my conception of music as moving in space" (Varèse [1959] 1998, 170). The very *idea* of multichannel music, however, was also arguably prefigured in scientific spectacles of previous centuries. In the *Invisible Girl*, a popular spectacle that was widely exhibited in the United States and Western Europe in the early nineteenth century, sound was simultaneously transmitted from a single source to four trumpets, which served as proto-loudspeakers (see figure 1.2). A visitor posed a question to an unseen girl by speaking into the bell of any one of the four trumpets. Her answer was

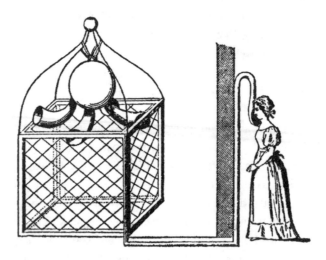

Figure 1.2
Illustration of the *Invisible Girl* from Rodolphe Radau's *Wonders of Acoustics* (Radau 1870, 62).

returned from all four of them at once, projected in what might be thought of as an early form of quadraphonic (four-channel) sound.

One advertisement for the *Invisible Girl* promised that "the voice of a living female . . . will answer questions put by any person present, Or maintain a *Conversation*, either in *Whisper*, or in a more *Audible Tone*; the Lady will also, if requested, entertain the company with specimens of vocal music, producing a most peculiar Effect" (cited in Connor 2000, 352; emphasis in original). Undoubtedly this peculiar effect resulted from the transformation of the sound of the singing voice as it was transmitted through the exhibit's apparatus. It would have equally resulted, however, from the uncanniness of hearing the same voice emanating from several points at once, an acoustic effect that would have rarely, if ever, been experienced so distinctly and reproduced so consistently.

The trumpets in the *Invisible Girl* acted both as reflectors or "projectors" of sound, and equally as receivers or "collectors" of sound. As such they would have recalled the many varieties of speaking trumpets and hearing trumpets that circulated in Western Europe by the early nineteenth century. The speaking trumpet had roots in ancient cultures but it was revived and popularized in the 1670s by the English diplomat and inventor Samuel Morland, who designed several varieties of what he called the *Tuba Stentoro-Phonica* in 1670, and who subsequently published a detailed pamphlet on it (Morland 1672). A fashion for the speaking trumpet soon "spread throughout Europe, not only in the scientific world, but also in aristocratic and musical circles" (Barbieri 2004, 205).

In listening to the voice as it was projected via the speaking trumpet, Morland wondered how it was that voices could permeate the air while flying about "like Atoms" in it, only to be conveyed with "stupendious agility" to the soul (Morland 1672, 7).[12] He concluded only that the more one asked such questions the less one could be assured of the answers. Sound, and more specifically sound when considered in relation to its spatial effects—its effects in the material and spiritual world—lay outside the bounds of physics and philosophy. Morland thus abandoned the idea of developing a new philosophy of sound, but only after he conducted numerous tests with the speaking trumpet in which he tried to determine how sound was "multiplied" or amplified when it was projected through it, a process he illustrated in *Iconismus II* (see figure 1.3). In this figure, a voice produces "rays" of sound, depicted as straight lines inside the trumpet, and a multitude of sound waves that Morland described as "percussions of air." These percussions ripple forward from the speaker's mouth, and outward from the trumpet's bell, spreading in concentric waves ("spherical Undulations") until they meet some point of opposition, at which point they are reflected—"reundulated, multiplied, and reverberated" (11)—throughout the vicinity. Sound is everywhere at once and perpetually in motion. A voice has become air, or, more precisely, a movement of the air.[13]

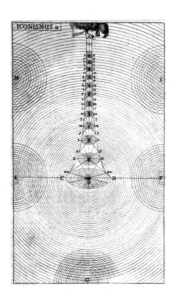

Figure 1.3
Iconismus II by Samuel Morland, depicting the physics of the speaking trumpet (Morland 1672, 8).

In seeking to perfect the design of the speaking trumpet Morland commissioned a variety of instruments in glass, brass, and copper. His trumpets ranged in size from 2.8 feet to an astonishing twenty-one feet in length, with bells measuring between eleven inches and two feet in diameter. On quiet and windy days, they could transmit speech clearly at a distance of nearly three miles over water. In 1671 Morland's associate Francis Digby wrote a letter to the British Secretary of State praising Morland's invention. In a passage from this letter that predicts the ear trumpet, a device that would come into fashion only in the mid-eighteenth century, Digby distinguished the use of the instrument when it was turned "trumpet-wise" from when it was turned "ear-wise." He remarked that "by laying one of these Instruments to the Ear, the Words are heard more distinctly" (Morland 1672, 4). Thus, from its inception, the speaking trumpet had two inclinations. Used as an instrument of speech, it functioned as a megaphone—a device for amplifying the voice and projecting it to distant places. Used as an instrument of hearing, it functioned as a receiver of sounds, one that focused distant sounds, seemingly bringing them closer to the listener's ear (see figure 1.4). In this latter inclination it was understood as a "reverse megaphone" (Chladni [1809] 2015, 153) and also as a "microphone," which was originally conceived as an aural analogue to the microscope—a device for magnifying quiet or inaudible sounds (Marsh 1684, 482).[14]

The growing popularity of auditory technologies like the ear trumpet, an early hearing aid that required the listener to turn *toward* the source of sound, gave strength to the idea that

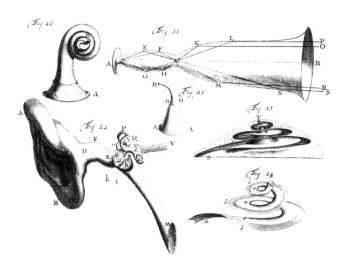

Figure 1.4
Varieties of eighteenth-century speaking trumpets and ear trumpets from Pieter van Musschenbroek's *Elementa* ([1734] 1739, facing p. 728).

not only the spatial properties of sound, but also the spatial aspects of hearing warranted further scientific attention. In early modern Europe, audition was studied almost exclusively as a monaural (one-eared) phenomenon. From the writings of Eustachius (1563) and Hieronymus Fabricius ab Aquapendente (1600) to treatises by John Elliot ([1780] 2013), Antonio Scarpa (1789), John Cunningham Saunders (1806), and Samuel Thomas von Soemmerring (1806), it was the physiology of the *single* ear that was under scrutiny in Western anatomy and medicine. Influential texts made scant, if any, reference to the action of hearing with both ears, what is now called "binaural audition," and what is widely understood as a fundamental aspect of "spatial hearing" (Blauert 1983): sensing the location, distance, and direction of sounds. Anatomical illustrations of the hearing apparatus from the early modern period almost invariably depicted a single ear, and depicted it as an isolated object, divorced from the cranium and floating in negative space. The ear, once excised, was further divided into constituent parts that played distinct roles in the physiology of hearing. An instrument thus isolated and fragmented, the ear-in-action was not easily linked back to the head from which it had been both literally and conceptually separated. To go from "the ear" to "the ears" in physiology required an even greater leap. In *Philosophical Observations on the Senses of Vision and Hearing* (1780), for example, the English physician and natural philosopher John Elliot briefly mentions the idea of hearing with both ears, but asserts that "though we have two ears, yet we hear singly" (Elliot [1780] 2013, 38). Thus, even as Elliot alluded to the idea of binaural audition, he dismissed its potential effects.

The physiological mechanisms of binaural audition would remain only superficially examined over the next fifty years, traceable to a handful of scientific papers (see Brech 2015, 17–33). Of particular interest among these are the 1796 experiments of the Italian physicist Giovanni Battista Venturi in which a blindfolded listener attempted to determine the direction of the sound of a flute being played around forty to fifty meters away. Venturi's experiments were conducted under different conditions of hearing: when one ear was stopped, when both ears were open, and while the listener remained stationary or else turned in place. Such experiments effectively laid the groundwork for theories of binaural audition to emerge. However, Venturi's work was "largely ignored and quickly forgotten" (Théberge, Devine, and Everrett 2015, 15), and the concept of binaural audition remained mostly elusive until the 1850s. In 1832, for example, the English surgeon David Tod spoke to the difficulty of accounting for two-eared hearing. "Nothing is more common than to say that we hear with our Ears, but it is far from being an easy matter to explain," he wrote (Tod 1832, 36). "We hear from above, below, before, behind, from the right and from the left, and from all points. How do we become acquainted with the direction from whence sounds reach us? This is a question which every one who has investigated the economy of the Ear has been unable to answer, even plausibly; for all that has hitherto been said on the subject is equally unscientific and uninteresting" (36).

1.5 *Stereophonica*

Stereophonica picks up at the point that binaural audition enters the scientific lexicon and spatial hearing becomes a sustained object of scientific inquiry. Chapter 2 explores spatial hearing in the nineteenth century in connection to binaural and stereo technologies of this period. It tracks the rise of the binaural listener, an auditor who listened through a binaural apparatus and observed sound in three dimensions. The binaural listener was a *descendent* of the binocular viewer that, as Jonathan Crary (1990) has argued, emerged around the same time in connection to three-dimensional viewing apparatuses like the stereoscope. I show how a science of binaural audition emerged in connection to an existing science of binocular vision, and how theories of auditory space perception were developed in connection to existing theories of visual space perception. This chapter also examines the binaural listener in connection to technologically mediated sonic cultures of the nineteenth century, in particular through a discussion of the théâtrophone, a broadcasting system that transmitted live opera, music, and theater to mass audiences in stereo.

The binaural listener, born of and disciplined through nineteenth-century medicine and science, would soon become mobilized and militarized through warfare. Chapter 3 examines the development of technologies for sound location during the First World War: technologies

that enabled military auditors to track the position of the enemy by listening to its movements. I explore how the listening act was reconfigured through the military science of sound location, and how this science shaped wider definitions of sound, in particular by making concrete the idea of sound as observable energy—as something to be *sensed* versus merely *heard*.

The science of sound location would have far-reaching repercussions. In particular it would resonate in postwar industrial research on sound recording and reproduction. Chapter 4 traces this historical connection through the work of scientists at Bell Telephone Laboratories (BTL), some of whom were directly involved in sound location research for the U.S. military during the First World War, and who subsequently designed some of the first systems for stereo and multichannel sound recording, transmission, and reproduction. BTL publicized its innovations in stereophony through a series of public demonstrations that were experienced, in one case, by over half a million people. I revisit BTL's demonstrations between 1933 and 1940, examining the confluence of scientific, aesthetic, and musical concerns that shaped these modernist versions of nineteenth-century spectacular science.

Part of my project in *Stereophonica* is to turn attention to the work of scientists and engineers who contributed in distinct ways to changing ideas of acoustic spatiality but whose work remains under-recognized or even unknown. Chapter 5 is conceived in this vein. It revisits the work of Harold Burris-Meyer, a drama instructor and sound technician at the Stevens Institute of Technology, New Jersey, whose work on sound was distinctly influential in a number of contexts in the 1930s and 1940s but is only now beginning to gain wider scholarly attention (Volcler 2017). I show how the idea of an "optimized acoustical environment" shaped Burris-Meyer's work in a number of contexts: multichannel sound design for the theater; "scientifically planned" music for the Muzak Corporation, where he served as vice president in the late 1930s; and applied psychoacoustics (psychological acoustics) for warfare during the Second World War. At the core of all these projects was a desire to create acoustic spaces that were optimally designed to produce specific emotional and physiological responses in listeners, whether theater audiences, industrial workers, or enemy combatants.

Chapter 6 returns to the realm of music and sound art, exploring the development of multichannel electroacoustic music in the 1950s and sound installation art in the 1960s and after. It considers how various musical and sonic practices of this period reflected, resisted, and produced particular conceptions of space—whether Cartesian and Euclidean conceptions of absolute mathematical and geometrical space, or extended concepts of social and political space. By turning attention to contemporary artists including Heidi Fast and Rebecca Belmore, whose sound works intervene in social and political spaces, this chapter makes a case for considering how "spatial music" and sound art can constitute a poetics, as well as a politics, of space.

Chapter 7 explores the visual representation of sonic environments or "soundscapes" through an examination of noise maps and sound maps, notations for soundscape that emerged in the twentieth century, and that have had enduring applications in noise legislation and acoustic ecology (the ecology of sonic environments). This chapter focuses on the noise mapping of cities, sonic environments that have particularly come into view through mapping. It examines the roots of noise mapping in such phenomena as early graphic notations for noise; decibel tables and charts; pictorial and iconographic noise maps; and "isobel maps" and sound maps by the Canadian composer R. Murray Schafer and the World Soundscape Project. By connecting specific visualizations of noise to specific forms of anti-noise legislation, this chapter suggests that conceptualizations of sonic environments are not limited to the world of ideas or aesthetics, but can have profound effects on environments and societies, at times to deleterious effect.

Chapter 8 stays in the realm of the acoustic city. It investigates recent approaches to sonic urbanism: ways of encountering and understanding the city in relation to sound. Taking Beirut as a case study, I examine the work of sound artists and urban designers whose sonic practices reveal aspects of the city that are either occluded from view or difficult to apprehend given the complex entanglements of local and transnational forces that shape cities today. I take interest in Beirut both as a city of the Global South, the fastest growing sphere of urbanization today, and as a city of perpetual upheaval and "mutation" (Atallah 2017). I consider urban sonic practices in Beirut not only for their conceptual innovations, but also in a forensic capacity: as *evidence* of what has happened, and is happening, in the city.

Stereophonica thus grapples with an array of historical phenomena connected to sound and hearing as they are understood in relation to space. It charts what may seem like an improbable path from studies of auditory space perception in the nineteenth century to the work of contemporary artists who reveal and reorient urban spaces through sound. This path moves outward, from the intimate and interior spaces of the human body to the enormous complexes of modern cities. Rather than trace a linear trajectory through any one historical route, however, I revisit a series of historical episodes in which the understanding of sound and space were distinctly transformed: the birth of a science of spatial hearing; the rise of acoustic defense; the invention of stereo sound recording and reproduction systems; the development of spatial music and sound installation art; the advent of noise mapping and sound mapping; and emergent modes of sonic urbanism. Each of these phenomena represents a distinct shift in how sound is created, experienced, or understood in relation to space. Further, each sheds light upon evolving acoustic and auditory cultures, ways of listening, and changing ontologies of sound and space. By focusing on such transformative episodes, whether they last several years or several decades, my aim is to set into dialogue various realms of thought and practice that bear upon contemporary ideas of acoustic and auditory

spatiality, but that are normally kept distinct within such disciplines as philosophy, physics, music, and urban studies.

It is for a similar reason that this study takes a wide historical lens. Each chapter could theoretically form the basis of a much longer discussion or even an entire book. The chapter on stereo sound reproduction at Bell Telephone Laboratories in the 1930s, for example, could be expanded to include Alan Blumlein's parallel, and better known, work on stereo reproduction in England. It could likewise be extended to the present day, taking into consideration more recent manifestations of spatial audio like Ambisonics and virtual reality (VR) audio. My aim, however, is not to chart a comprehensive history of any single scientific, technological, philosophical, or cultural phenomenon connected to evolving ideas of sound and space. I have chosen not to write, for example, a comprehensive history of spatial audio or a history of multichannel music. Rather, my aim is to cut *into* and *across* normally distinct histories, in order to show how various conceptions of acoustic and auditory spatiality have evolved over time and in connection to one another. Whereas a history of multichannel music would be underpinned by a predominating set of concerns that emerged from musical cultures and communities, I am interested in ideas that emerged between the worlds of music, engineering, warfare, theater, industry, and urban design. I avoid retracing already familiar paths, by omitting certain topics that could fit within the scope of this study but that have already received considerable attention elsewhere, such as the development of architectural acoustics; or else by drawing attention to under-recognized historical figures or practices.[15] I therefore devote considerable attention to experimental projects, whether in science, music, art, or their interstitial spaces—including experiments that failed, were limited in their scope, had troubling ethical implications, or simply did not "succeed" in entering mainstream discourses and canons, but that are nevertheless important because of their conceptual, technical, and aesthetic innovations. It is within these experimental practices, those that test the boundaries of a field, that I find particular interest, especially with respect to ideas that defied conventional thinking and, in some cases, put wider social or cultural conventions under pressure.

While the book's title evokes the concept of stereo audio, and while several chapters are in fact devoted to a discussion of stereo in the sense of two-channel or multichannel sound, I propose the term *stereophonica* as a much broader category of phenomena that extends far beyond stereo sound to embrace sound in all of its spatial manifestations. The concept of *stereophonica* includes spatial music, sound installations, urban soundscapes, sound maps, and much more. It suggests that a vast range of acoustic phenomena can be understood as spatial—and even that most, if not all, acoustic phenomena can be designated *stereophonica*: phenomena that are spatially constituted and manifested. While music traditionally has been represented and analyzed as a temporal phenomenon, which is to say in relation

to its unfolding in time, positioning music as *stereophonica* reinforces the idea that a spatial analysis of music is needed, and that such an analysis can only enrich our understanding of music's effects. It also understands *all* music as essentially spatial, with "space" understood in physical as well as social and political terms. The broad scope of *stereophonica* as a category likewise invites us to reposition all aural cultures as spatial phenomena. In a sense, the concept of *stereophonica* aims to recover the dimension of space in the analysis of all acoustic, auditory, musical, and sonic cultures.

Finally, in contrast to discourses that understand "space" as a void to be filled with sounds, my discussion shows that acoustic and auditory spaces have never been empty or neutral, but instead have always been replete with social, cultural, and political meanings. The case studies are chosen to reflect a particular progression both within and across them: how spatial conceptions of sound and hearing were hypothesized, tested, applied, codified, problematized, and politicized. *Stereophonica* reveals how different concepts of acoustic and auditory space were invented and embraced by scientific and artistic communities, and how the spaces of sound and hearing themselves were increasingly measured and rationalized, surveilled and scanned, militarized and weaponized, mapped and planned, controlled and commercialized—in short, modernized. In the next chapter, I trace these modernizing impulses through the figure of the listener, a figure that, over the course of the nineteenth century, was increasingly understood in connection to three-dimensional space, and was thus made ever more real, more dimensional, more "solid"—what the ancient Greeks called στερεός, or *stereós*.

2 The Rise of the Binaural Listener: Spatial Hearing in the Nineteenth Century

2.1 "As if by magic": The Enchanted Lyre

In 1821, shoppers in Pall Mall, London, were treated to an unexpected whimsy as they passed by an instrument-making shop owned by William Wheatstone. It seemed to them that an ancient Greek lyre suspended in mid-air was producing music even though no performer could be seen. In actuality the performers were hidden in a room above the shop, where they played a piano, a harp, and a dulcimer—instruments whose soundboards were attached by brass wire to the lyre hanging below (see figure 2.1). When the instruments in the room above were played, "the lyre in the room below, as if by magic, would make music" (Wheatstone Collection 2018).

The Enchanted Lyre or acoucryptophone was the creation of Charles Wheatstone, the nineteen-year-old son of the shop owner. It was a simple if elegant demonstration of mechanical oscillation, but it suggested something far more unusual: that music could be transmitted across a distance.[1] A review of the Enchanted Lyre from September 1821 conjured the prospect of an opera being performed at the King's Theatre in London and "simultaneously enjoyed at the Hanover-square Rooms, the City of London Tavern, and even at the Horns Tavern in Kennington" (Ackermann and Shoberl 1821, 175). In this scenario sound would travel like a "gas," moving through "snug conductors, from the main laboratory of harmony in the Haymarket, to distant parts of the metropolis" (175). The idea seemed so fanciful, however, that the writer abandoned it, lest it inspire "endless speculation" (175).

Upon encountering the Enchanted Lyre, the Danish scientist Hans Christian Ørsted—who had conducted "many hundred experiments" on acoustic vibrations based on the findings of Ernst Chladni—encouraged Wheatstone to publish his studies on sound and transmission (Ørsted [1810] 2014, 264).[2] Wheatstone's "New Experiments on Sound" appeared in the August 1823 issue of Thomson's *Annals of Philosophy*. Four years later, Wheatstone wrote "Experiments on Audition" (1827), an article that signaled the imminent rise of otology as

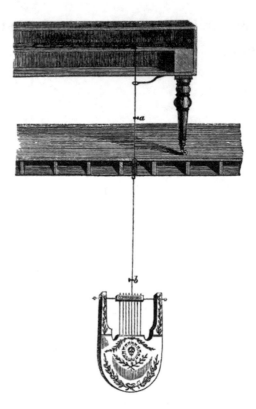

Figure 2.1
Diagram of Charles Wheatstone's Enchanted Lyre (Wheatstone [1831] 1879, 56).

a distinct branch of medical science. "Though the physiology of the ear has been an object of unceasing attention for many centuries," he wrote, "we are far from possessing a perfect knowledge of the functions of the various parts of this organ" (Wheatstone [1827] 1879, 30). In pursuing a more perfect knowledge of the ear Wheatstone conducted experiments with implements like tuning forks, ear trumpets, wool, water, and metal, observing the effects of different conditions of hearing upon his own perception of sound. He observed, for example, the changes he sensed in the quality of sound when he placed the stem of a tuning fork to his head when one or both of his ears were closed, and how these sensations changed when his ears were stuffed with wool or filled with water. In one experiment he held two tuning forks sounding in unison to the same ear and observed the changes that occurred when he moved one of the forks to the opposite ear. Wheatstone's first article, "New Experiments on Sound," had explored the phenomenon of mechanical oscillation in vibrating bodies. In turn, "Experiments on Audition" demonstrated principles of mechanical oscillation as these

applied to the auditory organ itself, whether in relation to specific parts of the ear—the ear canal, the pinnae, the tympanic membrane—or else in relation to cranium, the so-called "container" of the hearing apparatus. In this article Wheatstone also conjured the prospect of a microphone, conceiving it as "an instrument which, from its rendering audible the weakest sounds, may with propriety be named a Microphone" (Wheatstone [1827] 1879, 32). He imagined that the microphone could be fastened to the head itself—either to both ears, or, in a modified version, to one ear alone.

The Enchanted Lyre had succeeded in transmitting music across a distance.[3] Wheatstone's microphone, conversely, would have brought sounds from a distant source to the listener's ears. As such, Wheatstone's earliest experiments in acoustics can be said to have been concerned with overcoming a spatial dilemma: the annihilation of distance, a preoccupation that also fueled his most celebrated contribution to science, the invention of the electric telegraph.

Wheatstone's experiments predated the scientific concept of binaural audition. However, like Venturi's experiments from the late eighteenth century, they supported the idea of treating binaural audition as an object of scientific study, since they were undertaken with respect to the different circumstances of hearing with one or two ears. His experiments equally pointed to a new kind of scientific observer that would emerge over the course of the nineteenth century: an auditory observer who reported on their subjective impressions of sounds and auditory effects under different conditions of listening. Over the course of the nineteenth century this auditory observer would become increasingly understood as a binaural listener, one who listened with both ears through a binaural (two-eared) or stereo (two-channel) apparatus and who observed the behavior of sound in three dimensions.

In tracking the rise of the binaural listener, I explore *how* people listened as they listened through binaural devices, and I consider what they heard—and how they interpreted what they heard. In the nineteenth century the concept of spatial hearing was mostly foreign in science. In attempting to describe the novel auditory sensations produced by listening through binaural technologies, scientists grappled with a paucity of language. Many relied on visual analogies and metaphors to describe spatial auditory phenomena. More fundamentally, they relied on theories of binocular vision to explain phenomena of binaural audition. This reliance on visual language, technologies of vision, and optical science produced a distinct visual bias in emerging theories of auditory space perception. As this chapter will show, this visual bias is traceable in scientific theories that held that auditory space perception was secondary or "subordinate" to visual space perception, or that characterized auditory space perception as merely illusory—a construct of the mind, or a by-product of other sense perceptions, in particular of the senses of vision or touch. Even Arthur Henry Pierce, the theorist who most fervently argued that auditory space perception functioned *independently* of other

sense perceptions, nevertheless concluded that "hearing serves vision" (Pierce 1901, 185). He suggested that orienting oneself in physical space through listening would be akin to finding oneself in a hall of mirrors. Since sounds were always liable to be reflected, he wrote, one would never know "whither to turn" (186).

2.2 "We . . . place our ears in our hands": The Differential Stethoscope

Some thirty years after the publication of Wheatstone's "Experiments on Audition" the British physician Somerville Scott Alison designed a new kind of stethoscope (see figure 2.2), which he alternately called the "differential stethoscope" or the "stethophone."[4] In describing this device Alison developed new theories of sound that drew heavily upon Wheatstone's experiments in sound and audition, the only studies he claimed he could find to bear upon his observations.

Alison's device was a modification of the binaural stethoscope, which was invented in 1851 by the Irish physician Arthur Leared and refined in 1852 by the American physician George Philip Cammann. While the single-eared (or "uno-aural") stethoscope had been in use since 1816, Leared's modification—adding a second listening tube—did more than enhance its effectiveness. It suggested a new mode of technologically mediated listening, one in which sound was transmitted from one source simultaneously to both ears. In describing Cammann's stethoscope Alison coined the term "bin-aural," remarking that it enabled auscultators to apply "the principle of bin-aural observation" (Alison 1861, 324). Alison's own differential stethoscope went a step further, adding a second "trumpet" or "sound collector" to the binaural stethoscope, and thereby enabling auscultators, as Jonathan Sterne writes, "to listen to two separate points on the patient's body and compare the sounds" (Sterne 2003, 155).

In an 1858 letter to the Royal Society, Alison suggested that, when treating disorders of the heart, it was medically advantageous to be able to listen to more than one sound at the same time. With the differential stethoscope a physician could distinguish, for example, between a "whistling lung-sound" heard in one ear with a "loud blowing lung-sound" heard in the other, or a "hissing murmur" arising from the apex of the heart with a "rasping sound" emanating from its base (Alison 1858, 205). Alison was even more assured of the medical value of such a differential mode of listening, what he called "differential auscultation," in his 1861 treatise *The Physical Examination of the Chest in Pulmonary Consumption and Its Intercurrent Diseases*. There he wrote, "I can now conscientiously say, that I believe [the differential stethoscope] to be an instrument which should be in the hands of every practitioner who sees much of chest disease, and whose ears are tolerably equal in acuteness" (Alison 1861, 329). He argued that the differential stethoscope would enable physicians to gather evidence

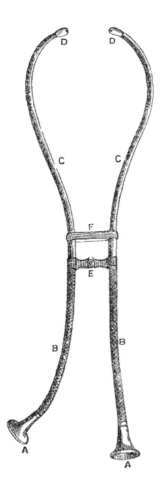

Figure 2.2
Diagram of the differential stethoscope by Somerville Scott Alison (1858, 198). Alison wrote that the two hearing-tubes "are composed of two parts nearly equal in length, one near the ear-knob, made of metal (C); while the other part, near the collecting-cup, is made of metal wire (B), to impart flexibility. The ear-end is curved, so as to approach the ear, and is supplied with an ivory knob (D) for insertion into the meatus externus. The other end of the tube, being intended to collect sound, is supplied with a hollow cup, or receiver (A) made of wood, or some such material. . . . The two tubes are brought near together, a few inches in front of the face, by means of a connecting-bar (E), but calculated to prevent the transmission of sound from one tube to the other. This bar is supplied with a joint, which permits the tubes to be freely moved. . . . The two knobs are kept steadily in the ears by means of an elastic band (F) connecting the two tubes near the bar" (197–198).

that could not otherwise be procured, "for by no other means is it possible to apply, as we virtually do when using this instrument, the two ears at the same moment on two different parts of the chest, and obtain those singularly interesting and highly valuable results in respect of the correlation of the two ears, and of two auditory sensations or impressions already fully referred to" (329).

Alison gave vivid impressions of the sounds he heard while listening through the differential stethoscope. He described "cavernous liquid bubbling sounds," "cracking and bubble noises," "loud explosion sounds," "sharp gurgling sounds," and "cracked-pot or money-jingle sounds" in listening to the audible traces of diseases like phthisis and consumption (Alison 1861, 184–227). He further analyzed these sounds according to where they originated in the body, how they changed over time, as well as their loudness, timbre, and other acoustic characteristics. For example, he observed of the "cracked-pot" sounds—which he associated with the first stage of phthisis—that the main sound to consider was "a loud, metallic, cavernous, abrupt sound, of short duration, suddenly arrested, and proceeding from hard, rather bound, materials, as walls of a cavity containing air, and in violent vibrations" (237). He also specified of those vibrations that they were "greatly confined, i.e. are not propagated to a distance among the solids. The vibrations proper to the sound are nearly confined to the area of the cavity walls" (237). Alison gave detailed instructions on what sounds to listen for, where to find them, how to interpret them medically, how to appreciate their acoustic characteristics, and how to do so comparatively, while listening to two different sounds separately but simultaneously in each ear.

The differential stethoscope not only afforded new techniques for auscultation; it also shaped ideas about sound and hearing as they were mediated through a binaural and stereo apparatus. Alison remarked that the differential stethoscope enabled the listener to analyze a "compound sound, or one composed of two sounds, and to divide it into its component parts" (Alison 1858, 205). He stressed that no such analysis could be made with the ordinary binaural stethoscope, since it conveyed the "mixed or compound sound to the ear" (205). The experience of listening through the differential stethoscope suggested that sound was made up of multiple components; and that these components could be picked up by different collectors, directed through distinct channels to distinct receivers, and followed simultaneously but separately by the two ears. As such, Alison's discussion of the differential stethoscope, a mechanical device, prefigured the idea of treating sound as an electrical signal—as something whose components could be combined and mixed through a transmission process.[5]

What Alison described as a process of separating "compound sounds" was specifically dependent upon a binaural and indeed stereo mode of listening. As Alison wrote, "The sound is divided into two parts, and one is heard in one ear, and the other part in the other ear"

(Alison 1858, 205). Although the term "stereophonic" had not yet been invented at the time of Alison's writing, it is today believed that the first experiments with stereophonic audition were with the differential stethoscope (Sterne 2003, 155–156). Sterne writes that the device produced a "weak" stereo effect: "by placing the two chest pieces in different places on the patient's body, the user created the illusion of a three-dimensional auditory field" (156). Sterne convincingly argues that the binaural stethoscope transformed auditory cultures in suggesting "an individualized acoustic space around the listener" (55). Along the same lines, the *differential* stethoscope was specifically important in further embedding the listener within this individualized acoustic space, by situating them within a three-dimensional auditory field. The differential stethoscope was equally important in enabling a differential mode of listening whereby multiple sources of sound could be followed simultaneously. It was thus influential in suggesting that multiple channels of sound might be observed (and eventually, recorded and reproduced) at once.

In describing the experience of listening through the differential stethoscope, Alison frequently conjured the visual and haptic senses. He likened the advantage of using the differential stethoscope to "that which we obtain, when having inspected a fine object with one eye only, we employ both organs" (Alison 1861, 322). Elsewhere he remarked that, with the instrument, "we . . . place our ears in our hands, apply them where we choose, and listen with them both at adjacent or distant points of the same surface, at one and the same instant of time" (Alison 1858, 206). Alison thus imagined the differential stethoscope as a device that could be used to literally "handle" sound. It extended the perceptive power of the ears through the dexterity and mobility of the hands, conferring upon hearing a newfound sense of tactility. Alison even compared the feeling of differential audition with the sensation of being touched in several places at once (201).

2.3 "By means of the ears": The Homophone

Two decades after Alison's experiments the German physicist Anton Steinhauser remarked that, while monaural audition had already been treated "in every textbook of Physics," the study of binaural audition had "never," to his knowledge, "been yet developed" (Steinhauser 1879, 181).[6] Steinhauser proposed, plainly, that a theory of binaural audition should consider issues of hearing "with respect in particular to the circumstance that it is performed with two ears" (182). In a series of experiments that aimed to establish the physics of binaural audition, Steinhauser closed his eyes to isolate the sense of hearing, and stuffed his ears with cotton wool to mimic the experience of deafness. He devised equations for calculating the different variables involved in binaural audition. One calculated the intensities of "rays" of sound with respect to the two ears, while another determined the "direction of best hearing"

Figure 2.3
Diagram of the homophone by Anton Steinhauser (1879). The listener, whose head was represented by
K, received sounds at the two ears, *O1* and *O2*, via cardboard funnels, *T1* and *T2*. The sound came from
two flute organ pipes, *p1* and *p2*, which were inserted into two holes in a wooden tube whose cross-
section was indicated by *a, b,* and *c.* The tube was closed at *a* and *c; b* represented a mouthpiece through
which air from the bellows could be continuously blasted. The organ pipes emitted tones of the same
pitch but of slightly varying intensities. These intensities were controlled by valves at *m* and *n,* which
regulated the air current.

(190), by which Steinhauser referred to where a listener should be positioned relative to a
source of sound in order for that sound to be most clearly audible.

 In the course of these studies Steinhauser invented a device, the homophone, which he
described as an aural analogue to Wheatstone's stereoscope, a visual apparatus that enabled
the observer to view a pair of photographic images as a single, three-dimensional image
(see Crary 1990). The homophone used a pair of organ pipes and bellows to deliver tones
of the same pitch but different amplitudes simultaneously to the two ears (see figure 2.3).
The idea was that the direction of sound would become more certain when the difference in
intensity between the sound at the left and right ears was increased. Steinhauser compared
this to how, analogously, "the distance of [an object] may be the more surely estimated in
binocular vision the smaller that distance is, or as the directions of the two optic axes differ
more and more widely" (Steinhauser 1879, 190). The homophone thus put into effect a kind
of "acoustic axis" for the ears, transposing onto the auditory realm an idea borrowed from
optical science.

 From a contemporary perspective, one of Steinhauser's principal conclusions in "The
Theory of Binaural Audition" seems almost too self-evident to repeat: that the two ears work
in tandem to locate the source of a sound. Yet in 1879 it was widely thought that the eyes,
not the ears, were primarily or even exclusively involved in making spatial determinations.
Steinhauser gave an everyday example to illustrate his idea that the ears also contributed to
the perception of space. He wrote, "When we try to find a lark which we may hear singing
above a field . . . we raise the head, making an arbitrary guess at the position of the lark in the

sky. Then we turn the head about, led meanwhile *by ear* until we hear equally well with the two ears and with the greatest possible intensity; and simultaneously we perceive the lark in the line of sight" (Steinhauser 1879, 197; emphasis in original). He concluded that people do not search for the source of sound with their eyes, but, instead, *"by means of the ears"* (197; emphasis in original).

2.4 "Illusions . . . in the acoustic perception of space": The Pseudophone

Nicholas J. Wade and Diana Deutsch suggest that it was not the stethoscope or the homophone, but another nineteenth-century instrument, the pseudophone, that would most distinctly shape the emerging science of spatial hearing (Wade and Deutsch 2008). The pseudophone was invented in 1879 by the English physicist and electrical engineer Silvanus P. Thompson, who conceived it as "an instrument for investigating the laws of Binaural Audition by means of the illusions it produces in the acoustic perception of space" (Thompson 1879, 385). Like the homophone, it was directly modeled on a visual apparatus invented by Wheatstone: the pseudoscope, a device that Wheatstone designed in the course of his studies of binocular vision, describing it as an instrument that conveyed to the mind "false perceptions [e.g. illusions] of all external objects" (Wheatstone 1852, 11).

Wheatstone introduced the pseudoscope in an influential two-part paper on binocular vision, "Contributions to the Physiology of Vision," published in 1838 and 1852. In part I of this paper he examined the role of binocularity in the perception of visual relief and perspective. Having established that the mind perceives a three-dimensional object by means of "two dissimilar pictures projected by it on the two retinae," he wondered what the effect would be when, instead of viewing the object itself, a projection of the object upon a plane surface was simultaneously presented to each eye (Wheatstone 1838, 373). In the course of this inquiry Wheatstone devised the stereoscope, a device he named as such in order to indicate "its property of representing solid figures" (374). Part II of Wheatstone's paper focused on a particular phenomenon of stereoscopic vision: the reversal of depth perception, which is to say, conversions of relief. Whereas the stereoscope had enabled the scientist to study conversions of relief as exhibited by binocular *pictures* when they were "transposed, reflected or inverted" (Wheatstone 1852, 11), the pseudoscope permitted the scientist to study conversions of relief by viewing the objects themselves.

Wheatstone shared his impressions of everyday objects as he saw them through the pseudoscope, listing a panoply of visual effects he associated with conversions of relief. He discovered that the concave interior of a teacup would appear solid and convex when viewed through a pseudoscope, while a small terrestrial globe would appear concave and hemispherical (Wheatstone 1852, 13). Wheatstone's experiences of optical illusions were vivid and

transfixing. In turning the terrestrial globe on its axis, for example, Wheatstone discovered the curious effect of seeing parts of the spherical map "appear and disappear in a manner that nothing in external nature can imitate" (13).

Wheatstone studied the optical illusions produced by looking through the pseudoscope under different conditions of seeing. He experimented with lighting conditions, for instance by using a candle to illuminate an object; and he observed the differences in the appearance of an object when it was either still or in motion. Revisiting Wheatstone's papers, it is clear that Thompson not only drew inspiration from Wheatstone's pseudoscope as the basis for his pseudophone, but was equally inspired by Wheatstone's experimental methodology, which highlighted the interplay of numerous factors underlying visual space perception. These factors included lighting, shading, and binocularity as they influenced the visual perception of distance, relief, depth, and perspective. Along similar lines, Thompson investigated binaural audition in relation to a range of acoustic factors that included pitch, timbre, amplitude, and phase.

Thompson introduced the pseudophone in an 1879 article, describing it as a device that consisted of two ear-pieces furnished with metallic flaps, which acted as sound reflectors (see figure 2.4). The flaps could be set at any angle relative to the axis of the ears. They could be further turned upon an axis, "so as to reflect sounds into the ears from any desired direction" (Thompson 1879, 387). As Herbert L. Pick writes, with the pseudophone a scientist could effectively manipulate "the interaural distance of the sounds' input to the listener's ears," such that a change in the angle of the metallic flaps would result in "a systematic direction

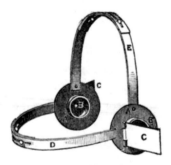

Figure 2.4
Diagram of the pseudophone by Sylvanus P. Thompson (1879). Thompson wrote, "The simple instrument for which the author suggests the name Pseudophone consists of a pair of ear-pieces, A A, furnished with adjustable metallic flaps or reflectors of sound, C C, which can be fitted to the ears by proper straps, D and E, and can be set at any desired angle with respect to the axis of the ears, and can also be turned upon a revolving collar about that axis so as to reflect sounds into the ears from any desired direction" (387).

change in all auditory stimulation" (Pick 2008, 32). Just as Wheatstone's pseudoscope could produce vivid optical illusions, Thompson's pseudophone could produce a wide range of auditory illusions. By reversing and adjusting the flaps a person could be made to believe that a sound actually originating behind them was instead situated in front of them. In listening through the pseudophone Thompson found that certain sounds—the ticking of a loud clock, the human voice, a tuning fork—were more prone to producing distinct auditory illusions than others. He remarked on the effects of external factors, such as architectural acoustics, on the quality of the illusions. One experiment succeeded in a room but not in open air. When conducting the experiment outdoors, where there were no immediate acoustic reflectors, the sound did not seem "to *have* any precise locality" (Thompson 1879, 379; emphasis in original).

Thompson devised the pseudophone in part to test Steinhauser's intensity theory of binaural audition, which held that the perception of the direction of sound was dependent upon the difference in the intensity of the sound at the two ears. If Steinhauser's theory was correct then a device that could virtually alter these intensities in ways that were unknown to the listener would create corresponding illusions in the perceived direction of sound. Thompson was not only concerned with the role of intensity in binaural audition, however. Following Wheatstone, he developed a theory of binaural audition as a complex phenomenon in which pitch, timbre, loudness, phase, and reverberation all played a role (Thompson 1877, 1878, 1879). While Steinhauser's theory of binaural audition was concerned solely with the role of intensity, Thompson wrote, his own experiments aimed to show that all these factors played a role in sensing the direction of sounds, and that phase was especially important in this regard (Thompson 1879, 385). This latter hypothesis was most famously corroborated by the English physicist Lord Rayleigh, who first conducted experiments on sound localization around the time of Thompson's own investigations (Rayleigh 1875), and whose 1907 paper, "On Our Perception of Sound Direction," would become the definitive study on the role of phase in sound localization in the early twentieth century.

In Thompson's papers from 1877 to 1879 we find increasingly detailed descriptions of the sensations of binaural audition. Thompson observed, for example, the interference patterns that became audible when listening to two tones that were out of phase. He also observed an "acoustic image" that formed in different parts of the head when listening to two tones that slightly differed in pitch and amplitude (Thompson 1879, 386); and tones that seemed to be localized at the back of the head or in the cerebellum under certain experimental conditions. In one experiment he listened through two telephone receivers. When his assistant tapped on the wooden support of the microphone, he felt as if "simultaneous blows had been given to the tympana" (386) of his ears. On reversing the current through one telephone, however, he experienced a sensation akin to "someone tapping with a hammer *on the back of the skull from the inside*" (386; emphasis in original). Steinhauser questioned whether

these auditory sensations were "physical, physiological, or psychological" (389), setting into motion a debate that would preoccupy a number of psychophysicists in the late nineteenth century, which I revisit later in this chapter.

2.5 "Sounds assume a 'solidity'": The Telephone and the Théâtrophone

In the late nineteenth century, the study of spatial hearing would come to encompass the physics of sound, the physiology of the ear, and the psychology of hearing, with listeners reporting on their auditory impressions in monaural, binaural, and stereophonic listening contexts. The term "stereophonic" was introduced by Alexander Graham Bell, who patented the telephone in 1876 and who subsequently conducted a series of experiments that aimed to establish whether the distance or the direction of sounds could be sensed through telephonic listening (Bell 1880). Bell's experiments on spatial hearing through the telephone were complex and laborious. They involved several assistants and multiple auditors who relayed their perception of the distance and direction of sounds, while listening in a number of different rooms and locations, using different kinds of transmitters; listening with one or two ears; listening while blindfolded or not; and listening while the source of sound was still or in motion. From these experiments Bell concluded that the distance and direction of sounds could *not* be reliably ascertained when listening through telephone receivers. Still, he noted that the differences between monaural and binaural audition were especially pronounced when attempting to locate the source of a sound, and that "whatever power a single ear may possess of determining the direction of a source of sound, both ears together are certainly much more effective for this purpose" (169).

Bell associated a particular sensation of hearing when listening with both ears versus one: that sounds seemed to gain a sense of "solidity." He wrote, "There seems to be a one-sidedness about sounds received through a single ear, as there is about objects perceived by one eye. When both ears are employed simultaneously, a sort of stereoscopic effect of audition is perceived. Sounds assume a 'solidity' . . . which was not perceptible so long as one ear was employed" (Bell 1880, 169). The concept of stereophonic listening was thus introduced into the scientific lexicon as an analogy to stereoscopic viewing.

Bell predicted that just as Wheatstone's stereoscope had been used to produce the peculiar effects of binocular vision, his telephone might one day be used to reproduce "the stereophonic phenomena of binaural audition" (Bell 1880, 169). Hardly a year after he made this pronouncement the French engineer Clément Ader filed a patent for a system that did just that. Ader's system used the Bell telephone to create stereophonic effects in transmitting music and speech from concert halls, opera houses, and theaters across telephone lines—in stereo. This broadcasting system not only fulfilled the prospect of a long-distance music

embodied in the Enchanted Lyre, but also transmitted this music in three-dimensional auditory relief. In this system—first known as the "Ader telephone" and subsequently commercialized as the Théâtrophone in France, the Electrophone in England, and Telefon Hírmondó in Hungary—a series of telephone mouthpieces were arranged in a row at the foot of a stage, acting as a microphone array. Several kilometers away listeners held not one but two telephone receivers to their ears in order to hear a *stereo* transmission of the performance as it unfolded on the stage.

In a 1981 feature celebrating the centenary of stereo sound in the *New York Times*, the electronics writer Hans Fantel wrote of the théâtrophone that, "in short, Ader had invented stereophonic sound reproduction" (Fantel 1981, 2A–23). For Fantel the concept of the théâtrophone as a system for broadcasting live performances was not particularly remarkable. Such an idea had practically suggested itself upon the invention of the telephone. In fact, the *New York Times* had itself predicted in 1876 that "by means of [the telephone] a man can have the Italian opera, the Federal Congress, and his favorite preacher laid on his own house" ("The Telephone" 1876, 8). What was striking about Ader's invention was not its underlying concept but its stereophonic implementation, as described in Ader's 1882 patent:

> I place a series of transmitters on the stage in the vicinity of the foot-lights, each of these transmitters being arranged, as usual in a local circuit, with a battery and induction-coil and a line-circuit extending from each such coil to the houses of the respective subscribers. Two line-circuits extend to the house of each subscriber and there terminate in two receiving-telephones, one of which the auditor is to place at each ear. The receiver which he should place at his right ear is connected with a transmitter at the right of the stage, and the one which he should place at his left ear is connected with a transmitter at the left of the stage. (Ader 1882, 1)

Like Bell, Ader associated the feeling of listening through two telephone receivers with that of looking through the stereoscope. He described the théâtrophone's effects on the ears as "akin to that which the stereoscope produces on the eyes" (Ader 1882, 1). Journalists also commented on these effects following two enormously popular exhibitions of the théâtrophone in Paris at the 1881 International Electrical Exhibition and the 1889 World's Fair. A science writer described "the new acoustic effect which Mr. Ader has discovered" thus:

> In listening with both ears at the two telephones, the sound takes a special character of relief and localization which a single receiver cannot produce. . . . As soon as the experiment commences the singers place themselves, in the mind of the listener, at a fixed distance, some to the right and others to the left. It is easy to follow their movements, and to indicate exactly, each time that they change their position, the imaginary distance at which they appear to be. This phenomenon is very curious, it approximates to the theory of binauricular audition, and has never been applied, we believe, before to produce this remarkable illusion to which may almost be given the name of auditive perspective. ("The Telephone at the Paris Opera" 1881, 422)[7]

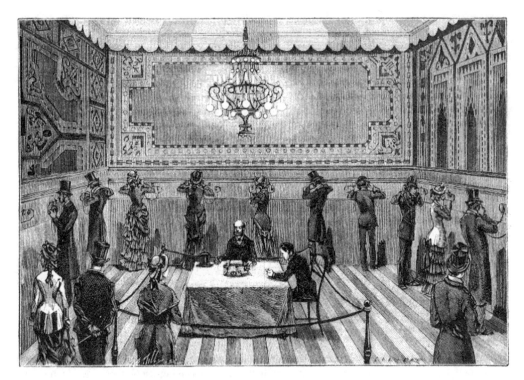

Figure 2.5
Woodcut depicting one of the four halls reserved for théâtrophonic audition at the International Exhibition of Electricity in Paris in 1881 (E. H. 1881, 260).

The experience of hearing electrically reproduced sound in auditory perspective would have been completely unknown to nineteenth-century listeners. Indeed, for many listeners, the théâtrophone would have simultaneously been their first experience of electrically transduced sound (Van Drie 2015, 84), acousmatic sound (Fauser 2005, 286), and stereo sound. The exhibition setup at both fairs emphasized these effects. Melissa Van Drie writes of the 1881 exhibition that "listeners entered a dimmed room and were instructed to stand at individual listening posts mounted along the wall. Facing the wall, they raised *transducteurs* [transducers] to their ears and listened in" (Van Drie 2015, 84) (see figure 2.5). At both fairs the rooms reserved for théâtrophonic listening were heavily carpeted and draped, thereby reducing the level of ambient noise and adding to the sense of a private listening space (Fauser 2005, 284–289). Within this space of heightened listening, listeners could be more fully absorbed within the acoustic spaces of théâtrophonic transmissions. As a journalist for

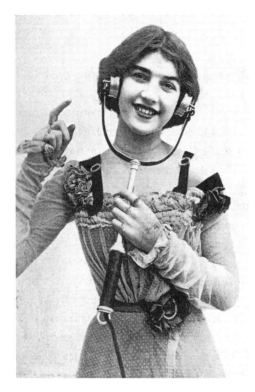

Figure 2.6
Electrophone demonstrator by Foulsham and Banfield, from the March 30, 1901, issue of *Black and White Budget* (13).

Le Figaro remarked, a listener, "caught by the illusion" of thinking that he was in the theater itself, "puts down his receivers in order to applaud; the laughing of his neighbors brings him back to reality" (Nemo 1889, cited and translated in Fauser 2005, 286).

Guisy Pisano suggests that listening through the théâtrophone was at once a private and public experience, and an individual and collective one (Pisano 2012, 85) (see figure 2.6). Théâtrophonic transmissions were "directed towards individual listeners" (85), but they were experienced simultaneously by numerous listeners, including those who listened at home, those who listened on public théâtrophone machines in cafés and hotels, as well as audiences at the live performances. For this reason, Adrian Curtin describes the théâtrophone as a "spatially discontinuous and dispersed" medium (Curtin 2014, 104) and remarks that, with this device, modern theater did not merely "take place"—rather, it *"took places"* (105; emphasis in original). The spaces of théâtrophonic transmissions even extended to the space

inside the listener's head, a space that was newly reconstituted as a stage in which musical and theatrical performances could unfold (Whitney 2013).[8]

2.6 Studies in Auditory Space Perception: The Rotating Chair

Just as the experience of théâtrophonic listening spanned a multitude of physical spaces, psychophysicists of the late nineteenth century debated the characteristics of a multitude of sensible spaces (see Hui 2013). In a 1901 article for *The Monist* the Austrian psychophysicist Ernst Mach explored the characteristics of "visible space," "tactual space," and "haptic space," comparing these sensible spaces with the absolute spaces of Euclidean geometry (Mach 1901). The idea that there existed an auditory space, however, remained widely contested. The American psychophysicist Arthur Henry Pierce wrote, "among the various spaces that have been overtly recognized—visual, tactual, etc.—it is only too evident that an auditory space has not been generally included" (Pierce 1901, 7). With his *Studies in Auditory and Visual Space Perception* (1901), Pierce sought to develop a counter-premise to prevailing attitudes toward the concept of auditory space—attitudes that, he wrote, consisted mostly of "adverse opinions" (16). The scope of these adverse opinions varied widely. Some had to do with the physics of sound, and whether sounds themselves could relay spatial information, while others had to do with the physiology of the ear or the psychology of hearing. For most theorists, Pierce explained, it was self-evident that sounds possessed in and of themselves "no spatial attributes. In themselves [sounds] are neither 'here' nor 'there,' neither 'massive' nor 'piercing'" (10). Other theorists believed that the *ear* did not possess enough physical surface to convey spatial impressions, but that it could only perceive "positions" in each moment. The Swiss theorist Max Egger transposed dichotomies of auditory and visual space onto dichotomies of time and space, arguing that the ear gave "successions" (in time) while the eye gave "positions" (in space) (Pierce 1901, 12; see also Egger 1898). Still others understood sound as capable only of producing "pure sensation," unable to yield "the consciousness of space" (12). One psychologist asserted that "auditory sensations, which have no spatial attribute, contribute nothing directly to our ideas of space" (Titchener 1896, 150). For the Scottish psychologist Alexander Bain, auditory space was merely an intellectual construct, with the direction of sounds perceptible only insofar as reasoning was applied to determining them (Bain 1855). Conversely, the German psychologist Theodor Lipps understood sounds *themselves* as possessing spatial attributes, but he did not connect the perception of space to the sense of hearing (Lipps 1883). For Lipps, the idea that sounds could be heard as being closer or further away was "like the notion that we immediately see things hard or soft. Distance is no possible object of hearing" (Pierce 1901, 14–15). Finally, some theorists believed that auditory space perception was a by-product of other sense-perceptions. For the American

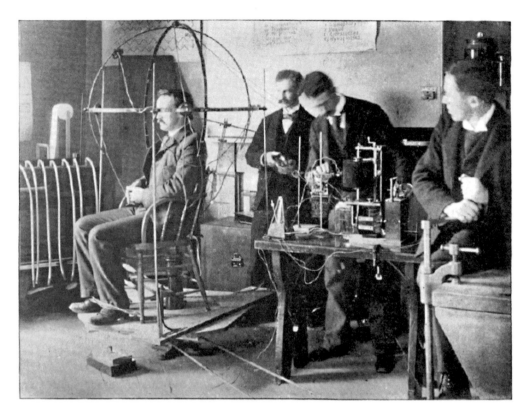

Figure 2.7
Hugo Münsterberg seated in the rotating chair at the Harvard Psychological Laboratory (from *Psychological Laboratory of Harvard University* 1893; see also Nichols 1893).

psychologist George Trumbull Ladd (Ladd 1894), auditory space was *not* a construction "of the ear." Rather, auditory localizations were localized "in a space *already constructed* by activity of eye, muscles, and skin" (Pierce 1901, 13; my emphasis). Similarly, for the German psychologist Wilhelm Wundt, auditory space perception always presupposed "space perceptions acquired through sight and touch" (14).

After a comprehensive review of the scientific literature, Pierce introduced his own studies on auditory space perception. He had embarked on these studies while undertaking a doctorate under the supervision of the psychologist and philosopher Hugo Münsterberg at the Harvard Psychological Laboratory the early 1890s, where they used a rotating chair apparatus (see figure 2.7).[9] Pierce later continued this research at Amherst College in 1897 and 1898, where he used a modified version of the apparatus. The rotating chair apparatus had a circular metal rim that could be adjusted to any height, and circular metal arcs that could

be adjusted on any plane. The observer sat in the center of the horizontal rim and listened to sounds emitted by telephone receivers, which could be fixed along any part of the rims. The duration and amplitude of the sounds emitted by the telephone receivers were controlled via an electrical switch. Münsterberg and Pierce claimed to have conducted "many thousand experiments" (1894, 465) with twelve subjects in 1892 and 1893. The subjects, who were all familiar with the rig, were considered trained auditors, and were submitted to regular hearing tests to reduce the possibility of error. Upon listening to a sound with their eyes closed, the auditors would guess its position. If they believed the sound was directly in front of them they would say "0," or "90" if the sound seemed to originate immediately to their right; "180" if it seemed to originate at their back; or "90-L" if it seemed to come from their left. The tests typically made use short bursts of sound(s), as per this small sampling of tests:

> Two sounds, one on each side, symmetrically placed. Duration one second. . . .
>
> Sounds symmetrical, the intensity of one gradually increased by moving the telephone along a graduated radius nearer the head of the subject. . . .
>
> Horizontal circle, both sounds on the same side of the median plane. . . .
>
> Two sounds symmetrically placed on the graduated radius at short distances from the head. Several very different intensities by means of the resistance-box in the electric circuit. . . .
>
> (Münsterberg and Pierce 1894, 465–468).

These experiments resulted in a systematic mapping of directional hearing, with auditors' responses analyzed to give a "normal" picture of auditory space perception: how test subjects, on average, ascertained the location of sounds in three-dimensional space; how this changed when the loudness of the sounds was increased or decreased; or when there were one or more sounds; and when the sounds were closer or further away.

In order to prove that auditory space perception functioned independently of the senses of vision and touch, Pierce proposed a theory that relied on a relatively untested space: the space inside the listener's head. In the course of the rotating chair experiments auditors sometimes reported hearing sounds that seemed to be located *inside* their own heads. Intracranial or endocephalic sounds had first been observed by the anatomist Jan Evangelista Purkyně around 1860, and later by Sylvanus P. Thompson, who had described harmonic beats that "seemed to be taking place within the cerebellum" (Thompson 1877, 274). They had also been observed by the otologist Victor Urbantschitsch, who described sounds that seemed to be localized inside the head, nose, and pharynx (Urbantschitsch 1881, 1883). In Pierce's own experiments the favored positions of intracranial sounds were between the eyeballs, near the occipital bone, or "deeply within the head, at or near the middle point of the line joining the two ear-drums" (Pierce 1901, 126).[10]

Sensing a sound as located inside one's own head had significant theoretical implications. For Pierce, the existence of intracranial sounds proved definitively that auditory space perception functioned independently of the senses of vision and touch, since those senses did not, and *could* not, extend into the interior of the head. He wrote, "intracranial space belongs neither to vision nor to touch. . . . *The intracranial localizations of sound must be independently accomplished*" (Pierce 1901, 180; emphasis in original). Pierce's "proof" of auditory space perception as an independent perceptual faculty thus lay in the most extreme version of a subjective experience of sound: the perception of a sound that seemed to be located inside the listener's own cranium—a sound that could only be sensed by the acoustic observer alone.

2.7 The Rise of the Binaural Listener

Over the course of the nineteenth century there emerged a new kind of listening subject: a binaural listener, one who was constituted in relation to three-dimensional acoustic and auditory space. The binaural listener was a product of nineteenth-century science, technology, and sonic cultures. He was produced through the emerging science of spatial hearing, the development of binaural and stereo technologies, and the experience of hearing theater and music transmitted in three dimensions. These developments took place in a wider cultural and philosophical context whereby "space" was increasingly understood not only as an absolute mathematical or geometrical phenomenon, but equally in sensorial terms, as something that could be sensed by the human subject.

Over the course of the nineteenth century the spatial properties of sound and hearing were increasingly measured, defined, and delineated; and practices of spatial hearing were codified and systematized, as in the increasingly standardized practice of binaural auscultation. As the following chapters show, these processes would continue to unfold and become much more extreme over the course of the next century. By the start of the First World War the binaural listener would not only be disciplined according to the logics of Western science and medicine, he would also be militarized and mobilized through warfare (chapter 3). By the 1930s the immersive acoustic spaces of théâtrophonic transmissions would become much more precisely controlled, with scientists attempting to create "acoustic facsimiles" of entire orchestras using stereo reproduction techniques (chapter 4). By the 1950s electronically reproduced music would no longer be transmitted via only two telephone receivers but projected over dozens or even hundreds of loudspeakers, whether in the context of spatial music or in multichannel sound design for theater (chapters 5 and 6). The rise of the binaural listener would thus have profound effects upon auditory and acoustic cultures, whether in the current proliferation of stereo sound or in

the increasingly common desire to "immerse" the listener in three-dimensional auditory space, as with VR audio. In these ways, the sonic spatial pursuits of nineteenth-century scientists and inventors—transmitting sound across a distance, establishing the principles of binaural audition, mapping auditory space perception, broadcasting music and theater in three dimensions—would have enduring repercussions in a number of contexts. They would anticipate and set the stage for a new century in which spatial hearing would not be remarkable but normalized, and would even come to dominate cultures of listening, whether in scientific, medical, military, musical, or artistic contexts—indeed, in all aspects of everyday life.

3 Powers of Hearing: Acoustic Defense and Technologies of Listening during the First World War

3.1 "The End of the War"

According to "The End of the War: A Graphic Record"—the image that graced the frontispiece of *America's Munitions*, a towering report commissioned by Benedict Crowell, the U.S. Assistant Secretary of War and director of munitions during the First World War—the Great War ended not with a bang, but, as in the famous verse, a whimper.

The image, which showed six horizontal lines on a filmstrip, depicted artillery activity at the American front near the Moselle River exactly one minute before and one minute after the time of armistice, 11:00 a.m. on November 11, 1918 (see figure 3.1). The left side depicted artillery activity at one minute before armistice, and showed a flurry of jagged lines ("All guns firing"). On the right side, which depicted artillery activity at one minute after armistice, there were only smooth lines ("All guns silent"). Two small dips around 11:01:01 were attributed to the exuberance of a doughboy who fired his pistol twice in celebration of the ceasefire. Apart from these gunshots, it appeared that artillery activity had ceased entirely, and that the battlefield had been suddenly drained of the throttling sounds of gunfire. The caption for "The End of the War" stated that it was the last record of artillery activity at the American front, and that the image issued from an American sound ranging apparatus.[1] "Sound ranging," it read, "was an important means of locating the positions and calibers of enemy guns."[2] When the image was reproduced in the *Journal of Electricity* the claims made about it were even grander: "Truly history has here been written electrically!" ("The End of the War" 1919, 441).

3.2 "Using our *ears* to aim with"

"The End of the War" was produced through one of numerous methods of acoustic defense that were invented during the First World War. At the outset of the war the concept of

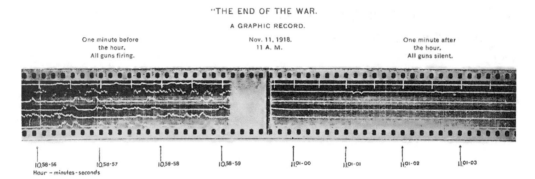

Figure 3.1
"The End of the War: A Graphic Record" (Crowell 1919, frontispiece).

acoustic defense was mostly unknown. None of the principal armies possessed reliable means for tracking the position of the enemy by following the sounds it made. By the end of the war, however, each had developed new technologies and techniques for sound location, typically in response to new technologies of offense, and each had employed these methods on countless occasions—thereby generating new modes of "acoustic defense" (Ganchrow 2009). As Hiram B. Ely, a lieutenant in the U.S. Army, wrote, "The old story of the appearance of a new offensive weapon calling for a new means of defense was repeated" (Ely 1926, 123).[3] In this case, the new offensive weapon was the airplane, "which sprang into existence as a war machine" during the war (123). A. V. Hill, a professor of physiology at the University of Cambridge and director of the Anti-Aircraft Experimental Section in England, remarked that "the necessity for sound-locators arose when night-bombing by aircraft became a serious menace" (Hill 1922, 147). The appearance of a new offensive weapon, however, did not mean that new methods of defense were easily produced. According to Alfred Rawlinson, lieutenant commander of the Royal Naval Volunteer Reserve, the enemy was prone to hiding behind clouds. How should the guns of the defense hit an object they could not see? The answer, he said, was "childishly simple—namely, though we can't *see* it, yet we can *hear* it. Therefore, as we cannot aim by using our *eyes*, we shall be obliged to shoot, if we are to shoot at all, by using our *ears* to aim with" (Rawlinson 1923, 108; emphasis in original). Still, he wrote, there was "a terribly long way to go before theory, however correct, could be turned into successful practice" (109).

This chapter explores the development of acoustic defense during the First World War, examining how theory was turned into practice, and how the practice transformed broader understandings of sound and audition. Recent scholarship on sound and conflict has been focused on the use of sound as a weapon (Cusick 2008, 2013; Goodman 2010) and on the

soundscapes of war (Feiereisen and Hill 2012; Birdsall 2012; Daughtry 2015). By contrast, this chapter is focused on technologies and techniques of acoustic location that were developed in order to locate and track the position of the enemy. It adds to recent studies on such phenomena as systems for underwater sound location and submarine detection (Bruton and Coleman 2016; Wittje 2016), sound mirrors (Ganchrow 2009), Italian methods of sound ranging (Schiavon 2015), and German methods of acoustic defense (Brech 2015; Wittje 2016). My own account focuses on French, British, and American methods of acoustic location, which were arguably the most advanced of the time and gave the Allied forces a distinct military advantage. In particular, I explore what Roland Wittje (2016) distinguishes as subjective methods of acoustic location, methods that required human auditors to listen in order to ascertain the position of the enemy. As discussed in chapter 2, until the early twentieth century, spatial hearing had been studied almost exclusively in terms of the physics of sound or the physiology and psychology of hearing. During the war it was recast as a tactical activity that was understood in strategic terms—as something that could determine human and even national survival. Auditory space perception, once considered subordinate to visual space perception, was newly understood as a vital skill, with "powers of hearing" suddenly mapped onto the powers of nation states.

3.3 The Rise of Acoustic Defense

Sound location technologies made audible—and visible via imaging techniques—those acoustic energies the unaided ear could not hear well. We therefore find in historical accounts the idea that these technologies enabled uncanny or even supernatural gifts of sense, as in the following passage from Crowell's report:

> In childhood we were enthralled by the tales of those magic persons whose keen hearing could detect even the whisper of the growing grass. As camouflage developed, modern warfare yearned for such supernatural gifts of sense that troops might detect the unseen presence of the enemy. Accordingly Science, the fairy godmother of to-day's soldiers, raised her wand, and lo, the Army was equipped with the wonderful ears of the fairy tale, uncanny no longer, but a concrete manufacturing proposition. (Crowell 1919, 383)

While the image of Science raising her wand and granting special powers of hearing to the U.S. Army may have been fantastical, it was not entirely an exaggeration. Scientific experimentation in sound and audition grew exponentially as a result of military research in acoustics. While nineteenth-century studies in acoustics were relatively occasional and small in scale, carried out by individual scientists or small groups of scientists in individual laboratories, wartime studies were innumerable, propelled by a sense of urgency, coordinated at the national and international level, and generously resourced. This surge in experimental

activity was perhaps nowhere more pronounced than in England and France. In England, A. V. Hill oversaw research in acoustics at the Munition Inventions Department's Anti-Aircraft Experimental Section (AAES), which had bases at Rochford and Orfordness. Informally known as Hill's Brigands, the AAES was largely made up of Hill's colleagues from the University of Cambridge (Thomas 2015, 14). Major William S. Tucker, who solved a key problem in sound ranging through his invention of the hot-wire microphone,[4] led a different group of British scientists at the Air Inventions Board's Acoustical Research Section (ARS) at Imber Court in Thames Ditton, Surrey (Zimmerman 1997).

Even a partial inventory of acoustic technologies used by the British military, as gathered from reports issued by the AAES and ARS, gives a sense of the magnitude of experimental activity in this area. Tube resonators, Helmholtz resonators, trumpet sound locators, ear-defenders, sound plotting devices, acoustic height and position finders, listening wells, carbon microphones, magnetophones, the hot-wire microphone, amplifying sets, microphone circuits, many varieties of sound mirrors, the Baillaud paraboloid, the Perrin telesitemeter, and at least two dozen varieties of hydrophones are all discussed in a handful of reports alone.[5] Furthermore, any one of these technologies was subject to extensive experimental testing and multiple design modifications, and each formed the subject of numerous communications, with knowledge regularly shared between Allied forces. Critical within this scheme was the support of private industry as well as of public institutions. The Imperial College of Science in London provided Tucker with the use of the National Physical Laboratory, and sound location instruments were developed and tested at the Psychological Laboratory at University College, London. The Cambridge Scientific Instrument Company, which normally supplied the University of Cambridge with scientific instruments, likewise manufactured a variety of sound location technologies for the British Army. In his report on the AAES, Hill detailed the vast network of collaboration that enabled research in acoustics to flourish in Britain during the war, praising the many scientists who "have thrown themselves into the work, in some cases as volunteers and in other cases for a completely inadequate wage" (Hill 1918, 2).

In France, research in acoustic defense came principally under the purview of l'Etablissement central du matériel de la télégraphie militaire (ECMT),[6] led by General Gustave-Auguste Ferrié. Ferrié was a renowned military leader and radio engineer who had once collaborated on wireless telegraphy with Marconi; he corralled prominent French scientists to work on the project of acoustic defense.[7] Among them was the astronomer René Baillaud, whose Souvenirs d'un astronome 1908–1977 (1980) serves as a key account of the development of acoustic defense in France during this period. Baillaud, who collaborated closely with a "lieutenant Labrouste," worked in parallel with a group of researchers led by Jean Perrin, a celebrated physicist and future Nobel laureate.[8] Another influential scientist involved in acoustic

defense research in France was Lucien Bull, an Irish-born French physicist who invented a string galvanometer that, when paired with Tucker's hot-wire microphone, formed the basis of the "Bull-Tucker apparatus" that became the standard instrument for sound ranging. The Institut Marey, a physiology laboratory in Paris where Bull served as director of research, was the site of the first experimental section in sound ranging in France. It has been speculated that it was due to "the ease with which the French scientist could travel between his laboratory in Paris and the front line" (Innes 1935, 140) that acoustic defense in France developed so rapidly. According to a British account, "The Frenchman could always fix up something in his laboratory, and if he could interest any of the authorities in his experiments they could roll up and see for themselves what he was doing" (141). In British and American accounts, the French are almost universally acknowledged as having pioneered new methods of acoustic defense, while British and American forces are generally agreed to have improved upon French designs.[9]

Critical to the success of acoustic defense in France was the establishment of *Écoles d'écoute*, "Schools of Listening" where French, British, and American soldiers received training in operating acoustic defense technologies. Since it was imperative to protect the French capital, such sites were established in towns near Paris, including at Bonneuil-sur-Marne, Dugny, Fontainebleau, Pagny-la-Blanche-Côte, Saint-Cloud, and Saint-Cyr. These sites were visited by French, American, and British military leaders; and they served as reserves for acoustic defense technologies, many of which were too large to store in any laboratory (see figure 3.2).

The participation of universities and public institutions was also key to the development of acoustic defense in Germany. Scholars have drawn attention in particular to the work of Erich Moritz von Hornbostel, musicologist and director of the *Berliner Phonogramm-Archiv* (Berlin Phonogram Archive), who, as Wittje writes, turned from studying "pieces of music" to analyzing "the sounds of guns and machines" during the war (Wittje 2016, 71; see also Hoffmann 1994). Hornbostel and Max Wertheimer, both former students of the psychologist Carl Stumpf, developed a key sound locator, discussed later, at Stumpf's Psychological Institute in Berlin (Wittje 2016, 75; Brech 2015, 95–104). Meanwhile, Rudolf Ladenburg, an adjunct professor of physics at Breslau, supervised a research unit on sound ranging at the *Artillerie-Prüfungs-Kommission* (Artillery Testing Commission). The future Nobel laureate Max Born was also engaged on the German sound ranging project, as were other prominent scientists from the universities of Göttingen, Leipzig, Jena, and the Technische Hochschule Munich (Wittje 2016, 73–74).

In the United States it was the Signal Corps, a division established during the U.S. Civil War for overseeing military communications, that was responsible for coordinating research in military acoustics. At the start of the war the Signal Corps was a tiny division with negligible

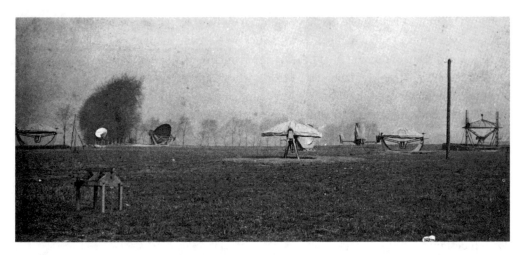

Figure 3.2
A School of Listening at Dugny, France, from 1917 (Baillaud 1980, 164). The photograph shows half a dozen Baillaud paraboloids. Copyright © 1980 by René Baillaud. From the private collection of René Baillaud.

resources; it was deemed "ridiculously inadequate to the requirements imposed by modern warfare" (Lavine 1921, 87). According to Abraham L. Lavine, an employee of the American Telephone and Telegraph Company (AT&T) and a captain in the U.S. Air Service, the military personnel attached to the Signal Corps in 1916 numbered only eleven officers and ten soldiers (87). On October 2, 1916, Major General George Owen Squier, the Chief Signal Officer, wrote to Major John J. Carty, Chief Engineer of AT&T, to seek support for his under-resourced division. Squier wrote:

> It is the desire of the Signal Corps to attract to its Officers' Reserve Corps the very best engineering talent in the country interested in our line of work. The American Telephone and Telegraph Company, the Western Electric Company, the Western Union and the Postal Telegraph Companies being engaged in work almost identical with the Signal Corps, it is very desirable that all these organisations be drawn upon in order that their wonderful resources can be utilised if necessary by the Government in any great national crisis. (Squier, cited in Lavine 1921, 63)

According to Lavine, Carty met with Squier in Washington, D.C., the very next day. The Signal Reserve Corps was established at this meeting. In only a few months, the Signal Corps grew to 107 battalions and 40 service companies, and a personnel of 2,712 officers and 53,277 men, most of whom belonged to the Signal Reserve Corps (Lavine 1921, 87). Carty was appointed a senior officer of the Signal Reserve Corps, and by the end of the war over four thousand employees of AT&T and its subsidiaries alone served under his command.

Figure 3.3
Diagram of the *viseur acoustique* by Labrouste (1916), where "M" indicates a plane mirror and "B" indicates a compass (Baillaud 1922, 61).

3.4 Observing Sounds: Acoustic Sights, Listening Discs, and the Baillaud Paraboloid

The first sound locators developed during the First World War relied heavily on the idea of "seeing" sound. Some were based on technologies of vision and transposed principles derived from optical science onto the acoustic domain. Labrouste designed a *viseur acoustique* ("acoustic visor" or "acoustic sight"), a handheld device that comprised a mirror and compass (see figure 3.3). A soldier used the instrument by centering the reflection of his face in the mirror such that he could *see* his ears equally well. The compass would then presumably give the direction of the sound. A French military manual from 1916, translated into English in 1917, gives this description:

> The mirror serves to orient the apparatus and the compass serves to determine its orientation with relation to the magnetic North. . . . [T]he observer, facing the sound, holds the acoustic sight in his hand at the level of his face and orients it so as to see the image of his face directly opposite him in the plane mirror. He will especially endeavor to get such an orientation of the acoustic sight that each of his ears will be seen equally by him in the mirror. . . . The simple reading of the blue needle of the compass when the acoustic sight has been oriented will give the direction of the noise which is heard. (War Department 1917a, 15–16)[10]

Experiments were undertaken in England with listening discs, a technology that was based on the idea that, when a soundproof disc was oriented toward the source of sound, an "acoustic image" would form at the center of the disc on the side opposite to that of the sound (see figure 3.4). The idea was proposed as an acoustic analogue to the Arago spot in optics, whereby a bright point appears at the center of the shadow of a circular object due to the wave nature of light.

Figure 3.4
Illustration of a listening well with a double-disc sound locator (Hill 1922, 136). This is most likely an illustration of a listening station installed at Joss Gap in the Isle of Thanet, England. Since airplane engines emit low frequency sounds that have long wavelengths, listening discs had to be at least twenty feet in diameter in order to produce a well-defined "acoustic image" at the center.

While technologies like acoustic sights and listening discs were neither particularly effective nor practicable, one of the most enduring acoustic defense technologies to emerge from the war, the Baillaud paraboloid (*paraboloïde Baillaud*), was also based on a technology of vision. Although there are examples of acoustic reflectors throughout history, such as whispering galleries (Ganchrow 2009, 71–72), the first parabolic acoustic reflector designed expressly for military use was invented by René Baillaud in 1916, and given the form of a dish or a bowl.[11] In a military manual produced by the ECMT and reissued in English by the U.S. War Department, we find this description: "It is well known that a paraboloid has the property that all straight lines parallel to its axis, when reflected at its surface, meet at its focus. If, therefore, the axis of the paraboloid passes through a very distant source of sound, a maximum intensity of sound will be audible at its focus, if an appropriate receiver is placed at this point. On the other hand, the moment the axis no longer passes through the source, the sound is totally extinguished" (War Department 1917a, 19). Baillaud, an astronomer

who was based at the Toulouse Observatory at the start of the war, modeled his device on a seventeenth-century visual apparatus, the Newtonian telescope. His design was based on the premise that parabolic mirrors must share the same properties of reflection whether they were reflecting light or sound (Baillaud 1980, 133).[12] He wrote:

> If we direct the axis of a polished parabolic surface . . . to a very distant light source, the beam of near parallel rays emanating from this source is reflected on the surface of the mirror and creates an almost point-like image in its focus; if we shift the mirror very slightly, the image shifts away from the focus. If one had to rely only on geometric notions the image would be point-like, and dimensionless, but the phenomenon of diffraction intervenes, giving it dimension. The diffraction spot becomes larger as the diameter of the mirror becomes smaller; nocturnal visitors to observatories are generally very surprised by it: the starry images that appear to them to be the most beautiful are not made by the most powerful instruments.
>
> These properties of parabolic mirrors, which form the basis of Newton's telescope, apply equally to all kinds of waves, including sound waves. A sound image is smaller when the sounds that produce it are more high-pitched; the sound emitted by a whistle, for example, gives a very delicate image near the point of focus. (Baillaud 1980, 133–134; my translation)

In his earliest attempts to focus sound using an acoustic reflector, Baillaud used a small wooden paraboloid with a diameter of 60 centimeters and tracked the sound of an electronic bell (see figure 3.5). The results of these tests were promising and suggested that such a parabolic dish might also be useful for reflecting the sounds of aircraft. However, when he attempted to use the same paraboloid to track aircraft, which emit low frequency sounds with longer wavelengths, he found that he required a dish of at least 2 meters in diameter. In Baillaud's memoirs a series of photographs shows the development of the paraboloid over an intensive, approximately year-long period of experimentation. We find instruments of increasing size, ranging from 60 centimeters to 3 meters in diameter; of varying shapes, whereby the dish appears less like a concave dish and more like a deep bowl; and of varying configurations, including a model with four paraboloids stacked in two rows of two. A single auditor who listens with a stethoscope-like device at the point of greatest focus becomes two auditors, who listen in tandem while each one is seated at opposite ends of the device, using hand wheels to rotate the dish (see figure 3.6). We also find the introduction of an *altitraceur automatique* (automatic course plotter), an imaging technology that traced the auditors' movements, thereby producing a visual record of the trajectory of the aircraft.

3.5 Diagnosing the Sounds of War: The Geophone

While some early sound location technologies of the war transposed optical principles onto the acoustic domain, others had clear antecedents in nineteenth-century binaural and stereo devices. The geophone, a French invention used in the early stages of the war, was a variation

Figure 3.5
René Baillaud (left) and a French soldier (right) maneuvering a wooden Baillaud paraboloid on the roof of the Paris Observatory, Meudon (1916) (Baillaud 1980, 144). This was Baillaud's first paraboloid; it measured 60 centimeters in diameter. Copyright © 1980 by René Baillaud. From the private collection of René Baillaud.

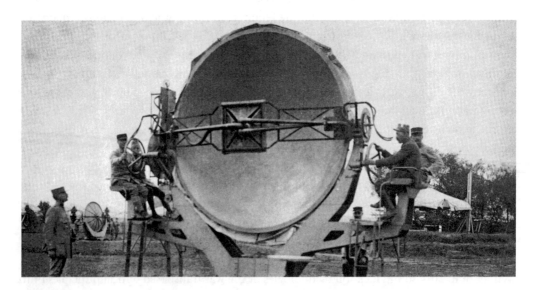

Figure 3.6
A Baillaud paraboloid with an automatic course plotter (1917) (Baillaud 1980, 158). Copyright © 1980 by René Baillaud. From the private collection of René Baillaud.

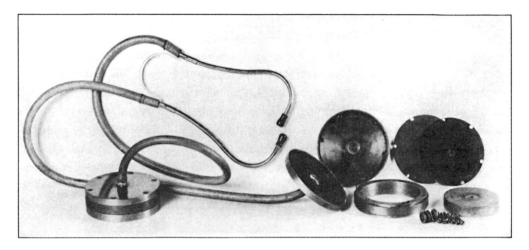

Figure 3.7
An American geophone, used for mine rescue work during the interwar period. From the U.S. Bureau of Mines (Ilsley, Freeman, and Zellers 1928).

on the differential stethoscope (see figure 3.7). It replaced the differential stethoscope's trumpets with seismic sensors; indeed, it was sometimes referred to as a "seismostethoscope" (War Department 1917c).[13]

A subterranean instrument, the geophone was used to detect enemy mining operations. Its sensors transduced vibrations of the earth, caused by movement, into sound. In its simplest arrangement the geophone was placed on the earth floor of a subterranean chamber and an auditor simply listened for movement, which could be detected up to one hundred feet away. In this arrangement, an expert auditor could discriminate between different kinds of sounds like "blows of the pick, boring, scraping" as these sounds were modified by different kinds of terrain like sand and chalk (War Department 1917c, 9). The geophone could also be used to ascertain the direction of these sounds. By placing the sensors a small distance from each other and moving them until the intensity of sound was equalized at both ears, the listener could tell approximately in which direction the mining operation was located (Crowell 1919, 384). In *The World of Sound* (1921) by Sir William Bragg we find a detailed description of the geophone as a directional listening device:

> One tube in each geophone was closed by a cork and the other connected to one of the observer's ears. . . . Unless the line joining the geophones was at right angles to the direction from which the sound was coming, the pulses would reach one geophone before the other, and it would seem to the observer that the sound was in the ear connected to that geophone. He could turn the geophones to new positions on the floor until the sound was equally heard in the two ears. He would then know the direction of the enemy. (Bragg 1921, 179–180)

Design modifications were made by each of the armies that adopted the geophone. The U.S. Bureau of Standards commissioned its Engineering Department to improve upon the French geophone; the American model increased the range of the device by nearly a third. The U.S. Army also developed an electromechanical geophone that could be connected by telephone wire to a central listening station. This model was so sensitive that it transmitted not only the sounds of enemy mining operations but also its footsteps and speech. It was therefore described as a "dictagraph of the war" (Crowell 1919, 385). While the geophone was a relatively basic technology, it was so effective that it rendered mining operations obsolete. In this sense it was one of the most successful acoustic defense technologies of the war.

3.6 The Binaural Principle: The Wertbostel and the Claude Orthophone

What Bragg called the "binaural principle"—the idea that a sound could be localized by equalizing the intensity of the sound at the two ears—was the principle underlying the geophone. Military scientists of this period were also aware of the role of phase in sound localization. Citing Lord Rayleigh's study from 1907, A. V. Hill wrote, "It has been shown experimentally that if a sound is heard in such a way that there is a difference in phase between the trains of waves between the two ears a sense of direction is produced" (Hill 1922, 89).[14] Several World War I-era devices extended interaural phase difference and interaural time difference by virtually extending the distance between the auditor's ears. They included the sound locator by Hornbostel and Wertheimer from 1915 (see figure 3.8) and the Claude Orthophone, a French invention from 1916.[15]

Such devices have been traced to another nineteenth-century listening technology: the topophone, invented in 1879 by the American physicist Alfred M. Mayer (see Brech 2015, 63–68). The topophone consisted of two small receivers joined together by a rod; the receivers were set about a meter apart. In one arrangement the auditor could wear the topophone on his shoulders (see figure 3.9). In his 1880 patent Mayer suggested that the topophone could be used on land or water, but that its primary use would likely be to guide ships in a thick fog (Mayer 1880; see also Mayer 1879). While the topophone itself was not used by the Allied forces during the war, military researchers were familiar with the device. Hill alluded to the topophone in describing an "apparatus consisting of two receivers or resonators attached to a yoke to fit on a person's shoulders and separately connected to his ears" (Hill 1922, 89). He speculated that it was not used because it could not sufficiently detect the low-pitched sounds produced by military aircraft.

3.7 Alt-Azimuth Listening: The Four-Horn Sound Locator

Military aircraft of the First World War produced several kinds of sounds: the beat of the propeller, engine sounds, and vibrations caused by friction between the air and the body of

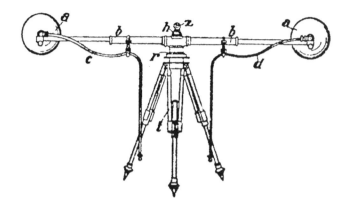

Figure 3.8
Diagram of the sound locator by Erich Moritz von Hornbostel and Max Wertheimer (Hornbostel and Wertheimer 1923). They write: "*a, a* are the sound receivers and *b* is a horizontal carrier capable of turning about a vertical axis *h* on a tripod *t* and having the receivers *a* fixed to its ends at an even distance from the said axis. *r* is a scale allowing to ascertain the deviation from zero of the carrier and *z* is a telescope for adjusting it in its zero position in a well-known manner. The sound is conducted from the receivers to the observer's ears for instance by aid of two tubes *c* and *d* of equal length" (1–2).

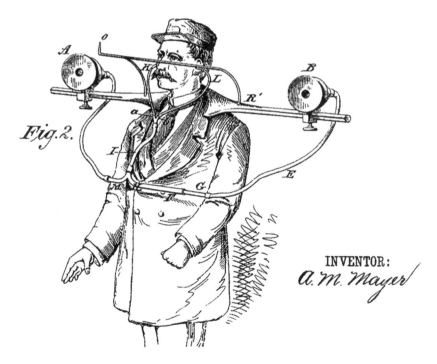

Figure 3.9
Illustration of the topophone by Alfred M. Mayer (Mayer 1880).

the moving airplane (Hill 1922, 13). The loudest and most easily identifiable sound, however, was what was called the "exhaust note." The exhaust notes of various aircraft ranged between 80 hertz and 130 hertz, and although this pitch varied somewhat when the aircraft was in motion, it was invariably a low-frequency sound. In order to reflect the low-frequency sounds of aircraft, each of the principal armies developed trumpet sound locators (also called horn sound locators) that replaced the small trumpets of artillery ranging devices with large conical trumpets or horns that could reflect low-frequency sounds. According to Hill, the first type of trumpet sound locator developed by the British Army had only a single pair of large horns, which measured approximately forty inches in diameter at the mouth. This device, which was first used as part of the Anti-Aircraft Defense of London in 1917, could determine only the horizontal bearing of enemy aircraft. A second model, which was developed almost immediately, had two pairs of horns and was sometimes called the "four-trumpet" or "four-horn" sound locator. It had significantly smaller (18-inch) conical horns, which were made of wood for portability and cost. A distance of approximately four feet separated each pair of horns. One pair of horns was used to determine the angle of elevation of the aircraft (its altitude), while the other pair was used to determine the angle of its horizontal bearing (azimuth). The "alt-azimuth" mounting of the horns necessitated two auditors, who engaged in what might be thought of as a "double binaural" mode of listening. Each auditor listened via a stethoscope-like binaural earpiece that was connected only to one set of horns (see figure 3.10). One auditor listened only to the aircraft's elevation, while another listened only to its horizontal bearing. It was therefore the auditors' *combined* auditory impressions that were used to track the aircraft, which was ascertained by equalizing the sound level at the two ears, a process that was called "bracketing the sound."

An American model of a four-horn sound locator in action can be seen in a two-reel, 18-minute film produced by the U.S. Signal Corps during the interwar period, *Historical Film No. 1132* (1935). Reel 1 shows an anti-aircraft gun battery and searchlight platoon. Together they occupy around a dozen trucks that move steadily through the Virginia plains in preparation for an anti-aircraft drill. One truck carries a sound locator so large that it occupies the entire carriage of the truck. Six men struggle to move it off the truck and mount it onto a trailer, and all six men are needed to drag it to its site (see figure 3.11). The sound locator, which had been dismantled for transportation, must then be reassembled. It is mounted onto a wooden plank on wheels (called a "turntable") so that it can be easily rotated along the alt-azimuth axes by two men, each of whom uses a separate hand wheel for rotating the device.

In Reel 2, an extended sequence of intertitles conveys the complexity of using a four-horn sound locator in battle:

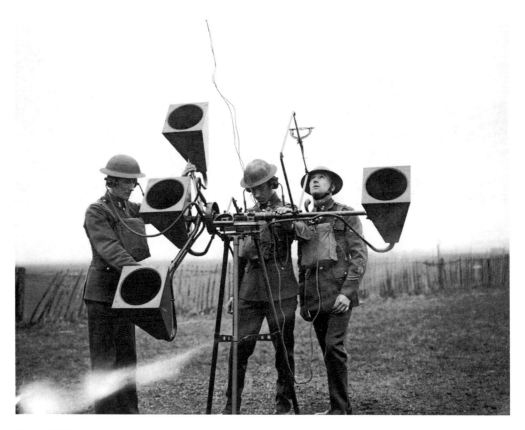

Figure 3.10
British soldiers with a four-horn sound locator (1938). © Imperial War Museum, Army Training 4/29.

Each man controls one pair of horns by means of the hand wheel and he "centers" the sound by the use of his binaural sense.

The angle of azimuth and elevation is recorded in the Acoustic Corrector which is mechanically connected to the moving horns.

Corrections are added for travel of sound, wind and other atmospheric conditions.

The corrected data is transmitted electrically to the Searchlight control mechanism.

The Searchlight is moved automatically so as to follow the corrected sound locator data—and when its beam is turned on it illuminates the airplane target.

At night, under cover of darkness, the airplane approaches and is tracked by the Sound Locator.

The data is transmitted to the Searchlight Comparator which in turn directs the beams of the powerful searchlights used to illuminate the target. (U.S. Department of Defense 1935)

(a) (b)

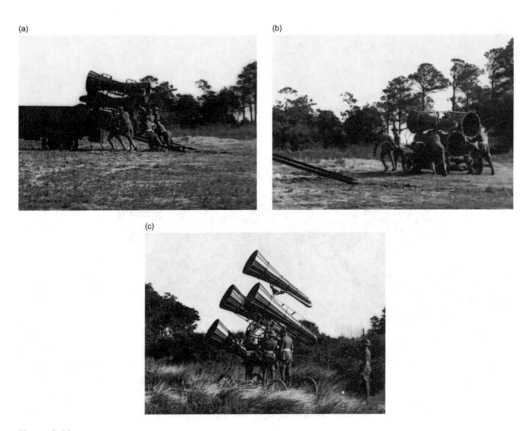

(c)

Figure 3.11
Screenshots from *Historical Film No. 1132* (1935) by the U.S. Department of Defense.

At this point in the film, a row of seven searchlights can be seen pointing concertedly in the same direction, illuminating an otherwise pitch-black sky. The final slide reads, "The instant the target is illuminated the gun crews adjust on the target—and firing commences."

The film makes clear that four-horn sound locators were heavy, labor-intensive devices that required considerable effort to transport and use. Moreover, it serves as a reminder that listening through trumpet sound locators was almost always done in adverse conditions that could not be replicated in any laboratory. Military auditors almost always operated in the dark—already a difficult task, as the film shows—and they often listened in poor weather and under the chaotic and terrifying conditions of battle. The "belliphonic soundscape" of the war—the totality of sounds produced as a result of warfare (Daughtry 2015)—was extreme. Some soldiers suffered "instantaneous deafness in one or both ears from the concussive effects [of sound] on the ear drums," and soldiers recalled "seeing gunners' ears bleeding"

(Stedman 2017). Carolyn Birdsall remarks that the outbreak of the war "has been described in terms of a technologised 'brutalising' of the soundscape (Tournès 2004). The overpowering sounds of modern warfare—with shells, guns and artillery—were produced at an intensity unlike anything experienced or imagined before" (Birdsall 2012, 15).

Hearing damage and listener fatigue were commonplace when listening through sound locators. Hill reported that, in addition to normal human error, "the danger of falling shrapnel and the noise of gunfire and bombs render the listeners liable to further error" (Hill 1922, 175). "Under such conditions," he wrote, "the ears may become fatigued and, if unequally so, a bias to one side may be developed in the listeners" (175). The English psychologist Charles Spearman, professor of philosophy of mind and logic at University College London, conducted a number of tests on listener fatigue in connection to the use of trumpet sound locators. These tests showed that, on average, listener reliability took a sharp dip after around nineteen minutes of continuous use. This breakdown in reliability occurred suddenly and drastically. In one of Spearman's experiments, discussed in Hill (1922, 175), two auditors took a series of readings of a moving sound source while listening through a trumpet sound locator. Observer A, described as a "less-than-robust man," initially showed signs of listener fatigue after six minutes, at which point his readings decreased in accuracy by around one degree. Observer A's readings then returned to normal accuracy for another six minutes, at which point the errors increased once again. Accuracy once again returned to normal, "after which the breakdown suddenly occurred." At 19 minutes 45 seconds, having conducted 79 readings, Observer A had "entirely lost his sense of direction" (175). The second test subject, Observer B, deemed to be the "strongest and healthiest man available and an expert listener," showed fewer variations in accuracy than Observer A, but was similarly found to have a sudden breakdown in accuracy at 19 minutes. In the context of a "brutalized" soundscape, listening through a trumpet sound locator was at best a terrifying prospect. Not only was the listener engaged in a difficult and taxing activity in unfamiliar and unpredictable settings, but he was almost certainly at risk of death. In this context, "heightened listening" was an extreme proposition.

3.8 Ear Training for Sound Observers: The Acoustic Goniometer

Given the precarious nature of listening in such extreme conditions, military auditors received extensive training to develop their directional listening skills. A military manual on the *goniomètre acoustique* (acoustic goniometer) contains passages on the "Training of Sound Observers" and "Ear Training for Listeners" (War Department 1917b). These passages describe in detail the various ear training exercises a military auditor was required to undertake in order to qualify for operating the acoustic goniometer, an alt-azimuth sound locator

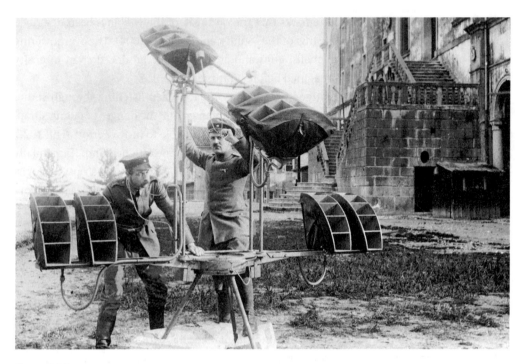

Figure 3.12
Soldiers with an acoustic goniometer (1917). Reprinted with the permission of the Imperial War Museum.
© Imperial War Museum, Q 23875.

in which two sets of ten small, clustered horns replaced the large conical horns of the four-horn sound locator (see figure 3.12).

Listening exercises with the acoustic goniometer were conducted in five stages. In the first stage an auditor listened to a fixed sound source located approximately one hundred meters away. An assistant provided the sound either by counting, clapping his hands, or sounding a trumpet. The assistant then moved sideways to another point while the auditor reoriented the instrument toward him. This first exercise served to eliminate unreliable listeners. If an auditor's "acoustic aimings" deviated too much, the auditor would not be permitted to pass to the second stage (War Department 1917b, 30). During the second stage an assistant mimicked a moving sound source, producing a continuous sound while walking continuously at a rate of approximately one meter per second, at a distance of approximately one hundred fifty to two hundred meters from the auditor. The auditor attempted to follow the sound by continuously reorienting the goniometer toward the assistant. An instructor who stood between the auditor and the assistant whistled at random. At these points the

assistant stopped moving and the auditor's acoustic aiming was verified. For the third and fourth stages the auditor followed the sound of an actual airplane, first tracking its horizontal bearing and then its elevation. In the fifth and final stage, two auditors followed an airplane simultaneously, with one listening for its horizontal bearing and the other for its elevation. It was decided that auditors "should be trained every day systematically" and that daily listening practice was "absolutely indispensable" (18). If an auditor did not practice every day, it was believed he would "quickly lose the efficiency acquired" (18).

3.9 Sonic Trajectories: The Perrin Telesitemeter

One of the most mechanically complex sound locators of the war was the Perrin telesitemeter (*télésitemètre Perrin*), named after the French physicist Jean Perrin. It was based on the premise that the amount of sound amplification that could be achieved by a conical horn was necessarily limited by the size and length of the horn. In seeking to increase the sound locator's amplifying power but not its size, Perrin designed a receiver that clustered dozens of elementary horns in hexagonal, honeycomb-like nests. These "primary horns" were connected to a central horn by a suite of tubes, and two auditors each listened binaurally via an additional length of tubing (Perrin and Gobel 1920). The idea was that the multicellular horn assemblages, called "myriaphones," would enable the device to collect a substantial amount of acoustic energy while the instrument itself could still remain relatively small and therefore practicable in the context of mobile warfare (see figures 3.13, 3.14, and 3.15).

According to Hill, many people believed that the Perrin telesitemeter gave a "more decided position of centrality" than trumpet sound locators, and that the sensation of passage of sound between the two ears seemed "more pronounced" with the telesitemeter (Hill 1922, 82). However, Hill maintained that it was not scientifically proven whether the device improved accuracy. In *The American Engineers in France* (1920), William Parsons gives a somewhat different account, writing that the Perrin telesitemeter was "recognized as probably the best form of field instrument" for sound location (Parsons 1920, 259), and that "two operators could take it apart in an hour and reassemble it in three hours [making it] the most mobile, the most easily worked and probably the most accurate sound detector in use" (259).

Perrin insisted that in order to track an aircraft effectively it was necessary not only to ascertain its bearings, but also to determine its trajectory. As his colleague André Jules Marcelin explained, in anti-aircraft operations it was necessary to "observe the course of the aircraft at each instant" (Marcelin 1926, 1). Once the position of the aircraft had been determined, some time would elapse before its coordinates were transmitted to the gunners, and more time was required for the projectile to hit the target: "The firing must therefore be effected

Figure 3.13

Diagrams depicting (a) side and (b) top views of the myriaphone (Perrin and Gobel 1920). Perrin and Gobel write, "The horns *a* are mounted on a partitioned plaque *c*, and their bases are joined in an even pattern resembling a honeycomb. In each battery [of horns] the elementary horns *a* are connected by pipes *d*, called 'suites,' all of the same length, to the base of a central collector *e*. . . . The central collecting horns *e* of each battery are connected by suites *g*, all of the same length and diameter, to the base of a main collector *h*" (2; my translation).

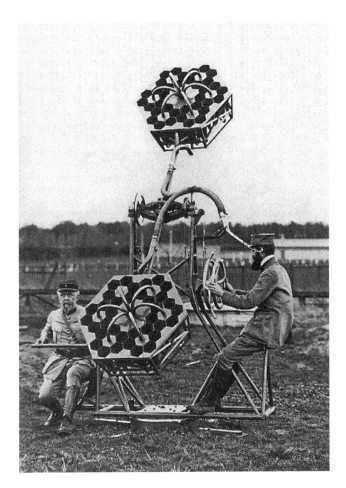

Figure 3.14
An early model of the Perrin telesitemeter, with only two myriaphones (1917). Source unknown.

upon a position of the aircraft which is situated upon its trajectory in advance of the deter-
mined position" (1). Later models of the Perrin telesitemeter included a course indicator that
visually plotted the trajectory of the aircraft. This course indicator is described in a report by
Archibald Ward, a lieutenant in the Royal Air Force who visited the *École d'écoute* at Saint-Cyr
in 1918 in order to discuss acoustic defense strategies with Perrin. Ward wrote:

> [Perrin] proposes to use a track chart. . . . The track can be plotted by hand if the two angles are read
> from dials, but Commandant Perrin is endeavoring to make a device for plotting the track automati-
> cally. This device in its present form comprises an incandescent electric lamp in a specially manu-
> factured spherical bulb. This bulb is coated with lamp black and a line is traced upon it by a fine

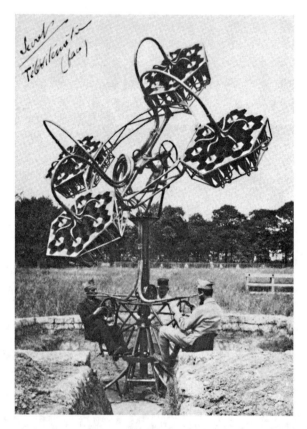

Figure 3.15
A Perrin telesitemeter with four myriaphones (Baillaud 1980, 151). Copyright © 1980 by René Baillaud. From the private collection of René Baillaud.

point which is mounted upon Bennett axes and is moved in accordance with the movement of the trumpet [myriaphone] axes. Above the lamp there is a horizontal ground-glass screen and the lamp projects upon it the trace made upon the lamp black; and so produces upon the screen the true track of the aeroplane. This is an extremely beautiful device which may be of use, but at present it appears to me to be considerably hampered by the necessity of working with it in a dark chamber. (Ward 1918, 3)

Although Ward was reluctant to adopt the Perrin telesitemeter for anti-aircraft operations in England, we learn from Hiram B. Ely that the Perrin telesitemeter was "adopted as standard by the French and was used very extensively toward the end of the war" (Ely 1926, 124). The course indicator would become a key feature of the telesitemeter, and Ely confirms that "many acoustic charts of airplane night raids were made by means of this instrument" (124).

3.10 New Frontiers in Listening

During the First World War an expert class of military auditor emerged, one whose ability to sense the location and direction of sounds became a key asset in military operations. In France, military auditors were trained on a daily basis, and directional listening was understood as a skill that could be developed through ear training. In the context of acoustic defense, a "good listener" was not necessarily someone who could hear well. Rather, a good listener was one who could use his sense of directional listening to locate and track the source of a sound.

Over the course of the war acoustic defense technologies became more complex, not only in terms of their increasingly elaborate designs, but also in the kinds of listening they required. Cooperative and collaborative modes of listening emerged that involved several auditors—and teams of others—who worked in tandem to sense and interpret acoustic activity. Especially in the later years of the war, listening in the context of acoustic defense was a distinctly group effort. David Bloor has described "the involvement of an ever-widening team of people" who were needed to operate four-trumpet sound locators:

> Each pair of trumpets fed, via a stethoscope, into the ears of a single listener, so there were two listeners, one trying to get the azimuth, the other trying to get the elevation. . . . Sound-locators were used in conjunction with searchlights. A third person, the "sighting number," had to use an instrument (such as a ring-sight) mounted on the locator to keep track of the direction in which the whole system was pointing at any given time. This continuously changing information was passed to a searchlight crew who would point the light in the direction they were told. . . . Then there had to be a "flank spotter" who stood to one side ready to see if the light actually picked up an aircraft. . . . The final step was to bring a battery of anti-aircraft guns into operation against the illuminated enemy. (Bloor 2000, 199)

As it turned out, the "wonderful ears of the fairy tale" described in Crowell's report were not only significantly extended through acoustic defense, but also vastly multiplied. Almost every act of defensive listening involved a complex sequence of procedures that required specialist knowledge, cooperation among several auditors and other observers, and communication between teams of people. In this way, listening became a fragmented process that was divided among many people, each assigned to a different part of the "listening act." Meanwhile, the listening act itself was reconfigured from a single, continuous, coherent act carried out by individuals in everyday contexts to a set of systematized, discrete actions carried out by groups of auditors under the extreme conditions of warfare.

Since the role of the military auditor was both to listen and to continuously report his findings, listening was further reconfigured as an act of data collection. The military auditor did not typically interpret the *meaning* of sounds so much as he acted as an acoustic sensor,

one whose role was fundamentally to observe and report physical acoustic data. In this sense, military listening was essentially a mechanical task that prefigured contemporary forms of machine listening. In machine listening, computational models of audition are used to interpret audio signals, and a machine learns, for example, how to identify or classify different sounds. During the First World War, human auditors performed the function that machines perform today, by enacting functional and highly rationalized modes of listening: militarized forms of what Jonathan Sterne (2003) has called "audile technique."[16]

Through acoustic defense, listening was equally reconfigured as sensing, observing, or visually plotting acoustic energy versus merely "hearing" sound. In some acoustic defense methods, the visual representation of sound, and calculations relating to acoustic activity—determining the influence of atmospheric conditions like wind and temperature on the propagation of sound on a particular day, for example—superseded the sense of hearing. In other words, it was not always how the sound "sounded" that mattered in acoustic defense. Rather, in many cases it was the physical behavior of sound that was the most consequential part of the listening equation. If sound is understood not as something to be heard but rather as something to be sensed—or indeed, observed—then its definition must also change. At the start of the war sound was commonly understood as "the effect produced upon the auditory nerve by certain vibratory motions," a definition that was cited as standard by Hill (1922, 5). However, this definition was not always applicable in the context of acoustic defense, since it was sometimes necessary to consider sound "without reference to its ultimate detection by the ear" (5). Hill therefore suggested that a more appropriate definition of sound would be that of "a vibratory motion of matter of the type to which the organ of hearing responds" (5). While this certainly corresponded to well-established ideas about sound, technologies of acoustic defense made it possible to experience sound as "a vibratory motion of matter" in a tangible way.

Acoustic defense equally made concrete the idea that "sound travels." Thousands of people—including military auditors, as well as the many civilians living under the threat of aerial bombardment—oriented themselves not toward the visible source of sound but toward the path of sound. Acoustic defense made sensible the idea that sound moves, and that, by orienting oneself toward its movements, one might reorient history itself.

4 Sound and Music in Three Dimensions: Spectacular Stereophony at Bell Telephone Laboratories

4.1 From Sound Locators to Microphonic Ears

As much as any other historical figure, Oscar, a mechanical man with a slight smile, stands out as a curious protagonist in the history of stereo sound. A tailor's mannequin with microphones for ears, Oscar was the picture of 1920s elegance, or at least half of him was. From the waist up Oscar was impressively humanlike, with eyebrows delicately painted on, a head of lightly thinning hair, and a permanent but seemingly nonplastic smile (see figure 4.1). He wore a three-piece suit with a jacket, a waistcoat, a crisp shirt, and, on occasion, a tie. From the waist down, however, the illusion of Oscar's humanity was discarded. On most days Oscar was fixed on top of a steel pole, with two wires dangling beneath his suit jacket where legs should be (see figure 4.2).

In 1933 Oscar was taken from Bell Telephone Laboratories (BTL) in New York City to Chicago, where he became one of the most popular attractions at the 1933 Chicago World's Fair, as part of the Bell System's exhibit on sound and telephony.[1] Here it became apparent that the key to Oscar's appeal lay neither in his immaculate appearance nor in his ability to perform robotic feats. Oscar could neither speak nor move. He was, however, a vessel through which people could hear electrically transmitted sound in a way that was more realistic than ever before. The experience was uncanny, evoking feelings of "acoustic transportation." Holding two telephone receivers to their ears (in an early version of headphones), audiences felt like they had been transported to Oscar's place. And, listening through Oscar's ears suggested something even more profound: it was not just the sounds themselves that might be reproduced using electroacoustic technologies; sensations of hearing and perspectives of listening might also be shared, transmitted from one set of ears to another.

Born in the mid-1920s, Oscar was a product of the war that had preoccupied his makers only a few years earlier. In a passage alluding to Oscar in his influential study *Speech and Hearing* (1929), the American physicist Harvey Fletcher wrote that during the First World War "the binaural location of complex sounds became very important. Its use made it possible to

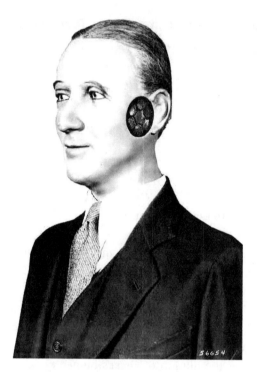

Figure 4.1
"Oscar the Dummy with Microphonic Ears" (1933). Courtesy of AT&T Archives and History Center. HM56654.

locate enemy submarines and aeroplanes" (Fletcher 1929, 192). He explained that a complex sound could be located when two transmitters (e.g., microphones) were connected to two receivers. If those two transmitters were further mounted on something resembling a human head, and at positions corresponding to the ears, then "a complete duplication of the binaural effect" could be obtained (192). Thus, before he was used in the context of applications like hearing aids and music recordings, Oscar took the form of a sound locator, albeit one of an electrical variety, as was the case in submarine detection during the First World War (Wittje 2016; Bruton and Coleman 2016).

As James Spurlock details in his study of the Bell System and the military-industrial complex, the war had "substantially increased" the organization's engineering departments, which had more than quadrupled in size between 1909 and 1919 (Spurlock 2007, 138). The mobilization of the Bell System's engineering departments meant that research was focused on such urgent matters as telegraphy, sound location, and underwater signaling. After the war, scientists in Western Electric's research department—which in 1925 merged

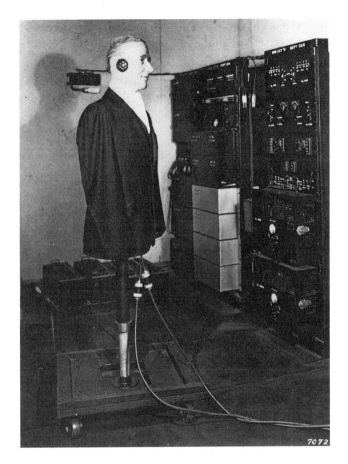

Figure 4.2
"Oscar, the Auditory Perspective Dummy" (1933). Courtesy of AT&T Archives and History Center.
HM70728.

with research departments at AT&T to form the Bell Telephone Laboratories—turned to more
mundane concerns. In the Acoustical Research section of BTL, headed by Fletcher, the prin-
cipal aim was to make telephone conversations indistinguishable from two people speaking
in the same room (see Fletcher 1929 and McGinn 1983). This was a complex problem that
required expertise in engineering (namely, designing instruments that could convert sound
waves into electrical energy and reconvert them back to sound with as little distortion as
possible); as well as an intimate knowledge of the mechanisms of speech and hearing, the
interpretation of speech sounds by the brain, and acoustic phenomena including masking,
distortion, and noise (Fletcher 1929, v).

As a wartime inductee into the Bell System—having joined Western Electric's research department in 1916—Fletcher's first foray into acoustics was in the context of underwater sound location. He recalled in a 1963 interview, "I tried to do some work on the war and tried to make an underwater sound detector, and made one that wasn't as good as the others—but I got to studying by myself and working up some various things which were in acoustics" (Barnett 1963, 7). Although this early work in sound location may not have yielded any new military devices, it nevertheless propelled Fletcher into a career in scientific acoustics that was nearly unparalleled in the first half of the twentieth century. This wartime research also sparked new lines of scientific inquiry that would take root after the war, in the context of studies on recording and reproducing sound and music in "auditory perspective": "the ability to judge the location and distance of sounds by the ears" (Snow 1934, 194). At AT&T, studies in auditory perspective transposed concepts and techniques developed during the war onto the realm of binaural and stereo sound transmission, recording, and reproduction. Although AT&T was not in the music business itself, there was a need for better acoustic products in the music, film, and broadcasting industries (Arnold 1932). Furthermore, the knowledge of hearing, fundamental to AT&T's interests in telephony, depended upon an intricate understanding of the voice—at once an apparatus of speech and music, what engineers thought of as a machine that "intoned" words.[2]

In seeking to reproduce music in auditory perspective, BTL scientists collaborated with musicians, most notably the renowned conductor Leopold Stokowski. As Robert E. McGinn (1983) writes in his meticulously researched study of this collaboration, the BTL-Stokowski partnership merits our attention for a number of reasons. Not only was it a rare example of a preeminent musician and an influential group of scientists working together toward a common aim for nearly a decade, as McGinn writes, but the collaboration marked "an aesthetic turning point in the relationship between classical music and electronic technology" (38). This aesthetic turning point hinged on the promise of reproducing music in high fidelity and in auditory perspective. The prospect of high-fidelity sound reproduction (reproducing the full dynamic range, frequency range, and timbral nuances of live music), and auditory perspective reproduction (reproducing the spatial characteristics of live music) meant that entire orchestras could be reconstituted anywhere in the world using only loudspeakers. Conductors would be able to recreate music in the concert hall exactly as they imagined it, using only a sound control panel, and without having to contend with the physical limitations of the orchestra. The questions at hand were aesthetic as much as they were technical or scientific. Was music more desirable when it was reproduced binaurally or in stereo? In what ways would binaural and stereo reproduction transform performance and compositional practices? How should music reproduced in auditory perspective be presented in concert in order to be best appreciated by audiences? All these questions and more came under

consideration in BTL's studies in stereophony, which the company publicized through a series of spectacular demonstrations that both amazed and terrified those present. This chapter revisits these demonstrations, exploring a project that would influence Western art music traditions not only through its aesthetic and technical innovations but also by staging new alliances between music and science.

4.2 Sound in Auditory Perspective

In a 1933 article, "An Acoustic Illusion Telephonically Achieved," Fletcher described the special powers possessed by Oscar, the mannequin with microphonic ears. He remarked that Oscar had been given "one capacity that was more than human: that of instantly communicating to others exactly what he heard, exactly as he heard it" (Fletcher 1933, 286). He characterized the experience of listening through the "head receivers" (telephone receivers) connected to Oscar's microphonic ears as akin to putting oneself "in Oscar's place" (286).[3] A person holding the receivers to their ears would be "acoustically transported to the location of the microphones, no matter at what distance from them he might actually be" (287). Thus, through their arrangement on a mannequin's head, microphones were used in such a way that they collapsed not only the distance between a listener and the source of a sound, as in Charles Wheatstone's conception, but also between multiple listeners, whether human or machine. Oscar conferred upon machines the ability to register acoustic information in a way that approximated the experience of human hearing; and it conferred upon human listeners the ability to hear "through the ears" of a machine—one that was designed to resemble a human listener and replicate the sensations of human hearing.

During the 1931–1932 concert season, Oscar attended rehearsals and concerts by the Philadelphia Orchestra at the Academy of Music in Philadelphia, where he was placed either among the audience or in the orchestra itself. The sounds picked up by Oscar's microphonic ears were sent to a laboratory in the basement of the Academy, where researchers from the Acoustical Research section as well as the Instrument Transmissions section conducted hundreds of listening tests. These tests aimed to show how various binaural and stereo recording and reproduction techniques affected the perception of frequency, dynamics, timbre, and a sense of space in reproduced sound and music. The test subjects were expert listeners who included Stokowski and members of the Philadelphia Orchestra along with other musicians whose "highly sensitive ears" were thought to be able to "detect the slightest variation from true auditory perspective" (Jewett 1933c, 5). Stokowski himself made detailed notes on the spatial effects of various recording and reproduction techniques, for example in the case of monaural reproduction through a single loudspeaker, or binaural reproduction through two head receivers. Among other findings, these tests established that many people found "an

appreciably enhanced value of the aesthetic appeal [of a recording] if auditory perspective is present" (Snow 1934, 194). This enhanced aesthetic appeal not only resulted from the ability to locate the positions of different instruments in the reproduced sound, but equally from a "general effect of space distribution, which adds a fullness to the overall effect" (198). In seeking to determine the cause of this "fullness" in sound, researchers tested such variables as the angle and depth of the recording, the position of the listener relative to the source of sound, the effect of auditorium acoustics on the reproduced sound, as well as the effects of various recording and reproduction techniques. Through these tests they evolved new methods, and arguably a new language, of sound and music in auditory perspective.

4.3 Binaural Transmission: The Oscar Show

Oscar's outings during Academy concerts were, at times, unexpectedly eventful. As the engineer Arthur C. Keller recalls in his memoirs *Reflections of a Stereo Pioneer* (1986), at one point during the 1931–1932 concert season Oscar was seated among the audience in the middle of the hall.[4] "A woman who had arrived at the hall late complained that Oscar was dead, as indeed he was!" Keller wrote, adding that the experiment was not repeated.

Oscar's most celebrated outing came on the heels of the Philadelphia tests, during the 1933 World's Fair in Chicago. Themed "A Century of Progress," the fair was held on the centenary of Chicago's founding, envisioned as a boon to a city that had become the fourth largest city in the world but was struggling under the weight of the Great Depression. It was directed by three former military leaders who, according to Cheryl Ganz, "championed corporate capitalism" and understood the fair as a "civil-military enterprise" (Ganz 2008, 1–2). These military leaders abandoned the humanistic idea of progress that had shaped previous expositions in favor of a futuristic vision of progress centered on scientific and technological innovation. This vision was encapsulated in the fair's motto, "Science Finds, Industry Applies, Man Conforms." As Ganz writes, "Science now constituted the autonomous force of progress, continually advancing humanity in economic, social and cultural ways, and as a result scientific authority was firmly established" (57).

Indeed, scientific authority was built into every element of the fair. Exhibits were selected by a Science Advisory Committee that oversaw thousands of proposals representing scientific achievements in every field. These proposals spanned an impressive range of media: "'talkies,' pageants, living models, animated transparencies, continuous graphical recorders, diorama and panorama, animated maps and charts" ("Scientists Mapping World Fair Display" 1930, 27). Frank B. Jewett, the chief engineer and vice president of AT&T and president of BTL, chaired the fair's Science Advisory Committee. In this role he promoted a vision of industrial research as a force for societal good:

Let us see what progress resulted from the advance in the use of science in industry. At the time of the Centennial Exposition [in Philadelphia in 1876] there was no telephone system, no electric light or power industry. There was no automotive industry. There were no aeroplanes—nothing which involved internal combustion engines. There were no chemical industries, which have grown up in the last recent years. There was no motion picture machine, no talking machine, no radio, no picture transmission. We can get up a list of things that are extremely important to-day, which did not exist at all at the time of the fair. Out of these have been built huge industries—the greatest outside of agriculture, which have given employment to untold thousands. (Jewett 1934, 302)

For Jewett, the fair not only represented an opportunity to publicize his own company's technological achievements; it was also an opportunity to push a broader agenda of seeing science and industry as natural partners. This vision was embodied in the Bell System exhibit, where innovations in telephony were framed in connection to the social and economic benefits that resulted from an increasingly modernized, corporatized, and nationalized telephone service. The exhibit literature conjured an image of the Bell System as a streamlined, centralized, efficient organization: a modern corporation that could provide increasingly standardized services to an exponentially growing number of users. The industrial research model was central to this growth, since the mother company "Ma Bell" held thousands of patents and could support scientific research on a scale that would be impossible for local or regional companies to match (American Telephone and Telegraph Company 1933, 8).

The Bell System exhibit opened on May 27, 1933. It was located in the Communications Hall, which along with the halls of Electricity and Radio formed the Electrical Group, a trio of buildings that evoked "a miniature Bagdad of gleaming towers and dazzling walls" on Chicago's North Lagoon (*Chicago and the World's Fair, 1933* 1933, 53). The buildings shared a common entrance that featured an enormous bas-relief depicting a man "of heroic proportions" and bearing the inscription "The Conquest of Time and Space" (53). The Bell System exhibit comprised nine displays, each of which explored aspects of this conquest as it pertained to modern telephony. One popular display allowed visitors to listen in on long-distance telephone calls placed by other visitors to any one of fifty-four cities in the United States. Other displays featured scrambled speech, the dial telephone, and multichannel telegraphy. The display featuring Oscar, which was variously called the "Oscar Show," the "acoustical illusion exhibit," or the "auditory perspective exhibit," spanned two spaces in the Communications Hall. Oscar himself was placed in a glass-enclosed, soundproof stage that resembled a modern-day living room (see figure 4.3). A separate mezzanine balcony containing thirty-two seats for visitors overlooked this stage. Each of the seats was equipped with two telephone receivers. The right-ear receiver was connected to Oscar's right-ear microphone, and the left-ear receiver was connected to Oscar's left-ear microphone. As one reviewer wrote, "Whatever those ears of Oscar hear, the visitor hears with such marvelous fidelity that he cannot escape the illusion of being in Oscar's place" (Edwards 1933, 9).

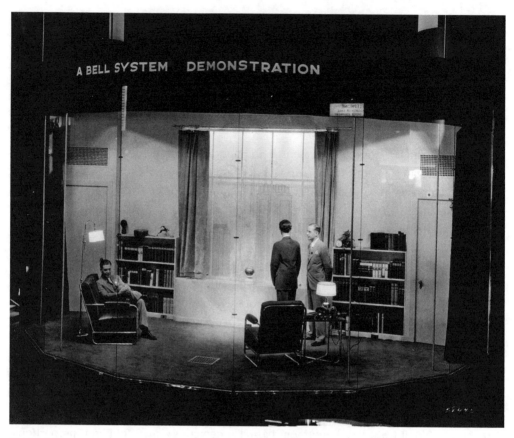

Figure 4.3
The stage of the Oscar Show at the Chicago World's Fair (1933). The photograph shows John Mills and
M. B. Long with Oscar. Courtesy of AT&T Archives and History Center. HM59336.

To signal the start of the Oscar Show the curtains on the stage were opened for a moment.
An announcement instructed audiences to keep both of their head receivers to their ears. The
curtains were then drawn, and remained drawn for most of the show, and the entertainment
then commenced, as per this account in *Bell Telephone Quarterly*:

> A voice would say, "Well, I guess I'll go down and put some coal on the fire," or "It's time to go up
> on the roof and feed the pigeons." Immediately after, the sound of a closing door could be heard;
> apparently the demonstrator had left the stage. For a moment it would be silent, and then a voice
> whispered directly into the left ear of the listener, "I beg your pardon, did you drop this?"; and then
> perhaps in the right ear, "Would you move over, please. I can't see a thing." Many of the listeners on
> hearing a voice, apparently of someone standing behind them, would look around to see who was

speaking. Later, a loud "Boo" brought instantaneous reactions on the part of the listeners in the form of startled exclamations and much laughter. (Smith 1934, 7)

Another report, in *Bell Telephone News*, fleshes out this account:

> Wherever [the speaker] is, the sound of his voice reaches your ears exactly as though you were standing where Oscar is standing. He tears up a newspaper close to Oscar's right ear, and you are almost ready to swear that someone is tearing paper close to *your* right ear. You are in Oscar's place the moment you put the receivers to your ears. Everything that he would hear, you hear in exactly the same way and from the same direction. ("Oscar 'Steals the Show'" 1933, 5; emphasis in original)

The Oscar Show was an unequivocal success. The report in *Bell Telephone News* indicates that there had "hardly been a minute" when every seat was not occupied ("Oscar 'Steals the Show'" 1933, 6). The show was given ten times every hour the exhibit was open, from 10:00 a.m. to 10:00 p.m., seven days a week, from May 27 to November 12, 1933. This meant that approximately 3,840 people put themselves in Oscar's place each day, and around six hundred thousand people heard the Oscar Show over the nearly six months the Chicago World's Fair was open to the public.[5]

The Oscar Show embodied the characteristics of the "modern sound" that, as Emily Thompson has argued, emerged during this period: clarity, efficiency, and status as a commodity (Thompson 2002, 3). Critics commented on the clarity and fidelity of the sound, describing how "Every tone and overtone of each sound in the glass-walled room is picked up and faithfully delivered to the visitor's ears" (Edwards 1933, 9). While very few of the visitors would have had any previous experience of binaural sound transmission (e.g., by listening through the théâtrophone), most would have been familiar with an analogous form of media consumption: viewing three-dimensional images through the stereoscope. As Jonathan Crary writes, the stereoscope was "a dominant form of the consumption of photographic imagery for over half a century," and stereoscopic images represented "the most significant form of visual imagery in the nineteenth century, with the exception of photographs" (Crary 1990, 16, 116). The stereoscope permitted viewers to gaze upon a visual scene from the same perspective, and with the same field and depth of vision, as the stereo photographer. In an analogous way, the Oscar Show enabled listeners to experience an auditory scene through the auditory perspective of another listener. The popularity of the Oscar Show suggested that binaural sound, like stereoscopic images, could be a ripe new medium for the mass consumption of audio products. The major difference between stereoscopic viewing and binaural listening in the Oscar Show, of course, was that stereoscopic images were static, and stereoscopic viewing took place *after* the images had already been already produced. By contrast, the binaural transmissions of the Oscar Show unfolded dynamically, in real time. As such, the Oscar Show represented a virtually untested medium: the dynamic and continuous transmission of a subjective spatial (auditory) perspective, in real time.

By hearing through Oscar's ears, audiences engaged in a kind of sympathetic listening. The Oscar Show enabled not only a shared listening experience, as in a regular concert setting, but one in which a listening perspective, and sensations of hearing, were also shared. The Oscar system transmitted not only auditory information, but also, in effect, subjective auditory sensations. In doing so, it embodied the idea that the experience of listening was one that could be transmitted from one person to another, transposed from one set of ears to another, communicated using modern technologies.

Oscar's microphonic ears equally functioned as an aural prosthetic. As with the théâtrophone, listeners held two telephone receivers to their ears. However, listeners at the Oscar Show were not only immersed in a three-dimensional auditory field, but their listening was also heightened and extended through Oscar's microphonic ears. They heard with more precision, clarity, and spatial sense than they could without the "head phones." The effect was of their own ears seemingly *becoming microphones*, and their own hearing becoming appreciably enhanced, able to "pick up" the slightest modulations in sound at whatever distance.

The Oscar Show also suggested an uncanny kind of listening experience, one that not only evoked feelings of acoustic transportation, but also merged human and machine forms of listening. In the show the bodies of the visitors and Oscar's lifeless body were conjoined through the act of listening. More broadly, listening was redrawn as an electromechanical act that could be performed by "microphonic ears." This particular act of electromechanical listening was extended from previous methods by giving it a human face. After all, Oscar's role was to register auditory sensation in a way that was as human as possible. The Oscar Show thus had resonances that extended far beyond the immediate aim of publicizing innovations in telephony. We might remember Oscar not only as a forerunner for the more advanced binaural and stereo sound systems that would soon follow, but as an early kind of listening cyborg that, in bringing together humans and machines in the act of listening, forced the question of what exactly is "human" about hearing.

4.4 Music in Auditory Perspective: The Philadelphia-Washington Demonstration

On April 27, 1933, a group of around four thousand five hundred scientists and engineers who were in Washington, D.C., for the annual meeting of the National Academy of Sciences gathered at Constitution Hall, an imposing space that remains the largest auditorium in Washington today. They were expecting to hear a concert by the Philadelphia Orchestra under the direction of Leopold Stokowski. The program was not particularly adventurous by Stokowski's standards. He famously championed the music of such modernist composers as Arnold Schoenberg, Igor Stravinsky, and Edgard Varèse. By contrast, this concert would feature such classics as J. S. Bach's *Toccata and Fugue in D minor*, Beethoven's Fifth Symphony,

Figure 4.4
The stage of Constitution Hall (1933). Courtesy of AT&T Archives and History Center. HM58347.

Debussy's *Prélude à L'Après-midi d'un faune,* and the finale of Wagner's *Götterdämmerung.* The concert, it seemed, was a tribute to so-called great music, if not to greatness itself.

When the concert started there appeared to be a misstep: a curtain remained draped across the entire front of the stage. It was presumably hiding a full symphony orchestra since the opening measures of Bach's *Toccata and Fugue* could clearly be heard. When the curtain was lifted, however, there was no orchestra there, but only three sets of giant loudspeakers (see figures 4.4 and 4.5). As it turned out, these were projecting a live performance by the Philadelphia Orchestra, who was playing in its usual home at the Academy of Music, around 140 miles away. Audiences were stunned by the revelation, gasping audibly. The quality of the transmission was so good, so lifelike, that it seemed inconceivable that an orchestra was not present on the stage before them.

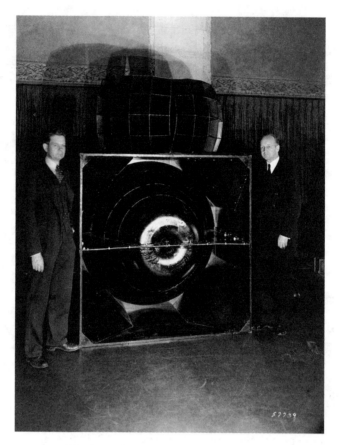

Figure 4.5
E. C. Wente and A. L. Thuras, with loudspeakers used for the reproduction of music in auditory perspective (1933). Courtesy of AT&T Archives and History Center. HM57739.

In one sense the Philadelphia-Washington concert was an inverse of Charles Wheatstone's demonstration of the Enchanted Lyre. Both had entailed a seemingly magical transmission of music from an unseen place. The catch this time, however, was that audiences believed that the music was being created in the same room in which they themselves were present, and not a different one. It was the fact that the music was transmitted at all that was the surprise. On the day after the concert, George Owen Squier, Chief Signal Officer during the First World War, sent a telegram to AT&T President Walter Gifford proclaiming that the concert signaled "a new era in the history of art" (Gifford 1933), while a reviewer for *The Philadelphia Inquirer* called it "an epochal event in the history of musical performances" (Martin 1933). Scientists at BTL had succeeded in transmitting orchestral music across vast

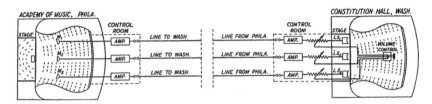

Figure 4.6
Diagram of the loudspeaker arrangement in the Philadelphia-Washington demonstration (Jewett 1933a, 437). From Frank B. Jewett, "Perfect Quality and Auditory Perspective in the Transmission and Reproduction of Music," *Science*, New Series 77 (2002) (May 12, 1933): 435–440. Reprinted with permission from AAAS.

distances in auditory perspective, using a three-channel system developed by Fletcher's Acoustical Research team (Fletcher 1934; Jewett 1933a).

The three-channel system (shown in figure 4.6) was a critical step toward producing what engineers at BTL thought of as an "acoustic facsimile" of the orchestra. In order to achieve as near-perfect a reproduction of the orchestra as possible, it was thought that a separate binaural system must be used for each listener—in other words, something akin to the first théâtrophone transmissions. However, as Frank B. Jewett wrote, "for obvious reasons it was never contemplated that such a system could ever be used for a general audience" (Jewett 1933a, 436). The expense of transmitting music to thousands of individual sets of telephone receivers made the prospect unfeasible. Still, Jewett and others maintained that "a very close approximation to complete facsimile reproduction" could nevertheless be obtained by using only three loudspeakers (436). Audiences and critics agreed. A critic for the *New York Herald Tribune* wrote, "Ordinary electrical music seems to come from the [loudspeaker], not from the orchestra. In Philadelphia this defect was overcome so perfectly that each of the musicians in the orchestra, really playing in another room, was heard as though occupying his usual seat on the empty stage" ("The Super-Orchestra" 1933). The composer Carlos Chavez remarked that the overall effect was one of "sound extraordinarily well outlined, balanced, and accentuated" (Chavez 1937, 86–87).

As was the case with the first théâtrophone transmissions in Paris, listeners in Constitution Hall could clearly distinguish the positions of the instruments in the distant auditorium where the music originated. The audience in Constitution Hall, however, was an audience of thousands who heard the music simultaneously and collectively through loudspeakers and not through individual telephone receivers. Further, the stereo effects were not only a result of the transmission process. They were also "enhanced" in the listening space by Stokowski,

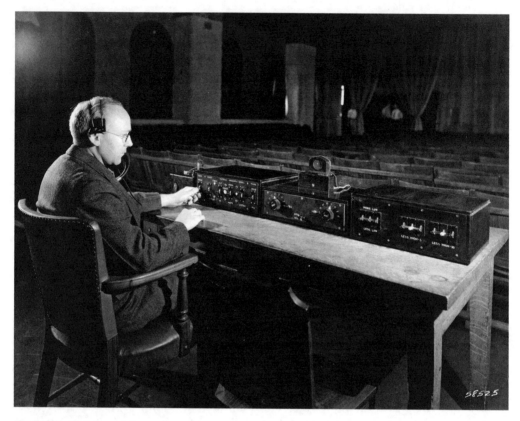

Figure 4.7
"W. B. Snow with control apparatus" (1933). Courtesy of AT&T Archives and History Center. HM58525.

who controlled the volume and frequency of the music in Constitution Hall using a small mixing unit—what engineers called an "enhancement unit" (see figure 4.7).

In his role as "enhancer" Stokowski was likened to a wizard who wielded special powers. One critic compared Stokowski to a "modern musical Jove" who "unleashed . . . electrical thunderbolts" (Martin 1933). *Science* reported that "the most advanced development of musical reproduction" to date consisted of several ingredients: three loudspeakers, three telephone lines running to three microphones, a group of telephone engineers, and "Leopold Stokowski turning electrical control knobs instead of wielding a baton" ("Reproduction of Music by New Methods" 1933, 6). Of these ingredients, the most important was arguably Stokowski himself. An endlessly inventive conductor, Stokowski continuously pushed against the tide in classical music circles. He presented the music of composers from underrepresented countries like India, Turkey, and Mexico and supported the efforts of avant-garde

music organizations like the International Composers' Guild, founded by Varèse in 1921; he publicly defended jazz as "the music of the future" when many of his peers derided it, and he programmed symphonic works by African American composers who were systematically excluded from the elite ranks of the symphony orchestra. Stokowski even insisted on presenting difficult and unpopular modernist works not once but twice during concerts so that audiences might better appreciate the most challenging music of their time.

Despite this consistently progressive outlook, when it came to matters of technology Stokowski was, as McGinn writes, often dismissed as a person who "knew nothing about the science and technology of electronic recording and reproduction" (McGinn 1983, 45). When examining Stokowski's contributions to music from around 1925 to 1940, however, it is clear that he anticipated, if not at times initiated, advances in sound recording as well as in radio broadcasting. Stokowski's interest in new technologies had to do with extending music's reach and expressive possibilities. He sought to create new avenues for musical expression through the use of electroacoustic instruments and to democratize music consumption by broadcasting the best performances to as many listeners as possible. In 1929 he commissioned the Russian inventor Léon Theremin to design an electric cello for the Philadelphia Orchestra, with the idea that an entire bank of such instruments might one day be produced ("'Ether Wave' in Orchestra" 1929). He even imagined a future in which traditional systems of music notation would be dispensed of, with composers instead creating their harmonies "directly in tone" using "electrical-musical instruments" ("Advance Is Shown in Music Recordings" 1931, 28).

Stokowski regularly espoused anti-elitist, egalitarian—even socialist—views of the promise held by new technologies. In 1932 he told the Women's Committee of the Philadelphia Orchestra that, in the future, "great gardens of recreation [would] serve factory workers who are fatigued and society women who are equally fatigued" ("Stokowski Seeks True Tone Colors" 1932, 23). These gardens would have "music from a series of sound towers that send equal tone to all parts of the garden" (23). Around the same time, he told a group of scientists that, with the advent of new broadcasting technologies, "we will be able to convey emotions higher than even thought—things subtle and intangible—almost psychic in their being. Radio and television will project them all over the world" ("Advance Is Shown in Music Recordings" 1931, 28).

While such overtures may have seemed far-fetched, Stokowski stood alone among prominent conductors in his knowledge of sound recording and broadcasting technologies. In 1929 he took a twelve-week leave from the Philadelphia Orchestra to study radio engineering at the National Broadcasting Company, announcing that he hoped revolutionize the broadcasting of orchestral music ("Stokowski to Study Radio" 1929). Two years later, the Columbia Broadcasting System (CBS) awarded him the Broadcasting System Gold Medal.

The president of CBS William S. Paley remarked that Stokowski "went into the laboratory and worked side by side with the engineers to solve the problems he realized existed. . . . Together they evolved great technical improvements" ("Stokowski Receives Broadcasting Medal" 1931, 41). These improvements were widely reported in the press. According to the *New York Times*, "The public was overjoyed to be afforded an opportunity of listening to such magnificent music without cost; the sponsors of the radio programs were much more than pleased; . . . the managers of [Stokowski's] concerts counted the increased receipts and smiled complacently. Indeed, every one was happy" ("Stokowski Has a Surprise" 1930, 8). In turning from radio broadcasting to sound recording and reproduction Stokowski once again assumed the role of a student. He took courses in physics, math, and electrical engineering at the University of Pennsylvania, where he worked closely with the engineer Charles Weyl. Weyl had studied the problems of electrical recordings, citing their limited frequency and dynamic range, extraneous noise, excessive reverberation, and the limitations of available sound reproduction technologies (Weyl 1931). Together, Stokowski and Weyl explored new techniques in stereo recording, microphone placement, and multi-mic mixing. According to Hans Fantel, "Instead of merely letting a single mike gather all the sounds of an orchestra from a distance, Stokowski took additional microphones right into the orchestra, positioning them in various instrumental choirs, carefully adjusting their relative balance so as to capture exactly the right blend of orchestral detail and massed sonority" (Fantel 1979, D26). Through such experiments Stokowski played a critical role in raising the status of the sound engineer from mere recordist to artist. In 1932 he wrote of these new technologies: "We shall have a most tremendous range of tone, of crescendo, of diminuendo, of the antithesis and contrast between very loud and very soft, of masses of loud tones, of other masses of soft tones . . . one begins to see dimly entirely new vistas and possibilities" (Stokowski 1932, 15).

The Philadelphia-Washington demonstration brought these new aesthetic possibilities to life. BTL's Director of Publications John Mills stressed that while the demonstration had certainly illustrated innovations in science and technology, "the emphasis was not upon how the electrons went around but upon the heights to which they could carry a listener" (Mills 1936, 140). Mills described "stupendous crescendos" and the "liquid notes [of] an unstrained solo voice" in Stokowski's mix of Wagner's *Götterdämmerung* (141). A critic for *The Philadelphia Inquirer* commented, "That mighty climax seemed fairly to split the universe, giving the destruction of Valhalla the epical emphasis demanded by the imagination, yet with the tone perfectly proportioned" (Martin 1933). Another reporter remarked: "The musicians in the audience freely admitted that they had never heard effects like those obtained by Dr. Stokowski. Pianissimi that conductors only hear in their mind's ear and never succeed in getting and . . . tumultuous crescendos that are beyond the power of orchestral performers, gave a new aspect to Wagner" (Kaempffert 1933, 1).[6]

What was not reported at the time was that the demonstration was not only a realization of scientists' desire to create an acoustic facsimile of the orchestra, it was equally a realization of Stokowski's dream of an orchestra that could be heard but not seen. In 1926 the *New York Times* announced that Stokowski had "long contemplated" an invisible orchestra ("Stokowski Asks Aid in Hiding Orchestra" 1926, 22). "Orchestra and conductor should be unseen," Stokowski had said, so that the listener "would be enabled to concentrate on the music itself. In this way all the attention would go to the ear and none to the eye" (22). Although it is not widely appreciated today, Stokowski's experiments with the hidden orchestra prefigured concerts of electroacoustic music in the 1940s in which music was projected through loudspeakers with no instruments visible on stage. What would eventually become known as "acousmatic music," or music derived from an unseen source, was effectively described and imagined by Stokowski in the 1920s. BTL engineers gave Stokowski's invisible orchestra a name, dubbing it the "ceno-orchestra." As Mills explained, "A cenotaph is an empty tomb. By analogy, ceno-orchestra reproduction of music is heard from an empty stage" (Mills, quoted in Kaempffert 1933, 1). According to Mills the audience of the ceno-orchestra felt "as if it were in the presence of disembodied performers under the direction of a discarnate conductor" (Mills 1936, 14). Although the conductor was no longer present in his usual form, he had nevertheless rematerialized in the listening space in the form of the live sound engineer or music "enhancer." Again, while this aspect of the demonstration was not explicitly reported at the time, the Philadelphia-Washington concert would have marked one of the first live *mixes* of acousmatic music in a concert setting. As such it signaled the emergence of electroacoustic music traditions in which a sound engineer would assume the role traditionally held by a conductor, mixing music over loudspeakers that in turn replaced traditional performers.[7] In BTL's experiments with stereo transmission and reproduction the conductor took the role that is today occupied by the live sound engineer—mixing, filtering, balancing, and diffusing sound in the concert hall. In this way the figure of the conductor was not secondary but essential to the project of reproducing sound and music in auditory perspective.

4.5 "Enhanced Music": Stereophonic Recordings at Carnegie Hall

The aesthetics of the live audio mix, nascent in the Philadelphia-Washington concert, took center stage in BTL's demonstrations of stereo recordings at Carnegie Hall on April 9 and 10, 1940. Billed as "Stereophonic Recordings of Enhanced Music," these demonstrations consisted solely of live mixes of sound recordings that had been captured on four-track film. Three tracks served as program channels and a fourth track served as a control signal (Fletcher 1940b, 1941; McGinn 1983). First, a recording was made of a performance using

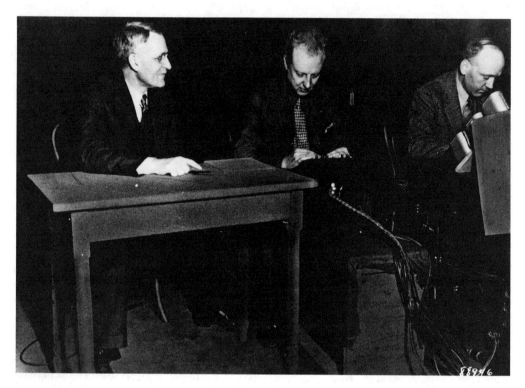

Figure 4.8
Harvey Fletcher, Leopold Stokowski, and W. B. Snow (1940). Courtesy of AT&T Archives and History Center. HM88946.

three widely spaced microphones. The artist then made "enhancements" by adjusting the volume and frequency of the three sound tracks; a fresh recording was made that captured their mix (see figures 4.8 and 4.9). These "enhanced" recordings were then played in concert, during which time the artist once again adjusted the dynamics and timbre of the reproduced sound to suit the acoustics of the hall. BTL claimed that the process gave music "spatial and emotional values heretofore unknown either in reproduced or original productions" ("Stereophonic Music" 1940, 2).

In his opening remarks at the Carnegie Hall demonstration Jewett spoke to the "years of painstaking scientific work" carried out by engineers in perfecting the stereo system on display (Jewett 1940, 1). His remarks are striking in that they applied a communications model of transmission and reception not only to sound, but to music, and in that they embodied key notions of acoustic modernity, celebrating the efficiency and signal-like clarity of the sound system on display. He said:

Figure 4.9
"The enhancement control unit of the stereophonic system" (Fletcher 1940b, 263; see also Fletcher 1941, 98). The top six keys controlled frequency (the keys on the left side adjusted the high frequencies on each of the three channels, and the keys on the right side adjusted the low frequencies on the three channels). The three faders or "handles" on the front of the unit adjusted the volumes of the three channels (Fletcher 1940b, 264). Courtesy of AT&T Archives and History Center.

> Every useful employment of sound for purposes of transmitting intelligence, be it in speech or music, involves a generator of sound vibrations, a transmitting medium, and a receiver. Where transmission is to a distance either in space or time it involves likewise a transformer of mechanical vibrations into electrical vibrations and the reverse. The efficiency of any system involving sound is dependent not alone on the absolute efficiency of its elementary parts but on their efficiency in relation to all the other parts. . . . The problem of recording, manipulating and reproducing sounds with complete fidelity and frequently [sic] in stereophonic perspective is one of prime interest in the development of a complete communication art. (Jewett 1940, 2–3)

Following Jewett's remarks, Fletcher, by then director of physical research at BTL, gave a brief demonstration, drawing attention to the system's dynamic range and stereo capabilities. He played two recordings. The first was of rustling leaves and the second was of shouting crowds. He told the audience that the second was "one hundred million times as intense" as the first (Fletcher 1940a, 1). Despite this warning, it would be reasonable to assume that no

one anticipated the sheer acoustic force of what ensued. "The loudest musical sounds ever created crashed and echoed through venerable Carnegie Hall last night as a specially invited audience listened, spellbound, and at times not a little terrified," reported the *New York Times* ("Sound Waves 'Rock' Carnegie Hall" 1940, 25). Engineers had chosen 100 decibels as the maximum level for the demonstration. The resulting "stupefying volume" seemed to "shake" the building (25). The *New York Herald Tribune* was even more pointed in its review, reporting that "a woman in the audience doubled up as if kicked by a horse" ("Thar She Blows" 1940, 27). This critic was not overly impressed by the demonstration, quipping that there were "too many real bombs falling on the world" (27). A guest, Otto G. Sickert, was equal parts impressed and dismayed. In a letter to Jewett he suggested that while the demonstration was "very remarkable" and would "go down in history with the other high achievements of the Bell Telephone Laboratories," the musical selections were "very poorly selected and much too long" (Sickert 1940, 1). For Sickert the achievements in the dynamic range of the softer passages had been "overshadowed by the extreme fortissimo which became at times atrociously loud and irritating" (1).

Not only were the Carnegie Hall demonstrations too loud; they also were undeniably long. Each night the demonstrations started at 8:45 pm and lasted until around midnight. Following the opening remarks by Jewett and Fletcher, a long series of recordings were "enhanced" by different artists. Stokowski enhanced recordings of orchestral music by Mussorgsky, Debussy, and Johann Strauss (respectively, *Night on Bare Mountain* and selections from *Pictures at an Exhibition; Clair de lune;* and *Tales from Vienna Woods*). Following an intermission, the drama instructor Harold Burris-Meyer enhanced a scene from Eugene O'Neill's play *The Emperor Jones*; the conductor J. Spencer Cornwall enhanced selections of choral music featuring the Mormon Tabernacle Choir; Alexander Schreiner enhanced selections of organ music; Cornwall enhanced excerpts from Mendelssohn's *Elijah*; and, finally, Stokowski enhanced a scene from an opera, "Brünhilde's Immolation" from Wagner's *Götterdämmerung*.[8]

What the demonstration lacked in concision or restraint, however, it made up for in technical prowess and aesthetic flair, especially with regard to the stereo effects. A review in *Nature* spoke to the marvels of a sound system that made recordings sound "real" and "spread out in space," and commented that "the whole width, breadth and depth of a symphony orchestra went into action" ("Stereophonic Recordings" 1940b, 174). This article also cited a review by L. Biancolli in *New York World-Telegraph*, in which Biancolli remarked that the demonstration had unveiled the "miracle" of "spread-out sound." Biancolli wrote, "Drums were at one end, flutes at another and in between other instruments were heard clearly across the stage. . . . The trick of giving orchestral music 'position' in recordings and weaving in nuances between nuances is now a perfected fact" (Biancolli, cited in "Stereophonic Recordings" 1940b, 174). Thus, while the demonstrations left some listeners stunned for the

wrong reasons, they also brought to life the new aesthetic possibilities of high-fidelity stereo reproduction. One guest called the demonstration an "epoch-making event" (Allen 1940, 1), while another commented that it should not be called "enhanced music but 'ENCHANTED MUSIC!'" (Penrose 1940, 1).

4.6 Sound and Music Made "Solid"

BTL's demonstrations of stereophony brought previously unknown experiences of sound and music to mass audiences: the transmission of an auditory perspective from one "listener" to multiple listeners in real time; the transmission of an "acoustic facsimile" of an orchestra; and the reproduction of stereo recordings in the concert hall. These acoustic spectacles played with listeners' sense of time and space and produced new sensations of hearing. Visitors to the Chicago World's Fair had the feeling they were being acoustically transported to the place of another listener and that their ears had become virtual microphones. Audiences in Constitution Hall were caught by the illusion that music originating hundreds of miles away was being created directly before them. Listeners in Carnegie Hall were stunned by the power of stereo sound that rocked the venerated hall. In conjuring acoustic illusions and playing with auditory sensations these demonstrations startled and shook listeners, at times literally so, into a new era of sound and music in three dimensions. This three-dimensional sound and music, in turn, embodied key aspects of acoustic modernity. It gave an impression of proximity, immediacy, and liveness even as it crossed distances and times. It conformed to a model of sound-as-signal and was lauded for its clarity and efficiency. It was developed in an industrial research context that aimed for the mass production of new acoustic products, a promise that would be borne out in the stereo boom that followed the Second World War.[9]

Studies in stereo sound at BTL not only aimed for scientific and technical progress, however. They equally sought to cultivate a new aesthetics of space in reproduced sound and music. As Stokowski wrote, "The power to send out tone from different sources in space adds greatly to the eloquence of music, and stereophonic reproduction is an important advance in the mastery of the spatial in music" (Stokowski 1940, 1). Upon hearing music reproduced in stereo, critics spoke of "A new world, populated with substances and entities fashioned of 'sculptured music', made 'solid' by giving it three dimensions through which distant things become 'substantiated' and assume the aspects of a reality that can almost be seen, touched, and felt" ("'Solidified' Music Shakes a Building" 1934, 15).[10] Stereo reproduction made sound and music seem more real, more solid—literally more sensational. Reproduced in three dimensions, sound and music seemed to be audible, visible, and tactile at once. These sensational effects were on full display in demonstrations that lifted auditory phenomena to the level of a true spectacle.

On the eve of the Second World War Fletcher told members of the Acoustical Society of America that acoustics was headed toward a new era of collaboration with music, and that the next decade of scientific acoustics would be marked by the development of new facilities and instruments for the purpose of musical creation (Fletcher 1939, 14). While the war would put such aims on hold, Fletcher returned to this idea again in 1947, calling for the establishment of an Institute of Musical Science that would "apply to the problems of music the techniques and instrumentalities which have been developed in the fields of acoustics, electrical communications, and electronics" (Fletcher 1947, 722). While Fletcher's institute would never materialize, the idea nevertheless signaled the dawn of an era of scientific music that would profoundly shape Western art music cultures after the Second World War (Born 1995). It presaged such musical-scientific institutes as Paris's IRCAM, predating them by around three decades.[11]

BTL's stereo demonstrations thus reverberated across the worlds of science, technology, and music, revealing new possibilities for their interconnections. Orchestral music was transformed into electrical currents and sent over miles of telephone wires to distant halls, where it became music once again—a full symphony orchestra reconstituted in only three channels of sound. Scientists marveled at the how a single metal diaphragm could faithfully reproduce the sounds of any instrument (Jewett 1933b). Concert halls were turned into laboratories, and laboratories became spaces for musical and sonic experimentation. For a time, it seemed that the possibilities born of the marriage of music to science were boundless. As Stokowski (1932, 18) remarked on the eve of the first demonstrations, "Physicists, musicians should understand what this extraordinary circuit is from inspiration through transmission, through reception, back to inspiration. As science grows, it must include everything in nature and everything in man, art, all the arts . . . the most reckless adventures of the imagination."

5 Psycho-Acoustics: Sound Control, Emotional Control, and Sonic Warfare

We have tried to control sound so that the artist in the theatre can use it to make a good show. . . . The limitations on the auditory component of the [theater] are off. The players may speak with the tongues of men and of angels. With sound you can compel the audience to laugh, to weep. You can knock them off their seats, you can lay them in the aisles, you can make them believe what you will.
—Harold Burris-Meyer (1940)

The theater of the future will be acoustically dead and . . . all sound will be distributed and given the necessary effect by means of vacuum tubes. But the audience will not be aware that anything has been done to the [actor's] voice. It will even think that the theatre is "alive"—in other words, that it reverberates or rings. Good actors with bad voices are about to enter an acoustic paradise.
—*New York Times* on Harold Burris-Meyer, June 2, 1940[1]

5.1 Hearing Panic

On September 29, 2017, two senior officials of the U.S. State Department held a press briefing about an incident that was gaining traction in the news. After hearing strange noises in their homes and hotel rooms, more than twenty U.S. government employees in Havana, Cuba, had mysteriously fallen ill. Their symptoms included hearing loss, dizziness, nausea, tinnitus, fatigue, headaches, memory loss, and difficulty sleeping. On balance the symptoms pointed to a mild brain injury. The word "concussion" made the rounds. In none of the cases, however, had there been any direct trauma to the head. Without giving any other details, the State Department officials suggested that the symptoms had been caused by "attacks." Nonemergency personnel in Havana were ordered to return to the United States, and a travel warning was issued advising U.S. citizens not to travel to Cuba. When a reporter asked what had caused the attacks, the reply was only that there were no definitive answers. The next question raised the specter of a sonic weapon: "there's obviously been a lot of speculation

about [a] sonic device or acoustic device. . . . Do investigators still believe that that would be a plausible device related to these illnesses?" The State Department official replied, "the investigation continues and we don't have any definitive conclusions regarding cause, source, or any kind of technologies that might be engaged" (U.S. Embassy in Cuba 2017).

Conspiracy theories filled the void left by the lack of an official narrative or a plausible medical diagnosis. An American doctor was sent to Cuba to investigate. He suggested that the cause "might be a weapon that used sound waves" (Hamilton 2019). This bolstered the claim, spread by numerous media outlets, that "sonic attacks" had taken place. Journalists wondered whether infrasonic or ultrasonic sounds (sounds with frequencies below or above the audible spectrum) had been used on the government employees to make them ill. The science writer Carl Zimmer debunked most of these theories, explaining that ultrasonic waves had to be administered at close range in order to cause damage to human tissue, while infrasonic waves were difficult to focus and therefore hard to weaponize (Zimmer 2017, A6). It was highly unlikely that a sonic weapon had been deployed on the employees without their knowledge. In the end it was mostly agreed that the likely cause of "Havana Syndrome" was something far more commonplace than a sonic weapon: stress.[2] Still, the incident revealed widespread fears about nefarious uses of sound, an invisible medium and therefore an ideal one onto which to project fears about stealth attacks. It also revealed particular anxieties about inaudible sounds and their potential to cause harm to people without their knowledge.

In 2017 these anxieties were projected onto wider fears about foreign intervention in national elections, electronic surveillance, and other uncontrollable and potentially unknowable forces at play in international politics. Around eighty years ago similar anxieties first surfaced in the United States when Harold Burris-Meyer, a theater director and sound technician at the Stevens Institute of Technology (SIT), New Jersey, used infrasound as part of a project on "sound control" in the theater. His idea was that inaudible sounds could be used to manipulate audiences' emotions subconsciously. Following a demonstration of infrasonics, which he called "subsonics," journalists speculated about the possibilities of mind control and mass hysteria. Especially worrying was the idea that politicians might use inaudible sounds to control unwitting populations. One journalist wondered what Adolf Hitler would do with the technology given half the chance (Parton 1935).

Although his name has mostly been lost to history, Harold Burris-Meyer played a critical role in the emerging fields of sound design for theater, music for industry, and psychoacoustics for warfare in the 1930s and 1940s.[3] His experiments are important to revisit in that they set the stage for a new era of theatre based on the use of electroacoustic sound design; but equally because they represented a novel approach to conceptualizations of sound and space: the idea that sounds could be used to create "optimized" acoustic environments that would produce specific emotional and physiological responses in people.

Burris-Meyer joined the faculty of SIT in 1929 and within a year had already established a research program on "sound control." Sound control as he imagined it encompassed the control of intensity, pitch, and timbre of all sounds heard in the theater, as well as the apparent distance and direction of sounds. Over the next decade Burris-Meyer and his collaborators, notably the engineer Vincent Mallory, designed several new multichannel sound systems for SIT, inspired in part by the work of Harvey Fletcher and researchers at BTL. Scientists at BTL, in turn, took interest in Burris-Meyer's experiments. In 1940 Burris-Meyer was invited to take part in BTL's evenings of "Stereophonic Recordings of Enhanced Music" at Carnegie Hall, where his work was introduced as representing the most cutting-edge research on sound for the theater. In the 1930s and 1940s this research was tested in major theater, opera, and Broadway productions in Manhattan, including productions by the Metropolitan Opera, the Theatre Guild, and the Playwrights' Company. It attracted the attention of the national press, including reports in the *New York Times*, *New Yorker*, and *TIME*; and it garnered the support of major sponsors including the Rockefeller Foundation, the Radio Corporation of America (RCA), Western Electric Company, and Electrical Research Products, Inc. (ERPI), among others.

In his earliest experiments on sound for the theater Burris-Meyer observed that audiences could be made to react in noticeable ways to acoustic stimuli: that, with sound, audiences could be "made to sit up, or move forward, relax, etc., almost regardless of the visual part of the production" ("Of Sound, Fury, and Stevens Tech" 1941, 1). These observations led him to conceptualize sound control as a form of emotional control and, consequently, to propose a kind of musical behaviorism: the use of sound and music to elicit specific responses in listeners. This aspect of Burris-Meyer's work drew the interest of the Muzak Corporation, a company that provided "canned music" to offices and factories to alleviate boredom and fatigue. Burris-Meyer was initially hired as a consultant for Muzak, and from 1939 to 1947 he served as its vice president. In 1943 he said of Muzak, "Our interest is in emotional control. We are interested in exerting it directly by emotional stimulus, and by inducing physiological change as the basis for emotion" (Burris-Meyer 1943, 262).

During the Second World War Burris-Meyer's sound control project moved beyond the theater and the factory into the arena of war. He was tasked by the National Defense Research Committee (NDRC) with leading a group of researchers at SIT to investigate "the potential applications of sound control, psychoacoustics, and use of theatrical techniques for military purposes" (Goodfriend 1985).[4] This group, who reported to the Applied Psychology Panel of the NDRC, conducted an extensive series of tests on the psychology of sound and noise and their potential applications in warfare. They sought to determine whether noise could cause pain or reduce visual coordination, for example, and whether sound and noise could have applications in the form of sonic warfare or sonic deception. For Burris-Meyer the roots of

such projects lay in something far more optimistic: a desire to make audiences believe that the theater was more alive—reverberating and ringing with sound.

5.2 Sound Control for the Theater

Burris-Meyer's sound control project was rooted in the desire to modernize the acoustic dimension of the theater. He maintained that while the visual apparatus of the theater had been sufficiently developed, the acoustics of the theater had barely evolved since the Middle Ages. In the early 1930s theater sound was generally constrained by the physical limitations of the human voice, acoustic instruments, mechanical sound props, and architectural acoustics (Burris-Meyer 1935a). Most major theaters in the United States used some sort of sound reinforcement technology, but this equipment was typically rented, cheap, and difficult to operate. Moreover, most productions did not have a sound technician with knowledge of electroacoustics; indeed, the role of the sound technician had hardly yet been conceived. Compounding these problems, even the most renowned theaters had problems with unintelligible speech and ambient noise. Burris-Meyer believed that sound control would improve audibility in the theater, reduce ambient noise, and make it possible to modify auditorium acoustics. Underlying this vision was a conception of the theater as a controllable acoustic environment. In technical terms this meant being able to manipulate the frequency, loudness, timbre, and other acoustic characteristics of sounds, as well as their apparent location and movement in space. He wrote, "it is necessary to be able to produce in the theatre any sound from any source so that the audience will hear it from any apparent source, from a moving source or from no apparent source" (Burris-Meyer 1935a, 74). Some sound control techniques were intended to create illusion and suspend disbelief. Without electroacoustic aids, for example, an actor who was thinking out loud would have normally been assigned what was then called an "alter ego." A second actor would appear on stage and speak the actor's thoughts for her. In order to avoid this artificial aside Burris-Meyer developed a technique he called the "stage soliloquy." Recordings were made of an actor speaking her character's inner thoughts. During performance these recordings were projected from loudspeakers hidden around the stage. An actor's thoughts could then follow her around the stage in a realistic way.

Other sound control techniques served as performance aids. For the "acoustic envelope" (also called the "Robeson technique" after the celebrated African American singer and actor Paul Robeson, with and for whom it was originally created), the sound of an actor's voice was fed back through a loudspeaker at the side of the stage, not far from the actor. Burris-Meyer thought of the acoustic envelope, what we would now think of as a kind of stage monitor, as the creation of a small, resonant "room." Performers reported that it greatly facilitated

certain kinds of speaking and singing. One said, "I could sing all night" and, "Why, it shrinks the room way down" (Burris-Meyer 1941c, 337). Burris-Meyer was especially concerned with the placement of loudspeakers and their effects upon an acoustic scene. He condemned the "unforgivable, still-too-common sin" of mounting a pair of loudspeakers on either side of the proscenium (Burris-Meyer and Mallory 1959, 17). Loudspeakers should be "heard and not seen" and used not only to amplify sounds but to create illusory effects (17).

As part of its research into the dramatic uses of sound the Sound Control Research group developed several new multichannel sound systems for the Stevens Theatre at SIT. The first was a two-channel system that was initially used for productions of the Living Newspaper, a kind of theater that entailed a dramatic reading of the news. The two-channel system could simultaneously receive four inputs and distribute sound to up to six loudspeakers, each of which could be individually controlled. With this system a sense of auditory perspective was achieved primarily through volume control (varying the signal intensity between adjacent speakers such that sounds seemed to move around in a seamless, naturalistic way) (Burris-Meyer and Cole 1949, 174). Burris-Meyer and Mallory then developed a more advanced multichannel system that could receive six inputs simultaneously. Burris-Meyer wrote of this second system that eight speakers were normally used "to provide auditory perspective on stage, above the audience and along the side of the house," and that up to sixteen speakers had been used in a single production, though never more than eight at a time (Burris-Meyer 1940b, 123–124; see also Mallory 1940).

Critics were quick to praise the new electroacoustic capabilities of the Stevens Theatre and in particular the spatial sound effects that could be heard there. The *New York Herald-Tribune* described the "tricks [that] can be done with directional sound," whether making "ethereal laughter whirl about above the audience," or making an invisible mob "rush across the stage, batter down doors and charge out over the footlights" ("Sound Control Possibilities in Theater Cited" 1935). *Science News-Letter* commented on the heightened sense of sonic realism achieved by these sound effects, remarking that they signaled the start of a "new era" in theater:

> Columns of troops are heard marching down the aisle of a theater—even though that aisle is empty. Or a line of tanks rumbles over the heads of an audience.
>
> An airplane is heard approaching—it flies around the auditorium and crashes in the orchestra pit.
>
> Angel voices seem to be all around, coming from no apparent source.
>
> These are some of the newest of sound effects for theaters. They have been worked out experimentally by Harold Burris-Meyer, in the Stevens Institute of Technology at Hoboken, N. J. Perhaps, soon they will be used to give the opera a new degree of realism. Imagine having the Valkyries riding right over your head! In fact, the effects that can be achieved lead some to think this may be the start of a new era, that may affect the movies, television and many other activities. (Stokley 1941, 314)

5.3 The Sound Shows

These innovations were most famously publicized through two "Sound Shows" held at the Stevens Theatre on May 4–5, 1934, and April 17–19, 1941 (see figures 5.1 and 5.2). At the start of the first Sound Show, Burris-Meyer told audiences that the techniques they were about to witness had already been "tried on more than twenty audiences" (Burris-Meyer 1934b, 2). He explained that the show was conceived as a kind of scientific experiment, a way of gathering feedback on various sound control techniques in order to gauge their effectiveness. The conditions of the experiment were less than ideal: the production was mounted not by professionals but by a crew of "embryo engineers" (2), and the plays themselves had not been written with sound control techniques in mind. Still, the historic nature of the event was not in doubt. A press release announced that the first Sound Show "should be an historic occasion for it will for the first time demonstrate that sound is controllable, and that controlled sound is as dramatically useful as controlled light" (Burris-Meyer 1934a, 3).

The first Sound Show was divided into two acts, each of which featured a number of theatrical or musical selections interspersed with brief explanatory speeches by Burris-Meyer. Act I consisted of an overture, scenes from Alice Gerstenberg's *Overtones* and Shakespeare's *Hamlet*, and a demonstration of "Canned Music." Act II featured selections of orchestral music, a dance pantomime, and a scene from Elmer Rice's *The Adding Machine*. Sound control techniques in the first Sound Show were mostly oriented toward manipulating the volume, pitch, timbre, and spatial characteristics of sounds. In *Overtones*, for example, Burris-Meyer used "voice dubbing" to create the parts for an actor's alter egos. He wrote, "The invisible [alter-egos] were heard . . . from wherever position the actress in question occupied [on the stage] but without the necessity of her opening her mouth" (Burris-Meyer 1935b, 185). In retrospect, the most notable technique in the first Sound Show was the one used in *The Adding Machine*. Here, technicians had used "arbitrary non-meaningful sound" to "induce nervous tension" in audiences (Burris-Meyer and Mallory 1950, 256). The scene was one in which a male character descended into madness. Accordingly, the sound design illustrated the character's growing despair. The audience was "enabled to hear all of the racket which went on within [the character's] brain" (Burris Meyer 1935b, 185). As the character grew more desperate, "the volume was increased and *the audience reaction was more apparent than it is in conventional productions of the same scene*" (185; emphasis in original).

The second Sound Show, which followed the first by six years, was significantly more complex and entailed no fewer than eighty intricate sound cues that required careful coordination between performers and teams of technicians. The program was also much more elaborate. There were several scenes each from Shakespeare's *Macbeth*, *The Tempest*, and *A Midsummer Night's Dream*; O'Neill's *The Emperor Jones* and *Lazarus Laughed*; and Gounod's

(a)

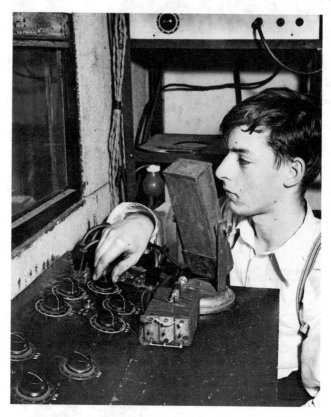

Figure 5.2
Inside the sound control booth at the first Sound Show (1934). Faculty of Stevens Institute of Technology Collection, SCW.007. Archives & Special Collections, Samuel C. Williams Library, Stevens Institute of Technology, Hoboken, New Jersey.

Faust. A musical program with excerpts from nine compositions by Mendelssohn, Prokofiev, Purcell, and others rounded off the evening. On the program each item was accompanied by a brief note indicating the sound control technique it demonstrated. Scenes from *Macbeth* demonstrated the "re-made voice." Here, witches' voices were "remade" using the Vocoder—a voice synthesizer developed at BTL—and made to span the entire frequency spectrum: one voice was high-pitched; another was in the middle range, and had a quality "somewhere between the sound of a rock crusher and a whiskey baritone"; and the third was "lower than a basso" (Burris-Meyer 1941b, 16). A scene from *A Midsummer Night's Dream* demonstrated "the re-made voice dubbed to a character." This technique was especially intricate and, according to a review in the *New York Times*, took weeks to perfect:

Bottom's remade voice in the scene from 'Midsummer Night's Dream' was the result of weeks of analysis in reconstruction. To build it the staff took a standard recording of an ass's bray and broke it down into hisses and buzzes, balancing them against each other. The frequency range of the bray was measured and adjusted to a machine into which the actor spoke the lines. The voice was recorded within the required range. The completed sound, reproduced from disk, is a remarkable synthesis of bray and the human voice. ("Science Remakes the Human Voice" 1941)

The "Toccata in F" from Charles Widor's *Symphony for Organ No. 5* demonstrated "reverberation control." Here, technicians artificially recreated the reverberation time of the Église Saint-Sulpice in Paris, the acoustic for which the work had originally been composed. Burris-Meyer reported that the experiment "was welcomed with considerable enthusiasm by all but a very few members of the audience"; one audience member, who had heard the "Toccata" in the church, remarked that the original acoustic had been perfectly recreated (Burris-Meyer 1941b, 18).

For the second Sound Show Burris-Meyer's group went beyond producing novel sound effects and producing a heightened sense of sonic realism. They also used inaudible sounds in an attempt to manipulate audiences' emotional responses to a scene. In one scene they used a technique called the "subsonic drum." Subsonic sounds were produced via loudspeakers hidden beneath the theater's seating area, so that audiences could "feel" the tension in the scene even though they could not hear it. Following this selection Burris-Meyer told audiences, "I didn't say anything about [*The Emperor Jones*] before it went on. You may have noticed that the rhythm of the drum-beat was present before you heard the drum" (Burris-Meyer 1941a, 3). He suggested that by using the subsonic drum throughout the piece and slowly bringing it up to an audible pitch, it would "condition the audience" in a way that was not possible with a conventional drum (3). What had at first seemed to be a simple problem of pitch shifting was, in fact, highly complex. The technicians faced problems with electronic wave generators, which produced audible harmonics, and loudspeakers, which could not produce enough power at the appropriate frequencies. After experimenting with different potential sound sources, they settled on using a thunder screen along with a low-pass filter that eliminated frequencies above 16 hertz, and they mounted loudspeakers "directly on the under side of the floor" (Burris-Meyer 1941b, 17). According to Burris-Meyer, "When the drum was to become audible the source was changed to a conventional thunder drum picked up by microphone, and speakers on-stage and in the house were added, but the subsonic channel was kept in operation and the shift was accomplished so gradually that there was no agreement in the audience as to when the drum became audible" (17). Audience members said they perceived the drum beat "as a throbbing sensation in the forehead, as a rhythmic intermittent oppressed feeling" (17); when the drumming sounds were discontinued, some felt as though a weight had been lifted from their chests. The *New*

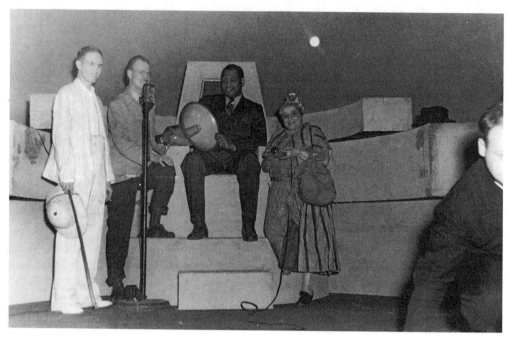

Figure 5.3
Paul Robeson (seated), Eslanda Goode Robeson (right), and Harold Burris-Meyer (second from left) at the second Sound Show (1941). Faculty of Stevens Institute of Technology Collection, SCW.007. Archives & Special Collections, Samuel C. Williams Library, Stevens Institute of Technology, Hoboken, New Jersey.

York Times reported that, for the second Sound Show, seventy loudspeakers of various sizes had been placed throughout the theater, and that even the auditorium floor had not been overlooked "for its possibility as a diaphragm" ("Science Remakes the Human Voice" 1941) (see figure 5.3).

It would not be an exaggeration to say that the theater had been reconstituted through electroacoustics. With sound control, characters who should be heard but not seen could be manifested only in sound; actors' thoughts could follow them around the stage in a realistic way; actors could better hear themselves in large halls and thus perform with a renewed sense of intimacy; background music could be replayed at an appropriate volume instead of inadvertently dominating a scene; audiences could better hear the action unfolding on the stage; and the auditorium could be made to sound as reverberant or dry as a scene required. The acoustic environment of the theater was reborn as a controllable environment, one in which "sound control" extended to the psyches and bodies of the listeners themselves.

5.4 From Sound Control to Emotional Control

Just as Leopold Stokowski had sought to use new technologies to deepen an audience's emotional response to music, Burris-Meyer sought to use sound control techniques to enhance, and later elicit, emotional responses in theater audiences. While Stokowski wanted to extend the emotional language of music, however, Burris-Meyer sought to produce audience "reactions," and believed it was possible to use sound a "means for stimulating predictable involuntary audience reaction" (Burris-Meyer 1940a, 380).

While most sound control techniques were devised to enhance the dramatic effectiveness of a scene, others were used in ways that would hardly qualify as artistically motivated. For example, in one technique an audience's applause was picked up by microphones and fed back into the theater. When the audience was able to hear its own applause, its enthusiasm became much greater. Burris-Meyer and Mallory suggested that this technique could produce "as many as five curtain calls more than the same show with the same kind of audience and no reinforcement" (Burris-Meyer and Mallory 1959, 28). In his earliest experiments in sound control Burris-Meyer had made casual observations of audiences in order to gauge their reactions. Later he sought to study these reactions systematically. His research on sound control had so far been qualitative, but he now sought to pursue quantitative methods: "the measurement of actual physical physiological and psychological reactions stimulated by sound in the theater" ("Sound Harnessed for Stage Effect" 1935, 12).

While the idea of measuring audience reactions might not have raised any eyebrows, not everyone was comfortable with the prospect of using sounds, especially inaudible ones, to produce involuntary reactions in audiences. Upon witnessing a demonstration of subsonics by Burris-Meyer at the Yale School of Drama in 1935, a journalist reported that, with subsonics, "The listener's bones can be made to rattle, his tooth ache and his head knock, and he can even be made to perspire" ("Science Makes Jitters Real" 1935, 16). Another predicted that the audience of the future "will have its emotions directed by sounds it cannot hear, rays it cannot see, waves of clammy air and electric forces which can make its hair stand on end" (Potter 1935). The same journalist wrote, "It may be that they cause effects on the body which stimulate or depress feeling. If so, a controlled 'soundless' sound attack on a theater audience might produce emotional effects without anyone in the listening group being any the wiser" (Potter 1935). Compounding these anxieties was the fact that the long-term effects of inaudible sounds on the human body were completely unknown.

The prospect of using inaudible sounds to manipulate human emotions had seemingly become a reality. Another journalist wondered whether the use of inaudible sounds might eventually find its way to political campaigns. "Suppose that when the next election comes around the Government leader installs apparatus to cause his election hall audiences fairly

to jump with joy and enthusiasm. How easy, then, to convince them with a little oratorical effort!" ("Inaudible Sounds Affect Mental Processes" 1935). Using infrasound to send inaudible messages to—indeed, transmit them *into*—unwitting populations had become a feasible prospect:

> In time we might even reach that stage of super and sub-sonic refinement at which the speeches of candidates could be dispensed with entirely, and audiences would attend meetings merely to receive through their pores such impressions as the sound-engineering departments of the various political parties sought to create. There would be nothing to prevent audible sounds being created at the same time, so that political audiences would assemble ostensibly to hear a symphonic concert or a violin recital, but while hearing the music would simultaneously have their political minds made up for them by the insidious, inaudible sound frequencies shooting at them from under the platform. ("Inaudible Sounds Affect Mental Processes" 1935)

In 1935 such dystopic scenarios were mapped out onto anxieties about the rise of authoritarianism in Europe. When Burris-Meyer announced that he had invented a sound machine that could "induce hysteria in an audience in less than thirty seconds," a reporter for the *Cincinnati Times-Star* quipped, "What a labor-saving device that would have been for Adolf Hitler!" (Parton 1935).

5.5 Music for Industry

Burris-Meyer's experiments in sound control and emotional control drew the interest of the Muzak Corporation. Muzak was founded by George Owen Squier in 1922 under the name Wired Radio, and renamed Muzak in 1934.[5] Burris-Meyer joined Muzak in 1938 and there quickly embarked on studying the physiological and psychological effects of music on industrial workers. He sought to perfect a formula for "functional music"—one that would improve mood, boost morale, decrease fatigue, and increase productivity. He was especially interested in the use of music to control such physiological processes as metabolism, respiration, and heart rate (Burris-Meyer 1943, 262). The effects of music on industrial workers had already been observed for decades. Frank Gilbreth had written positively about using music and storytelling to entertain workers (Gilbreth 1911; see also Styhre 2012, 29). In 1915 Thomas Edison had installed phonographs in factories to help alleviate boredom. The phonographs replaced the human readers who had previously been set to the task (Lanza 1994, 13; Bijsterveld 2008, 83). Such early experiments were limited by the sound reproduction technologies that were available at the time; the faint sounds produced by mechanical phonographs could not compete with the noise of factories. Richmond L. Cardinell, an acoustic engineer and director of research at Muzak, suggested that Edison's experiments had yielded positive results but had not been adopted more widely because the

sound reproduction equipment was so poor. "After all," he wrote, "this was before the days of vacuum tubes, public address systems, and other electronic devices which we now take for granted" (Cardinell 1946, 36).

Innovations in electroacoustics greatly expanded the possibilities of bringing music to the factory floor. By the early 1940s, a typical industrial sound system comprised several kinds of loudspeakers, power amplifiers, voltage amplifiers, filters, microphones, preamplifiers, equalizers, turntable units, microphones, circuits for volume compression, controls for input switching, and recording machines (Cardinell and Henry 1944, 44–48). The possibilities engendered by electroacoustics were compounded by the prospect of applying the scientific method to programming music. Muzak's "scientifically planned" programs accounted for such variables as employees' age, nationality, gender, level of education, and socioeconomic status; the type of work that was done; the time of day the music was administered; the duration of the program; and its loudness. In his pursuit of an ideal formula for music Burris-Meyer determined that the most effective "dose" was around ten to fifteen minutes of music "administered softly" every thirty minutes, as he told *TIME* magazine in 1942 ("Music: Productive Melody" 1942). His studies showed that foreign workers responded particularly well to opera, and that older workers preferred standards like "Bicycle Built for Two," while younger workers preferred contemporary popular songs. Rather than rely on trial and error to determine the effectiveness of a particular selection of songs, however, Burris-Meyer and Cardinell used performance indices to measure the emotional states of workers and validate their programming choices (Cardinell and Burris-Meyer 1947). In *Guide to Industrial Sound* (1944), Cardinell suggested that around 60 percent of music played in factories should consist of popular dance tunes, while the remaining 40 percent should be a combination of "Viennese waltzes, popular operetta melodies, polkas, novelties, marches and Latin American music" (Cardinell and Henry 1944, 56). Variety was key, such that no discernible pattern could be noticed by the worker, who was supposed to be aided, and not distracted, in his or her work. Certain genres were therefore deemed off-limits. "Hot music and Jive" were found to be "overstimulating," and it was determined that they should only be used sparingly even if the demand for them was great (58).

During the Second World War industrial music became inextricably linked with the war effort. Programs like the BBC's *Music While You Work*, which was administered twice a day in British factories via radio broadcast starting in June 1940, were based on the idea that music could encourage feelings of patriotism while also alleviating the strains of war (McConnell 1941). Such programs were thought to "[render] valiant service in strengthening morale" (Antrim 1943, 280). As the music journalist Doron K. Antrim wrote, workers would "straggle back to plants after a terrible night of bombing, and production would sag gravely. But as soon as the music came on, the production curve would begin to rise along with the spirits of the workers" (280). Installations in war plants lead to a dramatic increase in subscriptions to

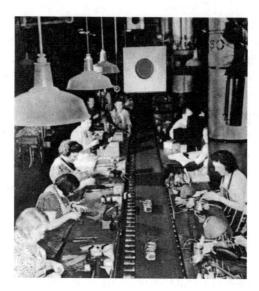

Figure 5.4
"Music at Work," from *Guide to Industrial Sound* (Cardinell and Henry 1944, 4).

Muzak and similar services (see figure 5.4). According to Cardinell and Burris-Meyer, by the end of the war the number of people working to music had grown to at least five million, a number that was constantly increasing (Cardinell and Burris-Meyer 1947, 547).

Muzak enabled Burris-Meyer to test on an industrial scale how musical sounds could be used to manipulate human physiology and emotion. It entailed creating precisely planned acoustic environments that, like the newly modernized sonic environment of the theater, were seamlessly controlled through a vast system of electroacoustic technologies. These environments were instrumentalized in the sense that they were designed for a specific purpose: to regulate the emotion and physiology of the industrial worker subconsciously. As such, Muzak represented a novel form of human systems engineering: the production of sonic environments that worked *on* the worker. Muzak linked musical rhythms to human biorhythms to the rhythms of industrial production, projecting music across factory floors and into workers' bodies and psyches. Muzak was not "performed" or "played" but "administered": an acoustic dose for the fatigued or war-weary worker. With Muzak, the atmosphere of work, and by extension, the worker in that atmosphere, was controlled, through sound, and on a mass scale.

5.6 Psychoacoustics for Warfare

During the Second World War it became newly urgent to understand how sound affected human psychology and physiology (Burris-Meyer, Forbes and Woolf 1942; Wolfle 1946;

Rosenzweig and Stone 1948). In their introduction to a bibliography of wartime research in psychoacoustics, Mark R. Rosenzweig and Geraldine Stone (1948, 642) remarked that this research was propelled by a sudden need for better voice communication technologies and equally by a need to measure and study wartime noises. In particular it was imperative to understand the effects of intense noise and vibration on psychomotor efficiency—for example, by studying the temporary hearing losses that followed exposure to noise or by examining the effects of noise on coordination and reaction times.

The rise of technological warfare had spawned a multitude of scientific questions on the effects of sound and noise. In their foreword to a technical report on combat acoustics and sonic deception, the engineer Vannevar Bush, director of the Office of Scientific Research and Development (OSRD), and James B. Conant, chairman of the NDRC, wrote, "How much noise can a human being stand? What clues must the human ear have in order to understand a spoken message? How much distortion can be tolerated [in deciphering speech]?" (Bush and Conant 1946, v). Bush characterized the period as one of rapid transition, from warfare between "hordes of armed men" to a new kind of warfare in which science was applied to the project of mass destruction (Bush 1946, viii). The weaponization of acoustics was part of this shift. Division 17 of the OSRD oversaw research in military acoustics. The division was made up of three sections: 17.1, Instruments; 17.2, Electrical Equipment; and 17.3, Acoustics. The latter tackled a range of problems including voice communication, noise exposure, sonic deception, mobile loudspeaker systems, and sound location. Scientists attached to the division were accordingly drawn from a variety of fields that included physics, acoustics, psychology, linguistics, and otology. Among them were the physicist Leo L. Beranek, who founded the Electro-Acoustic Laboratory (EAL) at Harvard in 1940 under an NDRC contract, and the Harvard psychologist Stanley S. Stevens, who established the Psycho-Acoustic Laboratory (PAL) at Harvard with NDRC funding the same year. Their collaborators included J. C. R. Licklider, who worked in PAL from 1943 to 1950 and who would later achieve fame as an Internet pioneer through his work on the ARPANET; George A. Miller, a foundational figure in psycholinguistics and cognitive science; and Vern O. Knudsen, who would write key texts on architectural acoustics. In *Acoustic Measurements* (1949), a nearly one-thousand-page textbook that captured some of EAL and PAL's research, Beranek suggested that progress in the field of psychological acoustics had historically been slow because of "the inadequacies of measuring equipment, the scarcity of physicists acquainted with psychological methods, and the lack of psychologists familiar with the tools of physics" (Beranek 1949, 2). The vast resources allocated to military acoustics research by the NDRC and OSRD made it possible to investigate psychoacoustic problems that would have otherwise been impossible to explore in the context of scientific experimentation. As a result of military funding Beranek built the first functional anechoic chamber in the United States, at a cost of $100,000: the equivalent of nearly $2 million at contemporary rates (Baxter 1946, 190; see also Beranek and Sleeper

1946). Together PAL and EAL spent the equivalent of $30 million in today's dollars on solving acoustic problems during the war years alone.

In his 2008 autobiography *Riding the Waves* Beranek recalls the establishment of PAL and EAL. In October 1940, having newly completed a PhD on noise reduction under the supervision of Frederick V. Hunt at Harvard, Beranek received a phone call from Philip Morse, professor of physics at MIT. Morse offered Beranek a role in an NDRC-sponsored project at MIT. The noise in military aircraft was overwhelming and urgently needed to be reduced. Beranek was eager to take on the project but Hunt objected to the move. The president of MIT, Karl T. Compton, decided that the work would be done at Harvard, with Beranek at the helm. As Beranek tells it, "Compton then proposed a supervisory committee, the Committee on Sound Control, with Morse and Hunt as chairman and vice chairman; with Harvey Fletcher, director of acoustics research at the Bell Telephone Laboratories, and Hallowell Davis, professor at the Harvard Medical School as members; and with me as secretary" (Beranek 2008, 50).[6]

The Committee on Sound Control oversaw research in acoustics not only at Harvard and MIT, but also at a number of corporations and universities including BTL, the Chrysler Corporation, the University of California at Los Angeles, Columbia University, Duke University, and SIT (Burris-Meyer and Mallory 1960, 1568). At SIT Burris-Meyer was tasked with leading a group of researchers whose mission was to study *"The effect of sound on man and the means of producing such sound"* (1568; emphasis in original). The SIT group included Mallory and Cardinell, T. W. Forbes, Steward Giles, Lewis S. Goodfriend, Robert M. Jones, Joseph McCord, and W. L. Woolf. Stanley S. Stevens from EAL and Hallowell Davis from the Harvard Medical School were assigned as consultants to the group, as were Clarence Graham, a psychologist at Brown University who studied visual perception, and Carney Landis, chief research psychologist at the New York State Psychiatric Institute and Hospital.

Burris-Meyer first publicly discussed the work of the group at an annual meeting of the Acoustical Society of America in 1957. He suggested that, before the war, knowledge about the effects of sound and noise on people had largely been based on rumor and conjecture, citing "myths about the auditory lethal ray" and "inaudible sound which paralyzes" (Burris-Meyer 1957, 176). The aim of the SIT group was to distinguish rumor from fact. One rumor held that empty bottles thrown from airplanes could produce a disconcerting noise. There had been reports to this effect from the frontlines but no scientific evidence to corroborate the claims. The group ran an extensive series of tests that established that falling bottles produced much the same sound as falling bricks, which is to say, not much sound at all. Another rumor held that noise could reduce visual coordination. The group determined that exposure to certain noises did indeed reduce visual coordination, but that a similar effect could be obtained much more easily by dirtying a pilot's windshield. They even tested the idea that the sound of jingling keys could induce coma, a phenomenon that had purportedly

been shown in rats (they determined it could not), and the idea that sound could induce pain (they determined that it could, but that it was no more effective than sitting on a tack) (Burris-Meyer and Mallory 1960, 1570; see also Burris-Meyer, Forbes, and Woolf 1942).

While these initial studies had limited use in military contexts, one line of inquiry held more promise: the "BJ scale," an idea proposed by Hallowell Davis and so named after the Beach Jumpers, U.S. Navy special warfare units involved in psychological warfare (Carlton 2002). The BJ scale was, in effect, a scale of unpleasantness of sounds. A square wave, for example, would rate higher on the BJ scale than would a sine wave of the same frequency and loudness. The SIT group set out to produce a series of BJ sounds that would give listeners "the worst possible time per decibel per second of exposure" (Burris-Meyer and Mallory 1960, 1570). They experimented with a variety of unpleasant sounds like sirens and crying babies, and tested sounds with frequencies that ranged from infrasonic to ultrasonic, and intensities that ranged from barely audible to "concussion." In one experiment they secretly administered high-BJ-factor sounds, via headphones, on an unwitting test subject. After fewer than ten seconds of exposure, the subject "tore off the headset, threw it in the corner, put on his hat, and went home" (1570). In another experiment they projected high-intensity, high-BJ-factor sounds from the highest point on the SIT campus across the Hudson River. Complaints came in from Manhattan.

While inducing headaches and causing annoyance would have had limited applications in warfare, the ability to create unpleasant sounds did have at least one useful military application: mimicking the disorienting conditions of combat and therefore serving as a psychological screening test for new recruits. The U.S. Navy investigated this potential application of sounds under the program "Battle Noise," which was studied at a U.S. Naval Training Station in Newport, Rhode Island, where medical officers tested its potential usefulness in screening out soldiers who would find the noises of battle so disconcerting that they would be ineffective in combat (Wolfle 1946, 49). For the Battle Noise tests, high-fidelity sound recordings of battle action, devised by Burris-Meyer and Cardinell (and later modified by Edward Plum of the Walt Disney Corporation) were administered at loud volumes (110 decibels and higher), and projected from a massive loudspeaker that was described as "about the same shape and just a little smaller than a box car" (Burris-Meyer and Mallory 1960, 1572). The test subjects' reactions were observed by a psychiatrist who watched for signs of disturbance. In some cases, the signs were obvious: "A few men broke ranks and ran away. A few were taken directly to the psychiatric ward. Many more showed pallor, sweating, or other emotional signs" (Wolfle 1946, 49–50). After each test the men were asked to indicate which symptoms they had experienced, by raising their hands or ticking symptoms off a list. They were then classified according to the number of symptoms they had experienced or reported. The same men were also given a psychiatric interview that assessed their fitness for battle. In

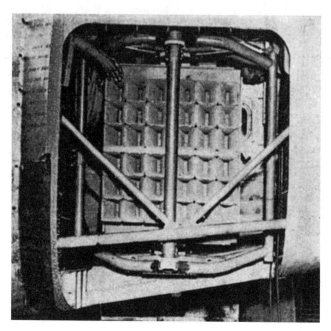

Figure 5.5
"One of Polly's loudspeakers mounted on a machine gun mount to make it possible to keep the signal on target" (1946) (Burris-Meyer and Mallory 1960, 1573). Reproduced from Harold Burris-Meyer and Vincent Mallory, "Psycho-Acoustics Applied and Misapplied," *Journal of the Acoustical Society of America* 32, no. 12 (1960): 1568–1574, with the permission of the Acoustical Society of America.

the end, it was determined that the psychiatric interview and the Battle Noise test produced largely similar results. Since the psychiatric interviews were cheaper and easier to administer, the Battle Noise program was not adopted more widely as a screening test. However, it *was* adopted in training programs as a battle noise simulator, an application that persists in various forms to this day.

During the war Burris-Meyer also supported Project Polly, which entailed developing an airborne public address system that projected high-intensity sounds from military aircraft. The project was taken forward by a number of different research groups including a group at BTL. BTL's Leonard Vieth reported that an advanced model of "Polly" boasted a 2,000-watt amplifier and a complex loudspeaker system that comprised a three-by-three arrangement of nine horns each, making an assemblage of thirty-six loudspeakers (Vieth 1946, 306). Polly had microphones for direct broadcasting and a magnetic wire recorder for playing back pre-recorded programs; it could project intelligible speech at a volume of around 130 decibels) (see figures 5.5 and 5.6).

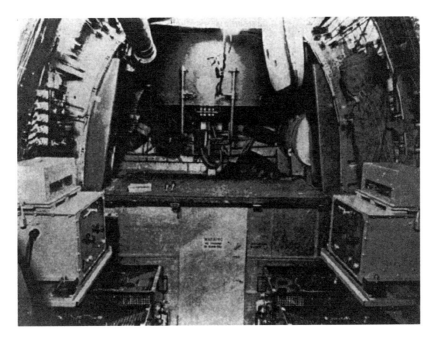

Figure 5.6
"Interior of the [patrol bomber] PB4-Y showing amplifiers (bottom, left and right), magnetic wire recorder-reproducers (center, left and right) and control panel (upper left)" (caption from Vieth 1946, 307; image from Burris-Meyer and Mallory 1960, 1573). Reproduced from Harold Burris-Meyer and Vincent Mallory, "Psycho-Acoustics Applied and Misapplied," *Journal of the Acoustical Society of America* 32, no. 12 (1960): 1568–1574, with the permission of the Acoustical Society of America.

A report in *Journal of the Franklin Institute* described how Polly was put to action in Wotje Atoll in 1944:

> Flying at 2700 feet, within machine gun range, a tough Ventura PV I twin-engined plane, carrying a crew of six, slowly circled the atoll and then blasted startled [Japanese] ears: "Attention, Japanese soldiers of Wotje Atoll, attention!" A short news broadcast followed, then a selection of Japanese popular music, a short propaganda talk and finally more news. The whole program took about fifteen minutes and was given twice. . . .
>
> Every day for two weeks the voice from the sky worked on the [Japanese]. They were told to be on the alert for an American landing craft which would land some day soon and pick them up. When the LCI [Landing Craft Infantry] beached on the atoll only nine ragged [Japanese soldiers], who had succeeded in evading their own troops, appeared for surrender. In succeeding campaigns, however, the bag of prisoners increased rapidly. (R. H. O. 1946, 310–311)

In supporting the development of Polly, Burris-Meyer, who had originally set out to produce a new kind of sonic realism for the theater, also helped to evolve new methods of

sonic deception for warfare. His obituary noted that "the aircraft that talked from as high as a mile above the ground" had been used "to obtain large numbers of peaceful surrenders" (Goodfriend 1985). While projecting voices from the sky might have been used to terrify isolated soldiers, the programs that were projected from Polly had a subtler effect, couching propaganda items between news items and popular music tunes—songs that would have been familiar and comforting to hear. These programs lasted approximately fifteen minutes, around the same time as an ideal Muzak program (during playback, the airplane circled over the targeted area). Once again, an acoustic dose was administered, this time to placate enemy combatants and entice them to surrender. "Sound control" thus extended to airspaces and battlefields, while emotional control extended to the psyches of enemy combatants.

5.7 Optimized Acoustic Environments

Burris-Meyer's sonic experiments took place in the theater, in the factory, and on the battle-field. In each space the aim was to create what Burris-Meyer would later call an "optimized acoustical environment," one that was most conducive to the project at hand (Burris-Meyer 1964, 1967). The acoustic environment of the theater was optimized to produce a sense of illusion; the acoustic environment of the factory was optimized to be most conducive to working; and the acoustic environment of the battlefield was optimized for military advantage. In each of these scenarios the idea of sound control as a route toward emotional control remained largely unchanged. In each space a captive audience, at times literally so, was subjected to electrically transduced sounds projected from loudspeakers that permeated the space and extended into listeners' bodies and psyches. In the theater, loudspeakers were mounted in every corner of the auditorium, hung from ceilings, and even placed beneath the auditorium floor, projecting sounds to audiences' ears and even transmitting them directly into their bodies. In the factory, loudspeakers were suspended above workers' heads, lined up in rows as if to sonically reproduce the industrial production line. In military aircraft, loudspeakers were assembled together by the dozens, amassing both literal and metaphorical power in amplifying and extending military force. In each of these contexts, loudspeakers served as the arm of an invisible operator: the sound technician, the factory manager, the state. It was in this sense that Burris-Meyer's experience as a drama instructor was vital for crossing over from an artistic milieu to an industrial context, and ultimately to a military one. In order for sound control to be effective as means for emotional control, listeners should not notice the sound effects at all. Rather, sound should manipulate their emotions subconsciously or subliminally, at the level of physiology. The optimal acoustic environment should be experienced as acoustic "scenery," a backdrop to the action at hand, masterfully conjured and used for "effect."

While the fears about mass hysteria and mind control triggered by Burris-Meyer's experiments in subsonics may have been exaggerated, his work did have significant repercussions, whether in revolutionizing sound design for the theater, in suggesting military applications for sounds, and especially in the pervasive presence of background music in everyday life today. In aiming to produce optimized acoustic environments, his experiments equally transformed ideas about sound and space. The "acoustic horizon" of these environments was not only limited by the physical space of the theater, the factory, or the battlefield. It extended to the body of the listener, who, through these experiments, was reconstituted as an entity that operated within an acoustic environment, and was operated on by that environment—controlled, regulated, and modulated, through sound.

6 From a Poetics to a Politics of Space: Spatial Music and Sound Installation Art

6.1 "New forms of art arose"

In a perceptive essay on Robin Minard, a Canadian artist who creates sound installations for public spaces such as subway corridors, the musicologist Helga de la Motte-Haber suggests that the development of sound installation art "marks the 20th century." She writes:

> With [the] new availability of [electroacoustic] sound material an art form congealed that overstepped traditional boundaries. The development of this art form marks the 20th century. Visual artists no longer had a monopoly on structuring space, just as musicians were no longer the only ones concerned with the aspect of temporal change. New forms of art arose that lay claim to simultaneous existence in space and time. Located beyond the realms of the traditional art world, installations created a new consciousness of our perception of reality. (de la Motte-Haber 1999, 41)

The emergence of sound installation art in the second half of the twentieth century reflects fundamental shifts within multiple arenas: conceptions of space and space-time; the ascendancy of site within the aural imagination; the extension of music and sonic arts into expanded models of sculpture and architecture; and the role of the public in aesthetic experience. Perhaps owing to its liminal position between more established disciplines, however, sound installation art remains under-recognized within historical accounts of twentieth-century art and music, even as it marks this history through such shifts, extensions, and ruptures.[1]

This chapter traces a genealogy of sound installation art, examining its precursors in electroacoustic spatial music composition from the 1950s and its inception within emerging interdisciplinary models in the 1960s and 1970s. Here, examples are chosen that highlight evolving concepts of space or spatiality and propose new modes of audience interaction. This precedes a discussion of two contemporary artists whose sound installations and site-specific sound works place new pressures on constructs such as "space," "site," and "public." The first of these, Heidi Fast, creates works that engage people's voices in enacting new modes of

community within shared urban environments. The second, Rebecca Belmore, engages what Lucy R. Lippard has described as "an activist art practice that raises consciousness about land, history, culture, and place [and serves] as a catalyst for social change" (Lippard 1997, 19).

Sound installation art, which Brandon LaBelle (2004, 7) has described as work in which "sound [is positioned] in relation to a spatial situation, whether that be found or constructed, actualized or imagined," has undoubtedly reoriented the sonic–spatial imagination. What is in doubt is whether or not this imagination is critically located or able to engage with the public in meaningful ways. My claim is that it can, when it is founded upon conceptions of space that account for social and political geographies, as well as physical ones. When space is understood not in abstract or absolute terms, but as socially and politically constituted, a spatial sound practice can emerge not only as a poetics, but as a politics; not only as an aesthetics, but as an ethics. Such a critical spatial sonic practice does not merely "happen in" space, but is poised to transform the very terms of its constitution.

6.2 "Music made of sound set free": Spatial Electroacoustic Music

Audiences at a sound-and-light spectacle at the 1958 World's Fair in Brussels, in which the overarching theme was nuclear disarmament, were overcome by the feeling that they were being bombarded by sound.[2] Electronic whines, human shrieks, moans and sirens seemed to come at them from every point inside a fantastical building whose interior surfaces were lined with hundreds of loudspeakers. Edgard Varèse, the composer of this unearthly music, later proclaimed, "For the first time I heard my music literally projected into space" (Varèse [1959] 1998, 170). Someone in the audience described the experience as a "modern nightmare" (Trieb 1996, 217).

Poème électronique, the name given to this eight-minute-long electroacoustic composition, was the musical component of an immersive multimedia work conceived by the architect Le Corbusier for the Philips Corporation.[3] The project combined architecture, film, hanging sculptures, colored lights, and multichannel electroacoustic music in telling what Le Corbusier thought of as a "story of all humankind." Varèse's music was recorded onto multitrack tape and diffused via an eleven-channel sound system to several hundred loudspeakers along nine "sound routes."[4] For Varèse the project represented the culmination of a lifelong pursuit to add a "fourth dimension" to music. In 1936 he had announced that, while there were "three dimensions in music: horizontal, vertical, and dynamic swelling or decreasing," he would "add a fourth, sound projection" (Varèse [1936] 2004, 18). He imagined that this fourth dimension would liberate Western art music from its stationary perspectives and allow sounds, which he believed to possess intelligence, to move freely in space (Varèse [1962] 1966, 19–20). Varèse had been claustrophobic since he was a child, and music seemed to him

"terribly enclosed, corseted" (Downes 1958, X11). From a young age he had imagined creating "a music made of sound set free" (X11).

Music's "journey into space," however wondrous, was not without its detractors. Hugo Gernsback remarked of *Poème électronique*: "Some people are apparently stunned and leave, talking in subdued whispers. Others are plainly bewildered—some look angered. Some laugh hysterically, others shake their heads" (Gernsback 1958, 47). The spatial sound effects were visceral and extreme: "The intense spine-tingling reverberations overwhelm you as the sound impinges on you from all directions at once, only to numb you in turn with extremely high shrieking, whistling eerie echos" (47).

Still, the transcendent potential of the work was not completely lost, either. The poet Fernand Ouellette remarked of *Poème électronique* that "one no longer hears the sounds, one finds oneself literally in the heart of the sound source. One does not listen to the sound, one lives it" (Ouellette 1968, cited in Trieb 1996, 210). In her memoirs, Carolyn Brown, a choreographer who traveled to the World's Fair as part of John Cage's entourage, remembers *Poème électronique* as a "gut-level experience, not only aurally and visually but intellectually and spiritually" (Brown 2007, 239). Listeners could move around the "soaring space" of the pavilion at will and "be engulfed by the music" from any point of their choosing (239). For Brown, Varèse's unbounded music eclipsed all the other music heard at the fair, including at Journées internationales de musique expérimentale (October 5–10, 1958), a festival of experimental music that featured the work of John Cage, Luc Ferrari, Pierre Henry, Györgi Ligeti, Olivier Messiaen, Pierre Schaeffer, Karlheinz Stockhausen, and David Tudor, among other leading figures of the Western musical avant-garde. "Compared with Varèse's cataclysmic spatial encounter," Brown writes, those concerts were, "at best, anemic" (239).

Regardless of its reception, *Poème électronique* was undoubtedly the most ambitious electroacoustic spatial music composition of the 1950s. Watershed moments in this history include Pierre Schaeffer and Pierre Henry's *Symphonie pour un homme seul* (1949–1950), a composition that made use of the *pupitre d'espace*, a spatialization system that could route sounds to four loudspeakers positioned around and above listeners (see figure 6.1);[5] Stockhausen's *Gesang der Jünglinge* (1955–1956), which was projected through five groups of loudspeakers positioned around listeners;[6] and the music of composers associated with the Music for Magnetic Tape project in Manhattan—including John Cage, Earle Brown, David Tudor, Morton Feldman, and Christian Wolff—who from 1952 to 1954 experimented with quadraphonic (four-channel) and octophonic (eight-channel) composition.

Early electroacoustic "spatial music" compositions were projected through experimental sound systems that were typically designed for a specific studio or even a single work (Manning 2006, 83–88). Schaeffer had conceived of the *pupitre d'espace*, for example, as a way to "restore a human touch" and bring a performative dimension to the presentation

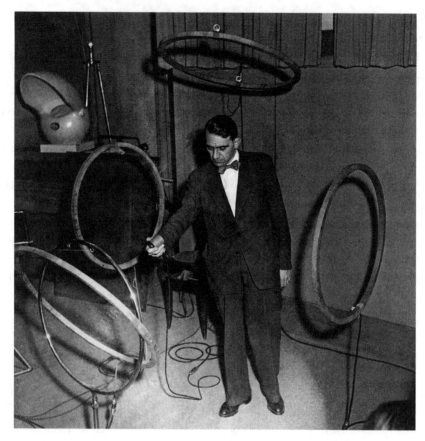

Figure 6.1
Pierre Schaeffer with the *pupitre d'espace* (1955). Copyright © 1955 by Maurice Lecardent (INA via Getty Images). Used with permission.

of acousmatic music by the Groupe de Recherches de Musique Concrète (GRMC) (Poullin [1954] 1957, 22; Teruggi 2007).[7] The engineer Jacques Poullin wrote that the pupitre d'espace enabled an operator "to suggest acoustic paths by means of gestures performed in front of the audience" (Poullin [1954] 1957, 22–23) (see figure 6.2). Following a festival of experimental music organized by the GRMC in Paris in June 1953, the *New York Times* music critic Peter Gradenwitz remarked, "The most exciting experience of the Paris week was the 'spatial projection of music' at the concluding concert" (Gradenwitz 1953, X5; see also Palombini 1993). According to Gradenwitz, "The music . . . came to one at varying intensity from various parts of the room, and this 'spatial projection' gave new sense to the rather abstract sequence of sound originally recorded" (X5). Schaeffer and Henry operated the pupitre d'espace for

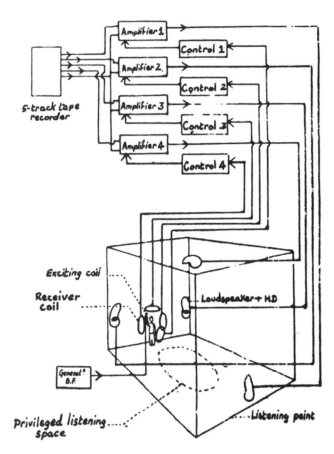

Figure 6.2
Diagram of the *pupitre d'espace* by Jacques Poullin (Poullin [1954] 1957). The operator held a transmitting coil while positioning himself between four receiving coils. Poullin wrote that the operator's movements "excite variable induced voltages at the terminals of the receiving coils, which, when suitably amplified and rectified, provide the anodic voltages for modulator stages inserted in each of the four amplification systems" (23).

most of the musical selections on this particular concert, while Vladimir Ussachevsky—who together with Otto Leuning would establish the Columbia-Princeton Electronic Music Center in 1958—used it to project his own composition, *Sonic Contours*. In the concert the pupitre d'espace was used to project not only music but also spoken texts based on the writings of François Rabelais, Yves Jamiaque and Franz Kafka. Spatial projection thus gave new sense to abstract musical sounds as well as to poetry and prose, bringing new meaning and form to passages like Rabelais' description of the Ringing Island in *Gargantua and Pantagruel*.

Along with developing experimental systems for the spatial projection of music and sound, the Western musical avant-garde cultivated a new poetics of space during the post-war decades. This poetics was firmly grounded within Cartesian and Euclidean models of space, concerned with the location of "sound objects" (*objets sonores*) in three-dimensional space and the movement of sounds along "sound routes" or "sonic trajectories" (*trajectoires sonores*). A text by Iannis Xenakis (1958), originally published as part of a volume on *Poème électronique*, reflected this approach. He described loudspeakers as "point sources" in three-dimensional space: "These sound points define space in the same way as geometric points in stereometry. Everything that could be said of Euclidean space could be transposed onto acoustic space" (Xenakis 1958, 230, my translation; see also Xenakis 2008, 130–134). In the same text he described "an acoustic line defined by points of sound" and "an orthogonal array of such acoustic lines defining an acoustic plane" (230). Xenakis's conception of acoustic space thus conformed to the geometrical conception of spatial music that Varèse had articulated in the 1930s, when he spoke of "sound-masses" undergoing "transmutations" on shifting "planes" and "moving at different speeds and at different angles" (Varèse [1936] 1966, 11). Indeed, Xenakis asserted that "the conquest of geometric space . . . appears to be achievable thanks to electro-acoustic techniques" (Xenakis 1958, 231).

The audiences of spatial music concerts were not necessarily imagined in active or productive terms, but more typically as "recipients" of music, in line with conventional models of concert listening. However, the focus on the movement of sounds in space as a compositional parameter drew attention to the fact that every listener has a unique experience of a composition depending on his or her position in the auditorium, and that a work cannot be fully appreciated outside of the particular, contingent situations of listening. This awareness inspired new compositional approaches that accounted for many individuals instead of a single "body" of listeners. The composer Henry Brant alluded to this idea in a 1954 article published in the *American Composers' Alliance Bulletin* in which he remarked, "Spatial music must be conceived in accordance with the premise that there is no one optimum position in the hall for each listener. . . . Spatial music must be written in such a way that the composer is able to accept whatever he hears as a listener, regardless of his position in the hall" (cited in Brant 1967, 224). In other words, the focus on the spatial distribution of sounds in the

concert hall or listening space made it necessary to account for the multiplicity of listening perspectives. This was an important step toward locating the value of a musical work not only within the abstracted medium of the score, but also in the actual, experiential dimensions of listening.[8]

6.3 "Take the sound of the room breathing": Fluxed Forms

The experimental thrust of the 1960s provided fertile ground for extended spatial imaginings within music, coinciding with the extension of music into intermedial forms that repositioned listeners as participants in and co-creators of music. John Cage's course on Experimental Composition at the New School for Social Research in 1958–1959 brought together such future Fluxus luminaries as George Brecht, Dick Higgins, Allan Kaprow, and Toshi Ichiyanagi, whose compositions typically embraced an anti-elitist, everyday aesthetic. Hannah Higgins writes, "The most durable innovation to emerge from [Cage's] classroom was George Brecht's Event score, a performance technique that has been used extensively by virtually every Fluxus artist" (Higgins 2002, 2). Event scores were brief, haiku-esque verbal scores that comprised lists of terms or open-ended instructions. They could be interpreted by anyone, realized using everyday objects, and often included audience participation in their scope:

Concerto for Audience by Audience
The audience is invited to come to the stage, take instruments that are provided to them, sit on the orchestra seats and play for 3 minutes. If the audience does not respond to the invitation, instruments should be distributed to them.
—Ben Vautier, 1965

Fluxus Instant Theater
Rescore Fluxus events for performance by the audience. A conductor may conduct the audience-performers.
—Ken Friedman, 1966[9]

In addition to breaking down composer-performer-audience hierarchies, Event scores brought external sounds into the rarefied spaces of the concert hall. The instructions for Richard Maxfield's *Mechanical Fluxconcert*, for example, indicated that "microphones are placed in the street, outside windows or hidden among audience, and sounds are amplified to the audience via public address system." The sounds of everyday environments thus leaked into the concert hall, while everyday actions with everyday objects replaced the specialized techniques and instruments as the tools for musical production.

Artists associated with Fluxus equally spearheaded the conceptual turn in art and music during the 1960s, ushering in extended concepts of space and spatiality. Yoko Ono's *TAPE*

PIECE II: Room Piece from 1963, for example, stands a universe apart from tape music of the 1950s. It reads:

TAPE PIECE II

Room Piece
Take the sound of the room breathing.

1) at dawn

2) in the morning

3) in the afternoon

4) in the evening

5) before dawn

Bottle the smell of the room of that particular hour as well.

Here Ono imagines a room as a living, "breathing" element: the subject and source of the music rather than merely its context or setting. She asks the performer to listen to the room, not in order to ascertain its acoustic properties, but to hear and capture its breath, and document its existence as it unfolds over the course of a day. *TAPE PIECE II: Room Piece* proposes that a room is not a static, absolute, or empty construction, but that it evolves and has a "voice" that also changes over time. The focus in this tape piece thus shifts from the evolution of sounds inside a space to the evolution of the space itself.

It was around this time that the composer La Monte Young conceived of *Dream House* (1962–ongoing) as having the potential to become a "living organism with a life and tradition of its own" (Young and Zazeela [1964] 2000, 13; see also Young 1969).[10] In its earliest incarnations the *Dream House* was a space in which musicians could play continuously for extended periods of time. Today it is manifested as "a time installation measured by a setting of continuous frequencies in sound and light" (Young and Zazeela 2016). This sound-and-light environment is made up in part of magenta-colored lights and hanging mobiles by Marian Zazeela, as well as a dense, synthesized drone comprising hundreds of sine waves, by Young. One visitor to the *Dream House* writes:

> Each sine wave vibrates in different parts of the room, so that the chord you hear changes as you move through the room. I like to sit on the floor in modified lotus position, tilting my head slowly back and forth, from side to side, to create my own melodies and sound textures. The visitor with an acute ear can actually "play" the room like an instrument: explore the sound close to the wall, close to the floor, in the corners, or just standing still. Or lie on the floor and allow the sound to float you to heaven, slide you into hell, or transport you wherever you want to go. (Farneth 1996)

Although the aural components of *Dream House* do not vary, every turn inside the room results in a dislocating shift in the listener's perception of sound and space, owing to the

action of the room upon an otherwise static sound. Again, the room is not an afterthought but a critical element of the composition, the source and place of the "life" of the work.

6.4 "All sound is sculpture": Sound in Conceptual Art

The influence of Fluxus upon emerging traditions of performance art and conceptual art is well known (Lippard 1973; Friedman 1998; Higgins 2002). Its footprints can also be found in the work of 1970s Bay Area artists who used sound to challenge the traditional dichotomies between performance and sculpture. From December 1979 to February 1980, the San Francisco Museum of Modern Art (SFMOMA) hosted one of the first major exhibitions in the United States in which works with sound were prominently featured. *Space, Time, Sound: Conceptual Art in the San Francisco Bay Area, the 1970s* brought together the work of twenty-one Bay Area artists, tying together a number of practices under the common banner of conceptualism: site-specific installation, sculpture, performance, and events. This was a daunting task considering that most of these works no longer existed by the time of the exhibition's unveiling. In her introduction to the exhibition catalog for *Space, Time, Sound*, the curator Suzanne Foley wrote that the SFMOMA "had decided to include works of a temporal and ephemeral nature, [considering them to be] worthy of recognition" (Foley 1981, 1). Paradoxically, many of the works that Foley felt warranted this disclaimer were conceived as "sculptures" although they closely resembled Fluxus performance. Some sculptures were particularly ephemeral, consisting of actions so incidental or brief that they would hardly warrant being framed as art under more conventional circumstances, much less as sculpture. In Tom Marioni's 1969 *One Second Sculpture*, for example, Marioni released a tightly wound piece of measuring tape into the air. The tape made a sound as it unfolded and landed on the ground in a straight line.

Other temporal sculptures lasted much longer, actions turned into ritual through their continuous repetition or extended duration. In *Action for a Tower Room* (1972), Marioni's frequent collaborator Terry Fox played the tamboura, an Indian drone instrument, for six hours a day on three consecutive days, "filling the space of a small, square, stone room at the top of a tower reached by winding stairs with a continuous, circular sound" (Fox 1972). Fox claimed that the "spatial sound" produced by his actions influenced the movement of a candle flame and made vibrations in still water. When Foley gathered such works for *Space, Time, Sound* her role shifted from curator to archivist, since most of these works could only be shown through their residual documentation. A common criticism leveled at the exhibition was that there was "no art there." A review in the *Oakland Tribune*, for example, took issue with "art which happens and then disappears. Except for its documentation" (Shore 1980, G32).

A key link between the Bay Area artists and Fluxus was the German artist Joseph Beuys, who participated in the proto-Fluxus concert *Neo-Dada in Der Musik* in Düsseldorf in 1962, and who subsequently abandoned more traditional forms of sculpture in favor of ritualistic performances, *Aktionen* (actions), many of which took shape as sound-based works. In a 1963 performance at the Galerie Parnass in Wuppertal, for example, Beuys "played the piano all over—not just the keys—with many pairs of old shoes until it disintegrated." He claimed that his intention was "to indicate a new beginning, an enlarged understanding of every traditional form of art" (Beuys 1990).

In 1967 Beuys co-founded the German Student Party, which was renamed Fluxus Zone West the following year. Like Cage in New York, Beuys attracted an international group of students and artists to Düsseldorf, where he taught sculpture at the Kunstakademie. Fox learned about Beuys through Fluxus publications and traveled to Düsseldorf in 1970 to meet him. According to David Ross, "much of Beuys's work, like Fox's, had to do with energy transfer through the artist's ritual interaction with materials. Fox learned from Beuys that the residue of a ritual action could retain the aura of the event" (Ross 1992, 10). Upon Fox's arrival in Düsseldorf the two artists collaborated on an impromptu work, *Isolation Unit* (1970) in a storage room at the Kunstakademie. As Fox tells it, they worked "simultaneously, although independently, but frequently came together, particularly in relation to sound" (Fox 1982, 30). Over the course of six hours, the two used acoustic energy to "connect" found objects:

> Beuys, clothed in a hat and felt suit, wandered around the room with a dead mouse in his hand. Later he spun the mouse on the spool of a tape recorder and used a silver spoon to eat a passion fruit, whose seeds he dropped with a bright, resounding tone into a silver bowl between his feet. Along with an electric light bulb, a candle, and a cross. . . . Fox had two metal pipes of different lengths, which he banged against the floor and against each other, producing bell-like, pulsing sounds. He also knocked the pipes against the four panes of a dismantled window unit, by observing the resulting resonances, he found acoustically dead spots in the glass. Then, one after the other, he smashed the panes. Now he could reach through the window, grasp the candle behind it, and place it in the middle of the room. He tried to influence an open candle flame with the sound waves from the pipes. (Osterwold 1998, 17)

Through his interactions with Beuys, Fox came to understand his actions as "plastic works that, extended in the temporal dimension, sculpturally form a situation and charge a space with energy and emotion in such a way that the visitors perceive its qualities as changed" (Osterwold 1998, 17). In Fox's performances, sounds were not considered musical but sculptural: tools with which to connect objects and transform spaces. Fox proposed that "all sound is sculpture," and stressed that his performances were geared toward discovering "the limitless sculptural possibilities of sound" (18–19).

6.5 "Sounds were placed in space rather than in time": Sound Installation Art

The disciplinary transgressions of Fluxus artists and conceptual artists working within expanded models of sculpture and performance were critical to the emergence of sound installation art, an interdisciplinary art form that developed at the intersection of music, sculpture, architecture and other disciplines from the late 1960s.

In 1967 the American percussionist Max Neuhaus installed a series of radio transistors along the side of a nondescript road in Buffalo, New York. People who drove on this road found themselves privy to a rich combination of sine tones that emanated from their car radios. The amplitude, frequency, and duration of these tones changed according to weather conditions, the time of day, and other environmental factors. In describing this work, *Drive-in Music*, Neuhaus coined the term "sound installation," distinguishing it from music by suggesting that in sound installations, sounds "were placed in space rather than in time" (des Jardins 1994, 130). Neuhaus's sound installations partly grew out of his experiences as a professional percussionist who specialized in contemporary music. He wrote:

> As a percussionist I had been directly involved in the gradual insertion of everyday sound into the concert hall, from [Luigi] Russolo through Varèse and finally to Cage who brought live street sounds directly into the hall. I saw these activities as a way of giving aesthetic credence to these sounds— something I was all for—but I began to question the effectiveness of the method. Most members of the audience seemed more impressed with the scandal than the sounds, and few were able to carry the experience over to a new perspective on the sounds of their daily lives. (Neuhaus 1988)

In attempting to change peoples' listening habits in a way that would extend into their everyday lives, Neuhaus carried out a series of participatory listening walks, *LISTEN*, between 1966 and 1976. When audiences arrived at a designated location (typically a concert hall) Neuhaus would stamp the word "LISTEN" on their hands and lead them outdoors to explore their everyday sonic environments through listening. He said that his interest in these walks was to "refocus attention on sounds that we live with every day. I felt that perhaps the way to do this was not to bring the sounds in but to take the people out" (Neuhaus and Loock 1990). Through these listening exercises Neuhaus hoped to alter listeners' relationships to their everyday environments permanently, by introducing them to a focused mode of listening that they could integrate into their daily lives. He characterized his mode of listening during these walks as being so "intense" that it transformed other listeners' own habits of hearing by virtue of proxy. He also imagined that this kind of focused listening would result in hearing "sound" rather than "noise" and, concomitantly, would transform a meaningless "space" into a meaningful "place."

Neuhaus's sound installations grew out of his everyday listening projects, which he extended into more permanent forms by installing sound works in everyday environments,

often as anonymous interventions in public spaces. In his best-known work, *Times Square* (1977–1992 and 2002–ongoing), synthesizers housed in a chamber beneath a subway grater on a traffic island in Manhattan's Times Square produce a continuously evolving, multifrequency drone. In the original manifestation of *Times Square*, there was nothing at the site to announce that there was an artwork there. Instead, Neuhaus hoped that listeners would accidentally discover it, and through that discovery, find a new point of connection to an otherwise impersonal space.

Neuhaus explained that his first sound installations were created for "a public at large; they were about taking myself out of the confined public of contemporary music and moving to a broader public" (Neuhaus 1990, 58–59). He said, "I had a deep belief that I could deal in a complex way with people in their everyday lives" (59). Neuhaus thus re-imagined the listening public as "anyone who happens to listen" rather than those who seek out—and gain access to—specialized listening experiences.

6.6 "Acoustic-Haptic Space": Sound Art for the Body

Since the late 1960s, sound installation artists have increasingly incorporated listeners into the scope of a work. Some have even created works in which the listening body becomes the site of a sound installation or sculpture. In Laurie Anderson's *The Handphone Table* (1978), for example, sound is conducted through a listener's elbows, transmitting a barely audible recording directly into the body (see Ouzounian 2006). Such works invite what Andra McCartney has described as a "full-bodied hearing" (McCartney 2004, 179). Other artists have created sound installations that position the body itself as a resonant space. The Austrian architect and sound artist Bernhard Leitner imagines that the "boundaries of sound spaces can [go] through the body" and that "space can extend into the body" (cited in Schulz 2002, 82; see also Leitner 1978). Leitner began investigations into what he called "body-space" and "sound-space" relationships in the late 1960s, conceiving of their merger as an "acoustic-haptic" space. He wrote, "In October 1968, I laid down the base for my Sound-Space-Work: Sound itself was to be understood as building material, as architectural, sculptural, form-producing material—like stone, plaster, wood. The invention of spaces with sound, formerly inconceivable as a readily available material, was the central artistic motive. Sound and its movement define space. A new type of acoustic-haptic space" (Leitner 1973).

In Leitner's 1975 *Ton-Liege (Deck Chair)*, a listener rests on a reclining chair fashioned with speakers that project sound to different points along the body (see figure 6.3). Helga de la Motte-Haber has remarked of this work that "space seems to be a movement that emanates from your own body, or flows through it" (de la Motte-Haber 1998). Leitner's 2003 CD *KOPFRAÜME/HEADSCAPES*, which is meant to be heard using headphones, presents

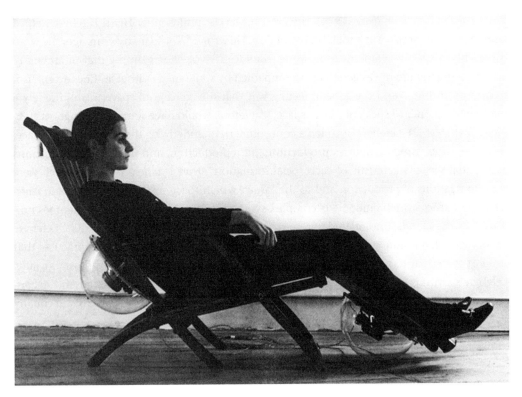

Figure 6.3
Photograph of Bernhard Leitner's *Ton-Liege (Deck Chair)* (1975). Reprinted with the permission of Bernhard Leitner. Copyright © 1975 by Atelier Leitner.

sound sculptures that seem to form inside the space of the listener's head, articulating precise points, lines, and geometries of sound in intracranial space as though it were an empty volume. For Leitner, "entirely new concepts of space open up through extended hearing, through bodily hearing" (Schulz 2002, 82). In the case of body-based sound installations, not only are new modes of listening imagined, but the location of the work also shifts to the individual listener, since these works cannot function or exist outside a listener's particular engagement with them.

Conceiving of the body as a site in which sounds can reside was an important step toward new models of composition that account for the listening body as a productive element of space, where space is understood not only as a physical quantity but also as something that is produced through the intersection of the body, space, and social action. Until the 1970s, the term "space" was used primarily to describe mathematical or geometrical space.

With *The Production of Space* (1974), the French Marxist philosopher Henri Lefebvre helped launch a notion of space as a social construction. He wrote, "Not so many years ago, the word 'space' had a strictly geometrical meaning: the idea it evoked was simply that of an empty area. In scholarly use it was generally accompanied by some such epithet as 'Euclidean,' 'isotropic,' or 'infinite,' and the general feeling was that the concept of space was ultimately a mathematical one. To speak of 'social space,' therefore, would have sounded strange" (Lefebvre [1974] 1991, 2). Lefebvre outlined a conceptual triad underlying the production of space: *spatial practice*, "which embraces production and reproduction, and the particular locations and spatial sets characteristic of each social formation"; *representations of space*, which were "tied to relations of production and to the 'order' which those relations impose"; and *representational space*, which embodied "complex symbolisms, sometimes coded, sometimes not, linked to the clandestine or underground side of social life, as also to art" (33). Lefebvre encouraged clandestine spatial practices like squatting and illegal immigration, practices that support the "right to space" of all people regardless of social status. Perhaps most crucially, Lefebvre's writing embraced the idea that spatial practices can be constructed and deconstructed, reflected and resisted through social action, and that artistic practices could equally operate within this model.

6.7 "Social sound sculptures"

Contemporary discourses on "spatial sound" continue to privilege Euclidean conceptions of space, and are focused upon the location and movement of sound within three-dimensional space. However, many sound artists have challenged this model, inviting audiences and participants to consider the Lefebvrian idea that space is socially produced and not an absolute or hegemonic quantity that exists outside of lived experience.

In developing critically oriented spatial sonic practices, sound artists have imagined new interactions with the public, creating works for specific audiences and communities who have particular relationships with, or interests in, the places in which these works reside. Such works are not only site-specific in terms of their physical or geographical location; they are also specific to the publics who engage with them, and are sometimes intended for a "localized public" or a specific group of people whose social composition is as central to the work as any other compositional element.

The Finnish artist Heidi Fast, for example, has created several sound installations that she calls "social sound sculptures" for various communities in Helsinki. In *A Nightsong Action* (2006) Fast invited the residents of apartment buildings surrounding Hesperia Park, a sprawling urban park in Helsinki, to join her in a "vocal course" through the park (see figure 6.4). Her hand-delivered letters of invitation asked residents to meet her at a specific time and

Figure 6.4
Heidi Fast and participants in *A Nightsong Action* (2006). Photograph by Anna Cadia. Copyright © 2006 by Heidi Fast. Courtesy of Heidi Fast.

place and walk with her through the park while making vocal sounds, in order to "diversify human voice in our common, public urban space":

> I will walk along Hesperia Park and sing a long and even tone. Answer me with your own voice, from your window or balcony (or your neighbor's) when you hear my voice, or come down to the street and sing with me! Sing with your voice until you no longer hear the others, or continue for as long as you wish. The point of *A Nightsong Action* is not to strive for the clarity or beauty of the voice. You can (and should, if you wish) join it with very hoarse or clear singing, with whispers or shouts that "become" from your throat. (Fast 2006)

Approximately a dozen people participated in the walk, while others joined in with vocalizations from their apartment windows, or simply watched. For Fast, this work did not have any "special meaning or function . . . it was an *un-function* in a way" (Fast 2008). She recalls that participants were at times self-conscious in that the action "did not involve singing collective songs, but just making [meaningless sounds]." The work's un-functionality was part of its critical orientation in that it offered a radical view of how collective song might emerge

within a public forum. The sounds of *A Nightsong Action* were not the patriotic songs that are typically heard in public gatherings, songs that serve to further a dominant conception of national identity. Instead, they were nonlinguistic sounds that were not necessarily coherent and that could not be reduced to a single model of collective identity.

In another project from 2006, *Song of the Dwellings*, Fast invited the residents of an apartment building in Helsinki to vocalize with her while walking up and down the building's central staircase (see figure 6.5). Around thirty people participated, including residents who opened the doors to their apartments during the event. In a way that recalls Neuhaus's *LISTEN* series, *Song of the Dwellings* invited audiences to form new relationships to familiar places through listening. Fast's work extends Neuhaus's proposition by asking participants not only to listen to their everyday environments, but also to create sounds in and through them, an act that draws attention to the "voices" of the places the participants inhabit, and to their own roles in constructing these voices (and by extension, places). Fast considers her work to be "political," although in a way that entails only "small displacements." The use of sound is critical in this context. She says:

> The voice—or sound in general—is not divisible into parts that can be controlled or quantified. Sound is not easily delimited. This is political, even though it may not be visible. My essential goal is to establish small islets that deal with multiplying the power in us, or in a nonhuman world. That is, to resist the violent praxis in society through intensities other than strong or powerful resistances: to ruffle and round the edges between interior and exterior, to open up the in-between. (Fast 2007)

The Anishinaabe artist Rebecca Belmore has similarly deployed the voice in powerful ways in articulating a critical spatial practice. Much of Belmore's work, including *Ayum-ee-aawach Oomama-mowan: Speaking to their Mother* (1991, 1992, 1996) holds particular weight for the Indigenous communities for whom it was created. Belmore originally created *Ayum-ee-aawach Oomama-mowan* in response to the Oka Crisis, a widely-publicized land dispute between the Canadian government and the Mohawk community at the Kanesatake settlement near Oka, Quebec, in 1990. The standoff, which lasted through the summer of 1990, was triggered by the town of Oka bidding to develop a golf course over Indigenous burial and sacred grounds, and the rejection of a land claim filed by the Mohawk community. Belmore's installation consisted of a giant megaphone that was designed to carry the voices of Indigenous Canadian speakers directly to the land. She said, "Protest often falls upon deaf government ears, but the land has listened to the sound of our voices for thousands of years" (Belmore, cited in Lippard 1997, 15). Belmore has described the genesis of the work thus: "During the summer of 1990, many protests were mounted in support of the Mohawk Nation of Kanesatake in their struggle to maintain their territory. This object was taken into many First Nations communities—reservations, rural, and urban. I was particularly interested in locating the

Figure 6.5
Heidi Fast during a performance of *Song of the Dwellings* (2006). Photograph by Pekka Mäkinen. Copyright © 2006 by Heidi Fast. Courtesy of Heidi Fast.

Aboriginal voice on the land. Asking people to address the land directly was an attempt to hear political protest as poetic action" (Belmore 1996).

Belmore's project to "locate the Aboriginal voice on the land" is striking in that it creates room for marginalized voices to emerge within a contested political sphere, and redraws the tensions figured in the conflict itself by inviting those voices to engage directly with the land. The intended audience for this project is not the typical one for a political protest (the government) or even the communities who are invited to interact with it. It is the land itself, which, through the mere act of being spoken to, is reconstituted as a living entity, and not an object that can be owned or occupied.

In one manifestation Belmore installed *Ayum-ee-aawach Oomama-mowan* in a meadow in the Rocky Mountains, as part of the 1991 exhibition *Between Views* presented by the Walter Phillips Gallery (see figure 6.6). Lucy R. Lippard wrote of this installation: "For an exhibition about nature and tourism, Belmore organized an eclectic gathering of Native

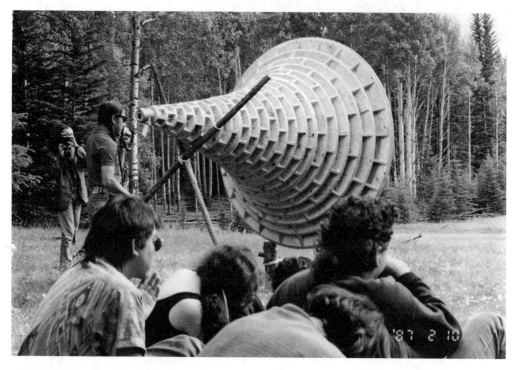

Figure 6.6
Photograph of *Ayum-ee-aawach Oomamaa-mowan: Speaking to Their Mother* (1991) by Rebecca Belmore. Photograph by Pauline Martin. Courtesy of the Paul D. Fleck Library & Archives at the Banff Centre for Arts and Creativity. From the Pauline Martin fonds (2010–15.09).

Canadians—leaders, writers, poets, social workers and activists—who spoke to their mother earth from an alpine meadow in the Rockies. The huge megaphone symbolized public address, carrying amplified Native voices far and wide. Self-determination and land rights were primary themes, but they were couched in the empowering language of celebration" (Lippard 1997, 15). According to Lippard, "Mowhawk Elizabeth (Toby) Burning said through the megaphone: 'You are our reason for continuing our resistance against development, and standing up for our language and for our past, because we are you'" (15).

Ayum-ee-aawach Oomama-mowan: Speaking to Their Mother draws attention to the uneven modes of political exchange that determine who speaks, who listens, and where. It shows that the place of political exchange is integral to that exchange: that the positions of political actors cannot be divorced from the place(s) from which they speak. Jolene Rickard, who included *Ayum-ee-aawach Oomama-mowan* in an exhibition she curated at the Smithsonian's National Museum of the American Indian in Washington, D.C., wrote that she found it to be "one of the most significant expressions of sovereignty beyond political boundaries" (Rickard 2005, 2). I would suggest that the very scope of political boundaries is redrawn in Belmore's installation: not only is the place of politics multiplied and diversified—and the boundaries between the powerful and the marginalized complicated—but the dimensions of political communication also are no longer limited to the sense of language. Here, the sound and the place of political speech are as important as its meaning, as is the unique ability of sound to bypass dominant modes of political containment and confinement.

Charlotte Townsend-Gault describes Belmore's work as blurring the distinction between "an aesthetics and ethics." She writes:

> Native artists in Canada over the past two or three decades have been expected to be embodiments of tradition, seers, perfect spiritual beings, and all-purpose spokespersons for the moral high-ground. This proved an untenable guide for reading native art and the hermeneutics has moved on. Yet it is exactly the precariousness of their position, caused by the tangle of aestheticised politics and desire, which certain artists of native ancestry like Belmore . . . contrive to make compelling. . . . [It] becomes evident that for her there is no sharp divide between aesthetics and ethics. (Townsend-Gault 2002)

The spatial practice embodied in Belmore's work is at once poetic and political, aesthetic and ethical, drawing upon marginalized social histories and voices in creating alternative expressions of place and public space.

6.8 From a Poetics to a Politics of Space

Sound artists have profoundly reconceptualized the meaning of "spatial sound" and its ability to reflect multiple dimensions of social and political life. In the 1950s, spatial music projects were predominantly concerned with articulating sonic geometries within three-dimensional

space: routing sound objects along Cartesian grids at different speeds and angles; articulating "masses" and "planes" of sound within Euclidean space. Since that time, myriad influences—ranging from experimental music and conceptual art traditions to expanded forms of sculpture and architecture—have contributed to the emergence of a critical sonic-spatial practice concerned not only with the sonic "composition" of acoustic space, but also with the confluence of acoustic, political, social, sensorial, and lived spaces. As sound art traditions move from articulating poetic to political concerns, theoretical discourses must also reflect these shifts. Rather than investigate the location of sounds in three-dimensional space, we might ask: how are spaces socially and politically constructed? How do sound works reflect and resist these constructions? What is the role of the public in shaping these forms? In developing such critical perspectives, the sonic-spatial imagination can be reoriented from absolute to experiential realms, from universal to particular ones, with social identities and political histories newly implicated in creating alternative spatial expressions and relationships to place through sound.

7 Mapping the Acoustic City: Noise Mapping and Sound Mapping

7.1 "A portrait of your city"

In *Book of Noise* (1970), one of his first treatises on soundscape, R. Murray Schafer wrote of a decibel table, "This is a portrait of your city. Listen to it closely" (Schafer 1970, 1). This "portrait" showed a city subjected to the increasingly loud sounds of cars, trucks, kitchen appliances, drills, amplified rock music, and jet planes (see figure 7.1). Schafer wondered whether these sounds had begun to resemble a form of sonic weaponry. "For the first time in history," he remarked, "man is less safe in the heart of his city than outside the city gates" (13).

Starting in the early 1970s Schafer and members of his research group, the World Soundscape Project (WSP), set out to document and analyze the soundscapes of cities and towns in North America and Europe in order to track the effects of noise pollution on them. In the course of these studies they created numerous maps depicting soundscapes, producing what Peter Tschirhart has described as one of "the most significant collection of sound maps anywhere in published literature" (Tschirhart 2013, 97). Some maps took the form of what today is called a "noise map": a topographical contour map that depicts the average noise levels of an environment. Schafer called these "isobel maps," a hybrid of "isolines" (lines of equal value) and "decibel" (a unit of measurement whose symbol is dB, typically a sound level measurement on a logarithmic scale). The WSP's "Isobel Map of Stanley Park" (1973) depicted concentric zones of loudness in a Vancouver park, from a hushed 40 decibels in the park's deep interior to a substantially louder 70 decibels near its roadways and bridges (see figure 7.2). This noise mapping was done systematically: researchers took dozens of direct measurements of sound levels using handheld noise meters, taking readings while walking along the park's footpaths. They took three readings every ten seconds, repeated this process every hundred yards, and averaged the values in order to determine the isobel contours. They noted the weather conditions and the time of day—variables known to affect the propagation of sound as well as the perception of loudness—and returned to the same site multiple times over a period of several months in order to produce a reliable noise map of the park.

Threshold of hearing	0 dB
Rustling of leaves	20 dB
Quiet whisper (3 feet)	30 dB
Quiet home	40 dB
Normal Conversation	60 dB
Average car (15 feet)	70 dB
Loud singing (3 feet)	75 dB
Average truck (15 feet)	80 dB
Subway (inside)	94 dB
Kitchen gadgetry	100 dB
Power Mower	107 dB
Pneumatic riveter	115 dB
Amplified Rock and Roll (6 feet)	120 dB
Jet plane (100 feet)	130 dB

Figure 7.1
R. Murray Schafer's "portrait of your city" in *Book of Noise* (Schafer 1970, 2). Copyright © 1970 by R. Murray Schafer. Courtesy of Arcana Editions.

Other maps focused on qualitative (versus quantitative) features of a sonic environment and were created in less systematic and more improvisatory ways. As part of their study *Five Village Soundscapes* (Schafer 1977b), researchers produced a pictorial map depicting the sounds they heard while standing on a hilltop near the German town of Bissingen during a half-hour period on a winter morning in 1975 (see figure 7.3). This map had symbols for distinguishing between continuous sounds ("birds") and intermittent ones ("bangs"), and it used arrows to indicate the direction of moving sounds. A notation of this kind gave an instantaneous impression of the soundscape just as a photograph might do for a landscape, as Schafer hoped when he called for a new notation for soundscapes (Schafer 1973a, 28); and it could be understood by anyone regardless of prior training or expertise. Such a map also went some way toward addressing the problem of using a static medium (drawing) to represent a dynamic phenomenon (sound).

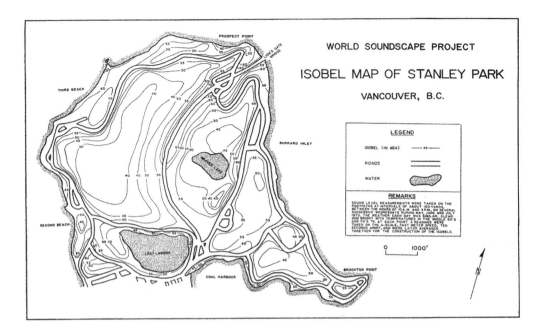

Figure 7.2

"Isobel Map of Stanley Park" (1973) by the World Soundscape Project (Schafer 1973a, 51). Copyright ©
1973 by R. Murray Schafer. Courtesy of Arcana Editions.

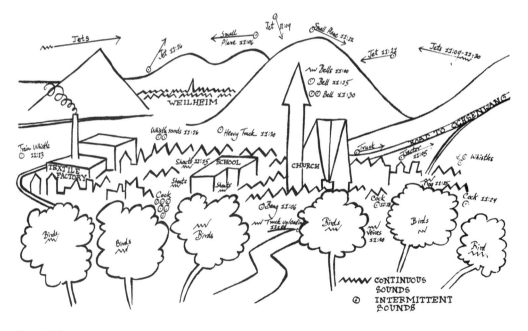

Figure 7.3

"Prominent sounds heard between 11:00 a.m. and 11:30 a.m., March 6, 1975, from a hillside about 500
meters beyond the village of Bissingen" (1975) by the World Soundscape Project (Schafer 1977b). Copy-
right © 1977 by R. Murray Schafer. Courtesy of Arcana Editions.

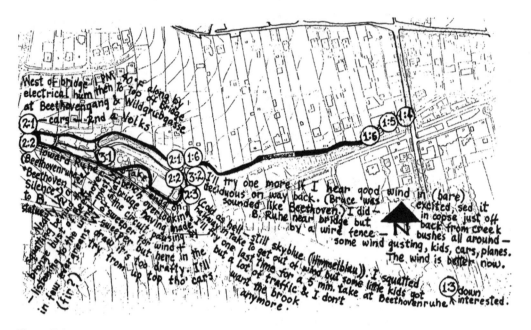

Figure 7.4
"Observations from the recordist's field notes, taken on a recording tour of Beethoven's traditional walking path in the Vienna suburb of Nussdorf" (1975) (Schafer 1977a, 38). Copyright © 1977 by R. Murray Schafer. Courtesy of Arcana Editions.

Other WSP sound maps were even more subjectively oriented. Some followed the contours of an individual researcher's own auditory impressions over the course of an exploratory listening walk. One such map, from *European Sound Diary* (Schafer 1977a), gathered the impressions of a researcher who walked along the same path once used by Beethoven in a Vienna suburb (see figure 7.4). It resembled something between a psychogeographical exercise and an ethnographer's field notes. Some maps also acted as scores, giving instructions for "soundwalking," a kind of guided listening tour (Westerkamp 1974; Schafer [1977] 1994). "A Stuttgart Soundwalk" (1977) classified sounds according to such categories as "human," "ambient," and "electroacoustic" in orienting soundwalkers. This map even guided their auditory imagination: "Put these . . . sounds back together in your mind's ear. Do you like the mix? Are you on a ship?" (Schafer 1977a, 99).

Since the time of the WSP's experiments, *noise mapping* and *sound mapping*—terms I use here to distinguish between quantitative and qualitative maps of sonic environments—have proliferated on a global scale. Conor McCafferty (2019) has documented over one hundred web-based sound maps created since the early 2000s as part of a project that explores their

potential use in urban planning. Noise maps are much more common, propelled by anti-noise legislation. Today, thousands of noise maps are issued by municipal and federal authorities in cities around the world in an effort to monitor and mitigate urban noise.

Departing from the premise that a map can both describe and shape an environment (Cosgrove 1999), this chapter explores the history of noise mapping, showing how these sonic notations evolved in connection to specific forms of noise legislation. Having elsewhere explored the recent history of sound mapping (Ouzounian 2014), my discussion here will focus on the noise mapping of cities, sonic environments that have particularly come into focus—were visualized and made increasingly legible—through mapping. Noise mapping is one of the primary mechanisms through which city authorities monitor and regulate the sonic environments of cities. It is therefore important to consider not only in relation to how noise maps *depict* sonic environments—and thus influence how sound is understood when it is imagined in relation to space and place—but equally because of the material effects that noise mapping has had upon these environments and the communities who inhabit them.

7.2 New Notations for Noise

Descriptions of urban noise circulated long before the advent of noise mapping. The first records of urban noise came from ancient cities. In *Epigrams* (ca. 86–103 AD), for example, the poet Martial famously decried the babble of ancient Rome, writing that there was "no place in town . . . where a poor man can either think or rest. One cannot live for schoolmasters in the morning, corn grinders at night, and braziers' hammers all day and night" (Martial [86–103 AD] 1865, XI.LVII, 570). The sources of ancient noise were multitudinous and, for the common Roman, inescapable: "Here the money-changer indolently rattles piles of Nero's rough coins on his dirty counter; there a beater of Spanish gold belabors his worn stone with shining mallet. Nor does the fanatic rabble of Bellona cease from its clamor, nor the gabbling sailor with his piece of wreck hung over his shoulder" (570).

Martial's epigram was written literally and metaphorically "from below." While his compatriot Sparsus could escape to a mansion "overlooking lofty hills," Martial was condemned to living at sea level, among the clamorous crowds. "All Rome," he lamented, "is at my bedside" (570).

As we know from recent studies, noise complaints have equally come "from above," penned by powerful members of elite classes who have disparaged the noisiness of their lower-class neighbors, foreigners, tourists, and other groups they deemed unsavory (Schwartz 2011; Bijsterveld 2013; Radovac 2014; Mansell 2016, 2017). The nineteenth-century mathematician Charles Babbage famously railed against the perils of street music in Victorian London, denouncing "the tyranny of the lowest mob" and its love of "discordant noises"

(Babbage 1864, 345). He systematically tracked street noises, at one point registering no fewer than 165 instances of noise in a period of around eighty days. He ordered these noises into lists, creating taxonomies of offending sounds. Under "Instruments of Torture" he listed organs, brass bands, fiddles, flageolets, hurdy-gurdies, bagpipes, half-penny whistles, tom-toms, and trumpets: all instruments associated chiefly with music of the lower classes (338). Under "Encouragers of Street Music" he pointed the finger at tavern-keepers, servants, country folk, and "ladies of doubtful virtue" (338). By monitoring and cataloguing noises Babbage tried to build a rational case against a seemingly irrational problem. His methods anticipated the approach that many municipalities would adopt by the end of the nineteenth century: an evidence-based, quantitative approach to measuring, monitoring, and categorizing city noises—and, by extension, quantifying and rationalizing the acoustic city.

By the late nineteenth century there were many more records of noise produced by municipal authorities themselves, created in response to what was increasingly viewed as a public health concern. Between 1890 and 1920 the Medical Officers of Health in London, for example, filed nearly one hundred reports on noise in relation to various London districts.[1] Some reports were detailed enough to serve, in effect, as verbal noise maps. They described in detail the noises that could be heard in specific locations at specific times of the day or week, and even their origin and direction. A 1902 report by the Medical Officer of Health of Wembley described "street calls and shouting, whether during the day or at the closing of the public houses, loud, vulgar, insane choruses by half drunken men in vans and brakes, especially on Sunday nights along the main road, the majority coming from the direction of Harrow and the regions beyond, vulgar horse play by lads at or near the station at night, perpetual barking of dogs often all night, especially in Ranelagh Road" (Rawes 2019). The Officer of Health suggested that county council bylaws be more rigidly enforced in order to combat the growing problem of noise, and he gave specific recommendations as to how various offenses might be punished. As officially sanctioned descriptions of urban sonic environments, such reports gave weight to the idea that noise was something that should be monitored, regulated—and even policed—by municipal authorities, and that the city was increasingly becoming a place of unwanted sounds.

By the early twentieth century citizen activists in many parts of the world joined the fight against city noise; in the process, they invented new notations for noise. In the United States the most influential anti-noise crusader of this period was Julia Barnett Rice, a wealthy Manhattanite who in 1905 founded the Society for the Suppression of Unnecessary Noise, which she ran out of her mansion on Riverside Drive at 89th Street (see Thompson 2002; Schwartz 2011). Rice was inspired to take action against noise after being kept awake by the "shrieking sirens" of tugboat whistles that travelled up and down the Hudson River at night (Logan 1912). In her bid to eliminate these sounds—what Hillel Schwartz has called "horn

swarms"—Rice commissioned students from Columbia Law School to produce records of the whistle-blasts (Schwartz, cited in Smith 2013). The *New York Times* published an excerpt of one of these records, calling it a "tootometer." It showed that, in the span of one hour, from 2:00 a.m. to 3:00 a.m. on December 1, 1905, more than three hundred whistle-blasts of varying duration could be heard in a single location in the Upper West Side (see figure 7.5).

The tootometer was an early graphic notation for noise. It showed the number of whistle-blasts per minute and their relative duration, registered over a specific period of time. Although it did not represent this information spatially, it made visible the invisible problem of rivercraft noise. The sheer quantity of the whistle-blasts could be grasped immediately by anyone who saw the graphic. As such, the tootometer helped move Rice's anti-noise agenda into public consciousness and into the sights of lawmakers. Prior to its publication, Rice's efforts to lobby lawmakers had all been thwarted. A mere few weeks afterward, however, the *New York Times* reported that a solicitor for the Port of New York had begun to punish captains who pulled "too strenuously" at their whistle cords ("Revenue Cutters May Chase the Tooters" 1905, 6). Armed with unassailable data, Rice continued to lobby state and federal authorities, gaining the support of Congressman William S. Bennet, who passed the Bennet Act through Congress in 1907. The first anti-noise ordinance in the United States, the Bennet Act gave authority to the Board of Supervising Inspectors to "punish unnecessary whistling."

7.3 Decibel Charts and Tables

Rice's tootometer belonged to an exponentially growing class of data on urban noise produced during the first decades of the twentieth century. This information was both quantitative and qualitative, gathered through such methods as noise surveys, questionnaires, and noise complaints. This surge in data was propelled by the growing hysteria around noise (McKenzie 1916). It was equally facilitated by scientific and technological developments, chiefly the invention of the audiometer and acoustimeter—instruments that enabled increasingly precise measurements of sound levels—and the adoption of the decibel. The decibel was originally developed at BTL in the mid-1920s in order to measure the transmission of energy in telephone lines, and it emerged as a new standard measure for acoustic energy by the late 1920s (see Thompson 2002, 158–164; Bijsterveld 2008, 104–110).

The adoption of the decibel meant that information on noise could be captured and represented in new ways. Scientists and citizen activists alike began to produce decibel tables that listed everyday sounds along with their average loudness levels as expressed on the logarithmic decibel scale. A representative example from this period was the American acoustician E. E. Free's "Approximate Noise Intensities" from 1933 (Free 1933, 369). At the bottom of the table was "zero decibel," a figure that represented the threshold of audibility. At the

Figure 7.5
Julia Barnett Rice's tootometer (1905) ("Woman Starts a War" 1905, 8).

top were "painful sounds," listed at 130 decibels and above. Between these two points, different sources of noise were listed in order of increasing intensity. They ranged from a single person's heartbeat in a soundproof room (10–15 decibels) to whispering (25–30 decibels) to a dog barking (70 decibels) to airplane engines and propellers (110–125 decibels).

Decibel tables both popularized and made more comprehensible the new unit of measure developed by engineers, which, while elegant, could nevertheless be perplexing in its scientific formulation. Take, for example, this description of the decibel by Rogers H. Galt of BTL:

> The difference in level, in decibels, of two sounds is by definition equal to ten times the common logarithm of the ratio of the two intensities, that is, the power ratio. When the sensation level of a noise is expressed as a certain number of decibels, the noise intensity is that many decibels greater than the threshold intensity of a noise of the same type, observed in a quiet place. When the deafening due to a noise is expressed as a certain number of decibels the meaning is that the intensity of the test tone which is just audible in the presence of the noise is greater, by the given number of decibels, than the intensity which is just audible in a quiet place. (Galt 1930, 36)

Galt, who worked closely with Harvey Fletcher at BTL, produced some of the most comprehensive decibel tables pertaining to city noise from this period. While most decibel tables assigned values to a relatively small number of sources, Galt's "Noise Due to Specific Sources" (1930) contained five data points in relation to fifty different noises that could be heard in New York City (see figure 7.6). It listed the minimum, average, and maximum levels of noises; the distance between the source of noise and the microphone during observations; and the number of observations that were taken. The noises themselves ranged from the innocuous (church bells) to the exotic (snarling tigers, as heard in a Bronx zoo). They also showed a city undergoing a technological revolution; airplanes and radio loudspeakers were heard alongside trotting horses, police whistles, and the sounds of sawing wood.

Galt's table was commissioned as part of the report *City Noise*, which disseminated the findings of the Noise Abatement Commission of New York's 1929–1930 noise survey of New York City (see Thompson 2002, 157–167). It conveyed the results of a vast survey in a way that could be easily digested by city officials, the scientific community, and the general public. Compare the legibility and the amount of information conveyed by Galt's table, for example, with Free's noise survey of New York City, the results of which were published in *The Forum* only four years earlier (Free 1926). Described by Free as "the first attempt . . . to obtain really accurate information about just how noisy a modern city is" (Free [1928] 1930, 277), Free's report relied on mental acrobatics to convey information about city noise:

> Instances [of particularly noisy streets] from New York City are the corner of Thirty-fourth Street and Sixth Avenue, and the corner of Forty-second Street and Fifth Avenue. With a few exceptions, where conditions are greatly abnormal, the first-named of these corners is the noisiest place we have found in New York. Its noise intensity is fifty-five sensation units above quiet, which means that when

SOURCE OR DESCRIPTION OF NOISE	NOISE LEVEL			DISTANCE SOURCE TO MICROPHONE	NUMBER OF OBSERVATIONS
	MINIMUM DB.	AVERAGE DB.	MAXIMUM DB.		
HAMMERING ON STEEL PLATE, 4 BLOWS PER SECOND —		113		2 FT	1
RIVETER: AS HEARD NEARBY —	94	97	101	35	16
AS HEARD ORDINARILY ON STREET —		79.5		200	3 ✳
BLAST OF EXPLOSIVES OPEN CUT DIGGING —		98		50	1
SUBWAY STATION UNDERGROUND: NOISE ON PLATFORM: LOCAL STATION: EXPRESS TRAIN PASSING —	88	84	97	15-25	5
LOCAL STATION: LOCAL TRAIN	85	88.5	91	6-30	3
5 TURNSTILES: RUSH HOUR	78	84	91	3-7	19
STEAMSHIP WHISTLE {TESTS NEARBY —	92	93	94	115	4
WHISTLE RATHER { TESTS IN 10 FLOOR OFFICE: WINDOWS OPEN	59	61	65	1450	4
LOUD { AS HEARD ORDINARILY ON STREET	47	56	68	2500	14
AUTOMOBILE HORN: 34 TYPES, DIRECTED TOWARD MICROPHONE —	72	91	102	23	34
AS HEARD ORDINARILY ON STREET	57	71.5	85	25-100	80 ✳
ELEVATED ELECTRIC TRAIN, ON OPEN STRUCTURE: AS HEARD NEARBY —	85	89	91	15-20	7
AS HEARD ORDINARILY ON STREET	70	81.5	91	15-75	54 ✳
AS HEARD AT 750 FT	51	57.5	63	750	27
CONSTRUCTION AND EXCAVATION: PILE DRIVER, STEAM OPERATED —	84.5	87	90	20-80	18
TWO STEAM SHOVELS, WITH ROCK DRILL	81	82.5	86	50	10
HAMMERING, BUILDING		76.5		100	3
IN BRONX ZOO HOUSE: LION ROARING —	87	87	87	18	3
SIBERIAN TIGER ROARING	70	79.5	87	7	15
BENGAL TIGER SNARLING	67	75.5	80	15	11
FIRE APPARATUS {SIREN AND BELL —		83		100	1
{BELL: FIRE CHIEF'S CAR		81		50	1
POLICE WHISTLE: AS HEARD NEARBY —	80	82	83	15	4
AS HEARD ORDINARILY ON STREET	84	74	83	15-75	53 ✳
AS HEARD AT 185 FT	55.5	57.5	62	185	6
RADIO LOUD SPEAKER ON STREET —	73	79	81	30	10
MOTOR TRUCK: EXHAUST NOT MUFFLED —	70	77.5	87	15-50	15
CHANGING GEARS	68	74	83	15-50	7
AS HEARD ORDINARILY ON STREET	55.5	73.5	87	15-50	203 ✳
SUBWAY NOISE ON STREET THROUGH GRATING: AS HEARD 5½ FT ABOVE GRATING —	74	77	79	5½	6
AS HEARD ORDINARILY ON STREET	60	69	79	5½-50	17 ✳
ELECTRIC STREET CAR: MOVING FAST —	73.5	76.5	77.5	10-15	10
OVER TRACK CROSSING	68	74	81	40	26
AS HEARD ORDINARILY ON STREET	63	72.5	83	15-50	129 ✳
MOVING SLOWLY	68.5	69.5	70.5	10-15	8
SNOW SCRAPING AND SHOVELLING —		75		15	1
HORSE-DRAWN VEHICLE: AS HEARD ORDINARILY ON STREET —	63	74.5	83	15-50	23 ✳
ON ASPHALT STREET	47	61	72	15-50	100
MOTOR BUS CHANGING GEARS —	68	71	75	15-50	10
AUTOMOBILE: SQUEAKING BRAKES —	62	71	76	15-50	10
CHANGING GEARS	60	70.5	83	15-50	10
EXHAUST	64	70	74	15-50	10
AS HEARD ORDINARILY ON STREET (NOT INCLUDING HORN)	50	65.5	83	15-50	162 ✳
THUNDER —	60	64	70	1-3 MI.	9
DOG BARKING, ON STREET —	49	63	76	20 FT	12
THREE AIRPLANES, IN FLIGHT OVER CITY —		82		3000	2
HORSE TROTTING ON ASPHALT STREET —	52	61	65	15	8
SAWING WOOD —		81		30	1
CHURCH BELLS —	52	57.5	61	1200	5

Figure 7.6
Rogers H. Galt, "Noise Due to Specific Sources" (1930) (Brown et al. 1930, 140; see also Galt 1930, 43).

you talk to a person at Sixth Avenue and Thirty-fourth Street, you must shout as loudly as you do to a person who is more than half deaf. (Free 1926, cited in "Noisiest Spot Here 6th Av. at 34th St." 1926, 7)

The decibel effectuated a common language for noise. It eliminated the need to describe loudness in terms of relative measures of sensation units, levels of deafness, and acts of shouting. Used in the context of decibel tables depicting urban soundscapes, the decibel also helped further the idea of the city as a manufacturer of noise and as something that could be meaningfully described in relation to noise levels.

Some decibel tables and charts from this period linked noise levels to specific urban features. In one chart, Galt plotted 32 successive noise-level readings taken on a residential street in New York City one afternoon (see figure 7.7). It showed that the average noise levels of the street ebbed and flowed in unison with the flows of road traffic. While such a finding may seem self-evident in retrospect, it nevertheless served as proof of the growing impact of road traffic, which would soon be identified as the city's most prominent and persistent source of noise. (As a point of comparison, Free's 1926 noise survey had found that horse-drawn carriages were louder than automobiles.)

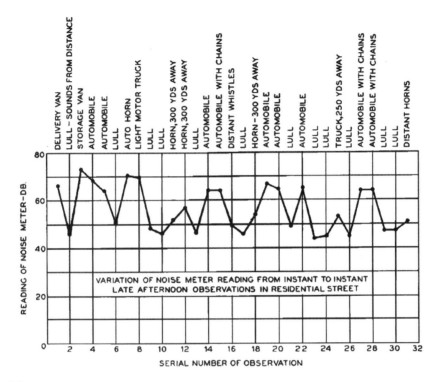

Figure 7.7
Rogers H. Galt, "Variation of Noise Meter Reading from Instant to Instant; Late Afternoon Observations in Residential Street" (1930) (Brown et al. 1930, 127; see also Galt 1930, 37).

Decibel charts also enabled the comparison of noise levels in different parts of the city. Another of Galt's charts depicted the average daytime noise levels of Manhattan streets with widely differing noise conditions by plotting noise measurements made at 100 locations (see figure 7.8). It showed that the campus of New York University had the lowest average noise levels in the city, at 47 decibels, while a subway excavation site near the Grand Concourse had the highest, at 80 decibels (Galt 1930, 48).

By visualizing the distribution of noise levels in the city, such tables and charts could be used by city officials in formulating plans for acoustic zoning, developing local anti-noise ordinances, or targeting noise abatement measures to specific locations, types of location, or types of noise. As such, these sonic notations or "sonographies" made the acoustic city increasingly intelligible to municipal authorities and, by extension, increasingly subject to government regulation. They also gave an impression of the acoustic city as something that could, and should, be described in quantitative terms.

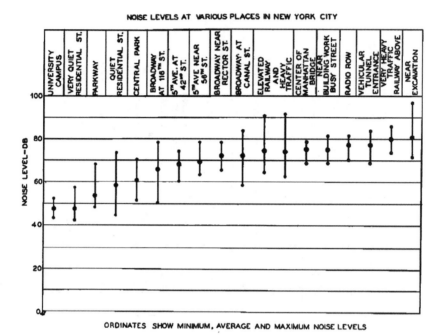

Figure 7.8
Rogers H. Galt, "Noise Levels at Various Places in New York City" (1930) (Brown et al. 1930, 129; see also Galt 1930, 50).

7.4 Early Noise Maps

In his second report on city noise in Manhattan, published in *The Forum* in 1928 and reprinted in full in *City Noise*, Free wrote, "The blanket of noise that covers a modern city has been weighed and measured. A noise map of virtually any city may now be drawn" (Free [1928] 1930, 277). He remarked, further, that the noise map of New York City was "approximately identical with a map of traffic on the streets" (277). The *City Noise* report featured only one map, which also depicted traffic noise. This map did not show loudness levels, as is common in noise maps today; instead, it showed the *locations* of particularly loud traffic noise, as reported by more than eleven thousand respondents to a questionnaire distributed by the Noise Abatement Commission of New York. The questionnaire listed common sources of noise and asked respondents to indicate the locations of the noises they found "most annoying" and the time of day at which they noticed them most often (Brown et al. 1930, 25). The map, which plotted the results of the questionnaire, visualized traffic noise in the city, showing a widespread distribution along most of the city's avenues and certain streets, and

Figure 7.9
"Traffic noise as revealed in the November questionnaire," Noise Abatement Commission of New York
(1930) (Brown et al. 1930, 30).

clusters at specific intersections (see figure 7.9). It corroborated Free's findings from 1926, showing an unmistakable cluster of traffic noise at 34th Street and Sixth Avenue.

Other noise maps from this period were similarly focused on depicting road traffic noise. The *New York Times* reported in 1934 that "the noisiest places in London, judged by motor traffic sounds, have been charted and placed on a map recently issued by the [British] Anti-Noise League" ("London Noises Mapped" 1934, 18). The acoustician F. J. Meister summarized contemporaneous developments in Germany:

> A fruitful development in the field of traffic noise started in Germany with Barkhausen's work [on sound level meters] during 1926 and 1927 and with that of the Heinrich Hertz Institute in Berlin in about 1929. This work led, in 1932, to the measurements of traffic noises reported by Bakos and

Kagan. In 1938 Lübcke reported the progress of these developments, particularly with regard to measuring techniques. . . . As early as 1938 Koesters and his associates had made the first sound level chart of Charlottenburg. (Meister 1957, 81)[2]

The "sound level chart" (or sound level map) of Charlottenberg was one of the first visualizations of noise levels, rather than sources of noise, in a city. "*Lautstärken-Karte eines Berliner Stadtbezirkes*" (Kösters, Bierreth, and Kemper 1938) was not a topographical map, and it did not use isolines to represent noise contours, as is common in noise maps today. Rather, it was a street map that used a graphical notation to distinguish between different *bands* of noise levels. Increasingly busy visual patterns, from dots to diagonal lines to dense grids, corresponded with increasing noise levels, from 50–54 phons, represented as dots, to 60–64 phons (represented as lines) to 80–84 phons (represented as grids)[3] (see figure 7.10). While these noise levels were artificially bounded by the streets themselves, this "loudness map" was nevertheless an elegant solution to the problem of depicting noise in relation to a map of city streets.

More typical of noise maps produced during this period were those depicting individual sources of noise. In 1935 The *New York Times* published what it called a "noise map" of New York City. This map, which accompanied an article by Noise Commissioner Henry H. Curran, was entirely iconographic: a pictorial map that purported to show "Manhattan's 10 Noisiest Noises." Icons representing various sources of noise were overlaid onto a basic outline drawing of the city in order of decreasing nuisance value. At the top of the map were automobiles, deemed the most bothersome noise; at the bottom were low-flying airplanes and boat whistles. In the upper right-hand corner, a zephyr-like policeman with bellows for cheeks appeared to blow the offending noises right off Manhattan island (see Curran 1935).

While such an illustration would have had limited value as a legislative tool, it nevertheless helped to shape public consciousness about city noise and elided in important ways with noise legislation of the time. Early representations of city noises—Rice's tootometer, decibel tables and charts, pictorial noise maps—typically depicted the impact of individual noise sources on the city. Anti-noise legislation of this period was correspondingly oriented toward reducing or eliminating specific sources of noise, whether tugboat whistles, automobile horns, or other nuisance sounds. William Rankin has observed that early city noise surveys were focused on the measurement and categorization of individual noise sources or noise events. He makes the compelling argument that these "tabular, event-oriented measurements were closely linked with a specific strategy of noise control—local anti-noise ordinances" (Rankin 2005, 372). This would change in the 1960s and 1970s, when noise was increasingly understood as a *pollutant*: as something that was not localized or localizable, and therefore could not be represented as a point or a line on a map, but rather something that permeated a city's soundscape and therefore needed to be treated globally.

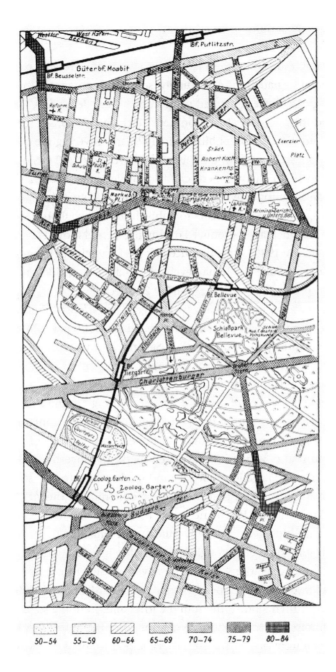

Figure 7.10
"Lautstärken-Karte eines Berliner Stadtbezirkes" (1938) (Kösters, Bierreth, and Kemper 1938, 312).

7.5 Mapping Noise Pollution

The idea of noise pollution emerged in late 1960s as part of a growing public consciousness about environmental degradation. Accordingly, sonic environments were recast in relation to "acoustic ecology," a concept defined by Schafer as "the delicate balance between living organisms . . . and their acoustical environment" (Schafer 1973b, 45; see also Truax 1978). A bibliography of noise pollution published in 1973 and covering the period 1965 to 1970 comprised a whopping 377 pages and included no fewer than 280 subject categories (Floyd 1973; see also Rosen 1974). Many experts cited a now-debunked idea that noise levels in cities were rising at an alarming rate of 1 decibel per year (Hildebrand 1970, 652). At that rate, noise would no longer be a mere "threat" to public health; it would be fatal, causing damage to internal organs. Decibel tables produced during this period moved far past the "threshold of pain" level seen in the 1930s. One, produced by the legal scholar James Hildebrand for the *Columbia Law Review*, included a "lethal level" of 180 decibels (Hildebrand 1970, 670). This table even listed a speculative "noise weapon" at 200 decibels.

The concept of noise pollution meant two things. First, it raised the status of noise from an intermittent or niche concern to an urgent one, putting it on par with other environmental crises that captured the public imagination. Second, as with air or water pollution, which were known to damage entire ecological systems, the concept of noise pollution conferred upon noise the perceived ability to permeate an entire ecosystem. Noise was no longer necessarily tied to a specific source of sound. It was something "in the air," and by extension, inside the human organism. During this period the idea of noise contaminating, invading, or spreading across a city emerged as common tropes. This "spread" of noise was linked to the growth of road traffic, which had increased markedly since the 1930s. As Hildebrand wrote, there were over 11.5 million new cars and trucks added to U.S. streets in 1969 alone (Hildebrand 1970, 652). The idea that noise was "something in the air," however, was not entirely imagined. During the 1950s and 1960s the number of airlines that operated commercial flights also multiplied considerably. Hildebrand remarked that "the greatest increase in the urban noise level has been brought about by the introduction of the turbojet engine into commercial airline operation" (652). The advent of supersonic transportation—of aircraft that travelled faster than the speed of sound—had brought a new dimension to noise pollution. Supersonic flights broke the sound barrier and, in doing so, created a previously unknown kind of noise: the sonic boom. When the sonic boom was first heard in the 1950s it was heralded by military leaders, industrialists and politicians as "a new sound of air power progress," "the proud herald of aviation's victory over the long sought-after speed of sound," and "the jet age's boisterous offspring" (cited in Roth 1958, 216). Citizens and scientists were less enthusiastic. In *Book of Noise* Schafer referenced a study which estimated that "each

supersonic flight across the country will startle up to 50,000,000 people" (Schafer 1970, 19). Leo L. Beranek, by then one of the world's foremost acousticians and cofounder of the acoustic consultancy firm Bolt, Beranek and Newman (BBN), warned that "large transcontinental and international jet airplanes may disturb and annoy thousands of people spread over many acres" (Beranek 1967, 15–16). "With the advent of supersonic aircraft," he wrote, "nobody in a nation can be sure of freedom from sonic booms" (16).

These anxieties were vividly reflected in depictions of noise from the period. One illustration in Schafer's *Book of Noise* showed an orderly, grid-like city plan with neatly arranged buildings and streets. Air traffic crisscrossed over this grid in every direction at once, ruining any semblance of order. The graphic announced, "Aircraft ignore hospitals, schools, libraries, churches, parks, homes" (Schafer 1970, 19). Another illustration in *Book of Noise* depicted road traffic noise and air traffic noise. The former was contained, limited to the road itself, while the latter created swirls of noise that lingered like plumes of smog above the city. Perhaps the most ominous depiction of air traffic noise from this period, however, was the map of sonic booms produced by the Aeronautical Research Institute of Sweden in 1967. This map showed dozens of "boom carpets" crisscrossing in the skies above Western Europe (see figure 7.11). They resembled invading armies, suggesting that a new form of warfare was imminent in a continent that had barely begun to recover from the Second World War.

7.6 Predictive Noise Mapping

Noise mapping in its current formulation evolved in relation to these new threats. Starting in the late 1950s, airports, airline companies, and aviation agencies faced growing pressure to respond to local communities' concerns about airport and air traffic noise. In turn, scientists and researchers, typically financed by government and military contracts, proposed new scales for measuring not only the loudness of aircraft sounds but also their perceived noisiness. Karl Kryter, now a researcher at BBN, proposed a new metric, the Perceived Noise Level (PNL), in "an attempt to [scale] the 'noisiness' of sounds" (Kryter 1959, 1422). In contrast to a scale of loudness, which relied on objective measurements of sound pressure levels, Kryter suggested that a scale of noisiness "should be concerned with how wanted, or conversely, unwanted a sound is considered to be by the average listener" (Kryter 1959, 1423; see also Kryter 1960 and Kryter 1970). The Perceived Noise Decibel scale (PNdB), which measured the perceived noisiness of jet aircraft by ground observers, was adopted as an international standard in 1966.

By the late 1960s noise mapping shifted toward depicting predicted versus actual noise levels of an environment, corresponding with the need to predict community responses to aircraft and airport noise. In the United States, predictive noise maps featured the Composite

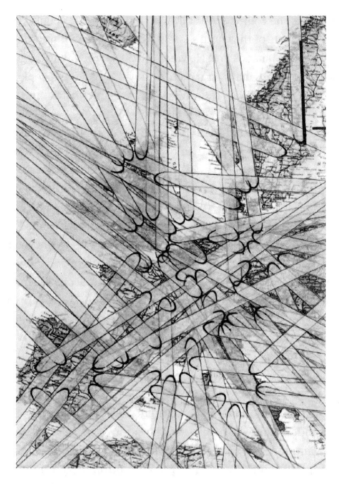

Figure 7.11
"Sonic Boom Carpets above Western Europe," by the Aeronautical Research Institute of Sweden ("Super-
sonic 'Boom' Carpet" 1967, 18). The caption read, "Some aeronautical specialists . . . maintain that the
shock waves set up by planes flying at from 1,500 to 1,800 m.p.h. will hit the ground in every spot
within a 'boom carpet' 50 to 80 miles wide along the entire flight path. Plotted on map are 'boom car-
pets' that might be 'unrolled' over Western Europe unless restrictions were imposed" (19).

Noise Rating (later refined as the Noise Exposure Forecast or "NEF"), a procedure developed by BBN researchers "to depict areas near airports having different degrees of noise exposure" (Bishop and Horonjeff 1969, 85). NEF contours, which were based on the PNdB scale, were used to predict "the degree of community annoyance from aircraft noise (and airports) on the basis of various acoustical and operational data" (Truax 1999). In order to generate NEF contours, digital computational methods were needed that could account for a large array of operational and acoustic parameters. A 1970 paper by BBN researchers, commissioned by the U.S. Federal Aviation Agency (FAA), introduced a computer program that could "generate contours of equal noise exposure about an airport community from given airport and aircraft operational parameters" (Horonjeff and Paul 1970, 111). This software, written in Fortran IV and later known as NOISEMAP, could account for large datasets: the performance characteristics of aircraft, airplane noise specifications, the volume of aircraft activity, flight data, and other variables.

Since the early 1970s the vast majority of noise maps have been based on the simulation of noise levels and generated in response to specific anti-noise directives. In the United States, the production of Noise Exposure Maps (NEMs), defined as "scaled, geographic depiction[s] of an airport, its noise contours, and surrounding area," is authorized by Part 150 of Title 49 of the U.S. Code (U.S. Congress 1994; see also FAA 2019). In his perceptive analysis of what he calls a "powerful and under-scrutinized regulatory tool," Peter Tschirhart argues that NEMs establish both figurative and literal boundaries. He writes, "not only do they define where sound is and what intensities should be expected, they establish sound as within the government's power to monitor and regulate" (Tschirhart 2013, 130–131). Tschirhart points out several peculiarities about NEMs: first, that they are calibrated on the A-weighted decibel (dBA scale),[4] which discriminates *against* low-frequency noise such as aircraft noise; second, that they cannot be used as evidence in a lawsuit;[5] and third, that they are almost universally produced using the FAA's preferred software, the Integrated Noise Model. Tschirhart suggests that, as such, the function of NEMs is primarily performative: "rather than contributing to an analytical or evaluative process, they are what stamps the process complete. Once certified by the FAA, there is no mechanism for property owners . . . to challenge either the location of a contour or, more importantly, the underlying activities responsible for generating it" (132–133). In this way, predictive noise mapping has become a tool that upholds the interests of airline industries over those of citizens and communities, further distancing individuals from the mechanisms that might have protected them from harmful levels of noise.

In the European Union, noise mapping is authorized by the European Commission's Environmental Noise Directive or "END" (Directive 2002/49/EC). It stipulates that, by 2013, every European city with a population of over one hundred thousand must produce a Strategic Noise Map: "a map designed for the global assessment of noise exposure in a given area due

to different noise sources or overall predictions for such an area." As the most comprehensive noise mapping policy in the world, END has led to "an inventory of noise maps for large cities throughout Europe" (D'Hondt, Stevens, and Jacobs 2012, 682). Noise maps produced in response to the directive are generated by noise prediction software like SoundPLAN, Geonoise, CadnaA, IMMI, and MITHRA (Beuving and de Vos 2004). In order to remain competitive in a quickly growing market, these computational tools must enable increasingly elaborate noise level prediction and noise visualization functions, for example by generating 3D graphic animations of simulated noise environments. This reliance on highly specialized software has come at a considerable cost. In his foreword to *Sounder City: The Mayor's Ambient Noise Strategy* (2004), the former Mayor of London Ken Livingstone remarked that "the Government has said it needs five years, noise mapping costing £13 million, and many other studies to prepare a national strategy [on environmental noise]" (Mayor of London 2004, i). William Rankin (2005) suggests that in the United States, "the development of noise maps went hand-in-hand with the desire to cut the citizenry out of decision-making" (374), while in Europe the expansion of noise mapping signals "a broadening of the legislative scale and scope of the European Union" (376). He writes: "The more large-scale statistical maps are used, the more regulatory authority is consolidated at a higher political level" (376), which is to say, out of the hands of citizens, communities, and local authorities.

7.7 Participatory Noise Mapping

Since around 2010 noise mapping has entered a new phase: the participatory or crowd-sourced noise map, which aims to recover the role of the individual or the citizen in the noise mapping and noise regulation process. Some crowdsourced noise maps fit within the scope of citizen science, with volunteers using their own mobile devices—typically, mobile phones—to take noise level readings. Citizen scientists provide an inexpensive if not always reliable way of gathering thousands of direct noise measurements of an environment, which would otherwise be a prohibitively expensive and labor-intensive task. Some participatory noise maps enable users to track their own noise exposure and compare it to that of other users. An emergent theme in such projects, among them NoiseTube, NoiseSPY, Ear-Phone, WideNoise, NoizCrowd, and NoiseBattle, is the idea of "people-centric sensing" or "community sensing" (Maisonneuve et al. 2009; Kanjo 2010; D'Hondt, Stevens, and Jacobs 2012). As the developers of NoiseTube write, "With your mobile phone you . . . can gather geo-localized [noise] measurements, annotate them and send them automatically to map local noise pollution, providing helpful information for local communities or public institutions to support decision making on local issues without waiting for officials [to] turn their attention to your neighbourhood" (Maisonneuve, Stevens, and Steels 2009, 79). Participatory noise mapping software developers argue that crowdsourcing democratizes the noise mapping process,

giving citizens an opportunity to participate in the noise monitoring schemes from which they had been cut out.

Participatory noise mapping projects have also emerged in connection to the "smart city," whereby large datasets pertaining to a city's infrastructure are generated, visualized, and analyzed in real time. As part of the project Sounds of New York City (SONYC), ongoing since 2013, researchers at New York University installed cheap microphones across the city. These microphones capture ten-second snippets of audio which are analyzed by a machine listening algorithm that identifies the source of the noise (e.g., "dog barking," "fire alarm"), as well as its level in decibels. The idea behind SONYC is that city officials can make more informed decisions about noise—and respond much more efficiently to noise complaints—when noise is monitored, reported, visualized, and analyzed in real time. While such projects are steeped in the language of citizen empowerment, they have also raised the specter of acoustic surveillance. In an article on SONYC for the *New York Times*, Emily S. Rueb reassured readers that the microphones "are not eavesdropping on your conversations," and that SONYC researchers could not reconstruct entire conversations from the audio snippets (Rueb 2016, A19). Still, while the SONYC project may have been ethically designed, the possibility of a noise monitoring system that generates a vast archive of geo-localized audio recordings captured in public spaces has raised eyebrows in the context of a surveillance society.

Projects like SONYC point toward a new model of the acoustic city whereby sonic citizens are cast as digitally enabled informants. In the case of SONYC, citizens are imagined as "nodes" in a "hybrid, distributed network of sensors and citizens for large-scale noise reporting."[6] Following from the SONYC model, one might imagine that noise mapping in the future will span both qualitative and quantitative realms, with individuals becoming points along a noise map. The noise map will continue to spread outward, supporting ever larger-scale, aggregate representations of noise levels over increasingly variable periods of time; it will also spread inward, with increasingly specific representations of individuals' exposure to noise.

7.8 Participatory Sound Mapping

While noise maps are used for noise regulation purposes, participatory sound maps—which typically invite the public to upload field recordings (environmental sound recordings) onto an online map of a city—have a range of purposes, from archiving the sounds of a place to raising awareness of acoustic ecology (Ouzounian 2014; McCafferty 2019). Participatory sound maps have proliferated since the late 1990s, underpinned by new mapping technologies such as Google Maps and supported by licensing agreements such as Creative Commons "Share Alike," which permits users to freely share and modify recordings for noncommercial purposes. An early example of a web-based sound map is Peter Cusack's "Favourite Sounds"

(1998–ongoing), for which Cusack invited anyone to upload a recording of their favorite city sound and pin it to an interactive map of that city along with written commentary explaining why it was their favorite sound. The optimistic premise of this project distinguished it in clear ways from the premise of noise maps, which are used by municipal authorities to reduce or eliminate unwanted sounds. The developers of the Montréal Sound Map (2008–ongoing) Max Stein and Julian Stein write that their project "promotes a more optimistic approach to acoustic ecology, encouraging listeners to lend a musical ear to the soundscape" (Stein and Stein 2008) (see figure 7.12). The nearly five hundred environmental sound recordings currently archived on the Montréal Sound Map can be individually selected for playback, and they can also be experienced in random sequence through an Autoplay function, with the map acting as a kind of indeterminate, always-evolving, collectively produced soundscape composition.

While participatory noise mapping projects typically cast the sonic citizen as an informant who reports on noise, participatory sound mapping projects tend to imagine the citizen as someone who possess other kinds of agency. For *X Marks the Spot* (2013–2018) the artist Matilde Meireles invited people to undertake a "sound hunt" of telecommunications boxes in Belfast. The boxes, which emit rich, droning electrical hums, are a pervasive feature of the city's infrastructure but typically go unnoticed. Meireles conducted a spectral analysis (frequency analysis) of these telecommunications boxes, making a poster for each one that listed its component frequencies (see figure 7.13). From these posters, passers-by could access the project website, and from there they could undertake a sound hunt or suggest other boxes for Meireles to "tag." The website features Meireles's recordings of individual boxes as well as compositions and sound installations that others have created from these recordings. Meireles writes that she wanted to "create an augmented sound map, a slowly growing and playful map of Belfast assembled by tagging specific telecommunication boxes, those emitting an audible drone (continuous hum). The tagging process aims to engage people with the space around them, to understand how sound shapes our experience of the city" (Meireles 2013).

Like the SONYC project, *X Marks the Spot* entails recording, analyzing, and mapping found sounds in the city, but for an altogether different purpose. By inviting participants to "Play!" Meireles constructs a different model of citizenship in the acoustic city. Whereas in most participatory noise mapping projects the acoustic citizen collects data on noise as a kind of civic duty, the participant in *X Marks the Spot* is variously cast as an acoustic explorer, a cartographer, a sound hunter, a player, an artist, a listener, or simply a member of a larger acoustic community. As an alternative sound map of Belfast, *X Marks the Spot* also stands in stark contrast to the official acoustic maps of the city: noise maps created in response to END. Meireles's project also maps noises in the form of surplus or throwaway sounds, but it reascribes value to them, inviting people to play with, and create art and music from, otherwise unwanted sounds.

(a)

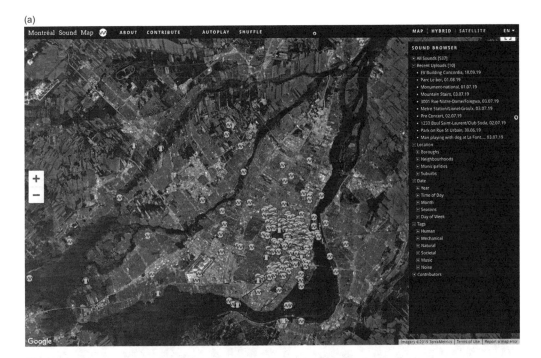

(b)

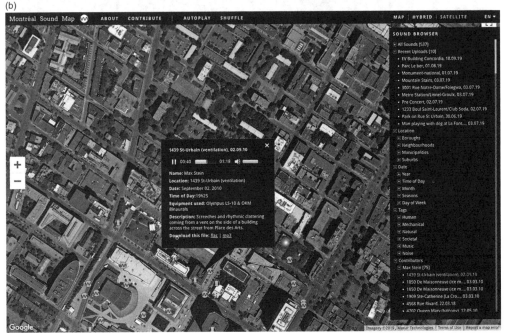

Figure 7.12

Screenshots of the Montréal Sound Map (2008–ongoing) by Max Stein and Julian Stein. Copyright © 2019 by Max Stein. Courtesy of Max Stein.

Figure 7.13
Photograph of a telecommunications box featured in *X Marks the Spot* (2013–2018) by Matilde Meireles. Copyright © 2013 by Matilde Meireles. Courtesy of Matilde Meireles.

7.9 The Noise-City

Noise maps and sound maps have given visual form to the idea of a sonic environment, and, as such, they have transformed how the acoustic city is imagined, understood, explored, regulated, and controlled. In examining these sonographies we might therefore ask how such representations shape sonic environments, how they position individuals and communities in relation to the acoustic city, and whether they serve to empower or disempower individuals and communities, and how.

Noise maps are, in general, officially sanctioned representations of sonic environments. They are created by experts who use expensive technologies and have access to specialized knowledge, and they typically use statistical modeling to predict the noise levels of a site. By contrast, participatory sound maps are typically grassroots initiatives populated by non-experts who use everyday technologies like mobile phones, and they represent the actual sounds heard at a site. Noise maps have been criticized for cutting out the citizenry from

decision-making processes around noise, although more recent participatory noise mapping projects aim to reinstate individuals' participation. By contrast, sound maps tend to specifically focus attention on how individuals perceive, navigate, experience, and inhabit the acoustic city.

As spatial representations of sonic environments, noise maps and sound maps are limited in what they portray. In web-based sound maps, sound recordings are typically "pinned" onto a map of a site that, in actuality, has a dynamic and continuously evolving soundscape. As such, sound maps have been criticized for artificially fixing a dynamic sonic environment (Ceraso 2010). Furthermore, sound maps and noise maps typically portray a bird's-eye view of a sonic environment, one that is almost always, in actuality, experienced on the ground.[7]

Beyond their limitations as spatial representations, however, these tools have fundamentally transformed how the city is imagined when it is imagined in relation to sound. Early representations of city noises—whether in the form of ancient epigrams, Victorian-era lists of street noises, reports by ministers of health, or tootometers by citizen activists—gathered increasingly detailed evidence of the city as both a manufacturer and repository of noise. In the early twentieth century these representations gave way to large-scale, government-sponsored noise surveys in which individual sources of noise were systematically measured and categorized. Representing this information spatially, in relation to a map of the city, meant that the acoustic city could be more effectively visualized, monitored, and regulated, and as a result, it designated the acoustic city as a "noise-city" as opposed to a "sound-city:" a place of unwanted sounds.

The noise map is an embodiment of the idea of the noise-city. It tells us where noisy "hot spots" are, or, rather, where they *could* be—what average noise levels one could expect to experience in a city at different times of day or night. The noise map also produces a particular kind of acoustic subject: one who is, in effect, subjected *to* more or less harmful levels of noise. The noise map does not invite listening so much as it functions as a barometer of how much noise the citizen will be exposed to. This barometer is biased and skewed in a way that reflects the interests of industries that already create noise and that seek to create even more. As such we might ask what the noise map does; who it protects; who it serves; and how this would change if the dominant representation of the acoustic city was not of the noise-city, but of the sound-city. If sound maps proliferated as widely as noise maps do, and if they formed the basis of acoustic zoning and other forms of urban acoustic planning, would we understand the acoustic city differently? How would the acoustic city be governed and regulated? Who would the acoustic subject be? And what would she hear?

8 Sonic Urbanism in Beirut

Essay in situ: March 19, 2018, 7:20 a.m., Gouroud Street, Gemmayzeh, Beirut

It's not every day you wake up wondering if the city is hammering inside your head. Rewind. Before that I wondered if the building I was ostensibly sleeping in was speaking to me. I awoke to find out that buildings can have rhythms. No, polyrhythms. Distinct patterns of creaks and groans and spits and tings! and clicks and tap-taps and switch-switches . . .

I now understand what my parents meant about their neighbors calling to each other from their balconies. I could stick my head out and call to this incessant hammerer. They would surely hear me, anyway. The city seems like it was designed for carrying sound.

It is far too early to be beeping one's horn. But still, they persisted. Now someone below me is dragging furniture. Back and forth. Back and forth. The will of the people makes itself heard.

More hammering. High heels across a platform. Hammering. Honking. High heels. The person dragging furniture has found new and bigger things to drag. And drop. The high heels have gotten faster. The hammerers have multiplied and found new surfaces upon which to strike.

Headache wouldn't be the right word for it. More like headache, full body pain, muscle spasms, nausea. We arrived just last night and fell asleep only a few hours ago. Some people think nausea and noise have the same etymological root, and now I know why. Is there a connection between noise-sickness and sea-sickness? Are we at sea? Are we drowning?[1]

8.1 Hearing Architecture

In 1957 the Danish architect and urban planner Steen Eiler Rasmussen wrote, "I hope that I have been able to convince the reader that it is possible to speak of *hearing architecture*" (Rasmussen [1957] 1962, 236; emphasis in original). Rasmussen studied the acoustic effects of architectural structures in Copenhagen—museums, tunnels, churches, passageways, town houses—and connected these acoustic effects to specific social and cultural traditions. In a Baroque mansion he found a salon with silk-paneled walls that "absorbed sound and

shortened reverberations," which is to say, a room ideally suited for chamber music (234). In the same mansion he discovered a woman's boudoir that he likened to "a satin-lined jewelry box," an intimate space in which friends could gather and whisper the latest gossip (234). Rasmussen's acoustic readings of architectural spaces were measured and methodical, a world apart from the Futurist composer Luigi Russolo's fevered call to "cross a great modern capital with our ears more alert than our eyes" (Russolo [1913] 1986, 26). Russolo hurled himself through the dizzying sensations of city noises, delighting in "distinguishing the eddying of water, the air or gas in metal pipes, the muttering of motors that breathe and pulse with an indisputable animality, the throbbing of valves, the bustle of pistons, the shrieks of mechanical saws, the starting of trams on the tracks, the cracking of whips, the flapping of awnings and flags" (26).

Through such sensorial encounters, architecture and urban design, once understood as the domain of form-making, have also come to be understood as practices of sense-making. Perhaps most eloquently articulated by the Finnish architect Juhani Pallasmaa, who observed that we "stroke the boundaries of . . . space with our ears" (Pallasmaa [1996] 2012, 55), this sensorial approach has reoriented architecture and urbanism by repositioning them in relation to the human body and lived experience. As Pallasmaa wrote, "I experience myself in the city, and the city exists through my embodied experience. The city and my body supplement and define each other. I dwell in the city and the city dwells in me" (43).

In parallel to this sensorial awakening there have been countless calls for architects and planners to embrace sound and "sonic thinking" within their practices. In 1969 the urban designer Michael Southworth warned that it was "no longer sufficient to design environments that satisfy the eye alone" and urged planners to consider the "sonic environments" of cities (Southworth 1969, 50). In the next decade, R. Murray Schafer cited Southworth in proposing acoustic design as a way of improving the soundscapes of postindustrial cities. Since that time, the calls for architects and planners to embrace sonic methods have persisted and even multiplied. In 1984 the musicologist Shuhei Hosokawa chided that the city remained "unheard," with urban planners neglecting the "kind of tone a city has, that the habitants (are obliged to) hear" (Hosokawa 1984, 173). The philosopher Gernot Böhme offered another variation on this theme, writing that urban planning must move beyond a paradigm of noise control and instead "pay attention to the character of the acoustic atmosphere of squares, pedestrian zones, of whole cities" (Böhme 2000, 16). More recently, in an article titled "Dear Architects: Sound Matters," *New York Times* architecture critic Michael Kimmelman suggested that while smell had plagued medieval cities, sound had become the "unspoken plague" of modern cities due to its persistent neglect (Kimmelman 2015).

For their part, architects and urban planners have not denied the idea that despite the sensorial turn in theory, sound remains, at best, an afterthought in mainstream architectural

and planning practice. Upon convening the 2006 conference Music/Architecture/Acoustics, the Canadian architect Colin Ripley declared that sound "has been one of the most neglected factors or components affecting the built environment" (Ripley 2006, 1); while the German architect Arno Brandlhuber has remarked, "Architecture is normally about avoiding sound," and "sound as a layer within the master plan remains vacant" (Brandlhuber and Emde 2008, 166–167).

At the same time, there has been an undeniable turn in more experimental corners of the architecture world, the art world, and in the broader humanities toward reimagining the city through a creative and critical engagement with sound. The concept of the "acoustic city" (Gandy and Nilsen 2014) has gained currency across the urban humanities, and studies of urban sound environments, histories, and cultures are now so plentiful that it would not be an exaggeration to designate "urban sound studies" a full-fledged subdiscipline.[2] Research groups on urban sound have multiplied, taking a cue from the interdisciplinary bent of Le CRESSON—a research center dedicated to urban sound that was established in Grenoble in 1979—as have sound art festivals that have a specifically urban focus. For the first installment of the festival Sonambiente in 1996, curators took inspiration from the "New Berlin" that was emerging post-reunification. They heard the pervasive sounds of construction work in the city as a marker of economic growth, a fertile backdrop against which to mount a sprawling exhibition of sound art (Kneisel, Osterwold, and Weckwerth 1996, 7). More recently, for bonn hoeren (2010–2020), a ten-year project directed by the curator Carsten Seiffarth, a *"StadtKlangKünstler"* ("City Sound Artist") is appointed each year to create sound art for Bonn (Seiffarth 2012). When visiting Bonn today it is not uncommon to find visitors taking guided listening tours of the city. They follow Sam Auinger's *Listening Sites in Bonn* (Auinger 2010), a handheld map of the unique acoustic features of the city. Another notable project, Tuned City (2008–ongoing), describes itself as "an artistic research project and festival trying to understand [the] city by the means of sound." It has already taken place in cities including Berlin, Brussels, Tallinn, Nuremberg, and Messenne. Directed by Carsten Stabenow, it has involved the participation of several hundred sound artists and theorists; Stabenow writes that the project "should not be understood as the attempt to 'tune' the city in terms of improvement," but rather as "'tuning into the city' as a different way of understanding city by the means of sound."[3]

Critical attention to and creative activity in the acoustic city is thus flourishing, inviting further and deeper entanglements. This chapter emerges from this flurry of interest while taking perhaps a different tack with regard to the promise of the acoustic city. In examining urban sonic practices in Beirut, a city that has been described by local architect-planner Antoine Atallah as a "victim of 'urbicide'" and a city of perpetual transformation (Atallah 2017), I suggest that the acoustic city of the twenty-first century might emerge *not* as a

way of rescuing architecture and urban planning from their visualist orientations; nor as a route through which urbanists might reexamine the city and understand it anew; nor as a platform through which to create alternative experiences of the city, as is often touted in the art world, even if these may be laudable and often fascinating pursuits. In the context of profound global flux, one in which cities emerge as sites of intense economic, political, social, and cultural contests, where the displacement of human populations, poverty, pollution, and uneven justice find their most vivid expressions, the acoustic city might instead serve as a figure of profound instability, and might be most productively examined as a site through which various forms of power, citizenship, belonging, and community are negotiated. The impetus would no longer be to *improve* the soundscapes of cities. Rather, it would be to attend to aspects of the acoustic city that escape the fixity and authority of the master plan. Given the vast transnational movements, sudden territorial shifts, and uprisings that shape contemporary cities, particularly cities of the Global South, it is perhaps no longer even appropriate to speak of urban "planning." We might instead understand cities as places where social, cultural, and political formations foment and burst, sometimes so suddenly that they can hardly be documented, much less analyzed. The idea of "listening" in such a context is already in doubt. While Pallasmaa's idea that city and the body dwell in one another may be appealing, the very notion of dwelling in the contemporary city is troubled. The processes of furious acceleration, accumulation, and rapid movement that shape such places conjure a city not as a dwelling-place for bodies, but as a technology into which bodies are input and through which they are processed, often in violent and destructive ways.

The status of art—and the ethics of artmaking—in such a context must be carefully reconsidered. Although many cities remain hubs of cultural activity, the art born of the city-in-perpetual-upheaval is not necessarily emancipatory or redemptive. Rather, art might most productively be engaged as a force that can reveal the hidden processes and forces that shape the city, including those processes of exclusion that, for a majority of the world's urban populations, determine everyday life (Sassen 2014).[4] Sonic urbanism might then be understood not as a new layer to the city plan, or as a fresh approach to urban architecture, but as *evidence* of a city that is profoundly, and perpetually, unplanned.

8.2 Listening Ecologically: *The Invisible Soundtrack*

The city of the twenty-first century belongs predominantly to the Global South. It is increasingly poor, and increasingly young (Drieskens, Mermier, and Wimmin 2008). It is also heavily shaped by conflict, stemming from both internal and external forces, and not always in ways that can be easily tracked.[5] Beirut, a city that was once seen as an idyllic cosmopolis—the "Paris of the East"—has emerged as such a city, following a brutal civil war that lasted

from 1975 to 1990, resulted in over one hundred and fifty-thousand deaths, and was marked by sectarian division, paramilitary rule, political infighting, foreign invasion, population displacement, and mass exodus. After the war, further devastations brought renewed attention to Beirut: the assassination of Lebanese prime minister Rafik Hariri in 2005; the 2006 Israel-Lebanon war, which resulted in extensive damage to civilian infrastructure and the displacement of around one million civilians; a garbage crisis that stemmed from the suspension of the city's waste removal services—a crisis that, for many locals, symbolizes the ineptitude and dysfunction of the Lebanese government; and the recent influx of over one million refugees fleeing the civil war in neighboring Syria, with over a quarter million Syrian refugees registered in the capital city alone as of June 2018 (UNHCR 2018).

The vast destruction of Beirut's built environment during the Lebanese civil war, which Atallah estimates at up to 80 percent of the urban fabric, has been well documented, as have the recent efforts to rebuild the city, which have been widely criticized as insensitive to local contexts, overly glitzy and corporate, and literally molded by corruption (Wainwright 2015). Solidere, the entity charged with redeveloping Beirut's city center, is a private business that, as Oliver Wainwright writes, "also enjoys special powers of compulsory purchase and regulatory authority, giving it the mandate to manage the city centre like a mini-fiefdom" (Wainwright 2015). Signs condemning Solidere are visible throughout the city, with one large enough to cover half the façade of a building. When I visited Beirut in March 2018 for the project *Urban Sound and the Politics of Memory*, which brought together sound artists, architects, and urban theorists from Lebanon and the UK, someone had graffitied the words "STOP BUILDING" on a billboard announcing a new development project.[6] New developments in Beirut typically are financed by foreign investors and contracted to international "starchitects," resulting in what many see as a strange and sterile remaking of the downtown area, the Beirut Central District. As Wainwright writes, "The grocer and fishmonger have been exchanged for the luxury boutique and high-end restaurant, while the apartments above the shops have mostly been sold to Gulf investors and wealthy expats, their sky-high prices out of the reach of the majority of locals, in a city with a desperate shortage of affordable housing" (Wainwright 2015).

Alongside these problems in the city center are those that plague the Greater Beirut Area (GBA). Some neighborhoods in the GBA are undergoing renewal and even gentrification, while most stagnate in various states of ruin and decay. Many have the haunted air of a city emptied of itself. Atallah sees Beirut both as a "ghost city" and simultaneously as a city of "accelerated transformations" and "perpetual mutation" (Atallah 2017). For *Panoramic Beirut* (2017) he visualized these transformations through a series of annotated photographic panoramas that capture the city at various critical points in its history. He remarked of Beirut's most recent postwar phase, "The war and its destructions, the abusive demolitions

of the Solidere plan . . . and the final exodus of families and businesses that gave life to the city mark an extremely violent rupture in Beirut's development." Government policy has turned Beirut into "a series of plots available to the highest bidder," and "not enough freedom has been given to the city for it to resume writing its own story with its own hands."

This stranglehold on local spatial practices is compounded by the widespread privatization of formerly public spaces, an issue that has mobilized local communities of artists, architects, and activists (Fernández 2015). One prominent campaign is The Civil Campaign to Protect the Dalieh of Raouche, a mission to stop the privatization of a much-beloved, untamed rocky formation on Beirut's coast (see figure 8.1). One of the last remaining public access points to the sea, Dalieh was slated for a luxury hotel contracted to OMA, the architecture

Figure 8.1
Photograph of Dalieh (2018) by John Bingham-Hall. Reprinted with the permission of John Bingham-Hall. Copyright © 2018 by John Bingham-Hall.

firm headed by Rem Koolhaas (Battah 2015). In 2017 the arts organization Temporary Art Platform (TAP) teamed up with the Campaign to Protect Dalieh to stage a two-day art intervention at the site. The curator Amanda Abi Khalil, one of the founders of TAP, remarked that reconstruction efforts had not taken into account "the importance of commonness and shared spaces" (Khalil 2018). Reconstruction policy, she said, was rather "oriented towards real estate speculation."

As part of the TAP intervention at Dalieh, the composer and sound designer Nadim Mishlawi made a series of underwater recordings at the site, using hydrophones to capture the sounds of underwater life—an invisible but, once heard, undeniable presence. To do this, Mishlawi returned to the site many times, recording sounds along the coast and in the sea, both above ground and below the water's surface. He said of the vibrant underwater soundscape near the shore that "there was something very musical about the way the animals [underwater interacted]; it was almost like listening to a free improvisation of life because there were so many different sounds happening in such a confined space" (Mishlawi 2018). During the TAP intervention at Dalieh, Mishlawi's *The Invisible Soundtrack* (2017) could be heard at a listening post at the site.[7] Wearing headphones, listeners could hear the sounds of breathing, bubbling, spitting, creaking, bursting, and other acoustic signs of underwater life: evidence of the rich underwater ecologies that would be destroyed if Dalieh were to be turned into yet another luxury hotel. Khalil remarked that Mishlawi's intervention was particularly compelling in that it showed "how can sound contribute to a social, political struggle, and not only art" (Khalil 2018).

The Invisible Soundtrack was a sonic embodiment of the deeply layered strata of Beirut, which require slow and careful attention to navigate and unearth—precisely those qualities that are in short quantity in the rush to capitalize on the postwar construction boom. In Mishlawi's words, "It was like the area had a new soundscape, even though the sounds were all captured in that area. And because the work was part of a larger campaign, it also highlighted [that the location was] much denser than what appears on the surface; as if to say that there are many more possibilities here to consider" (Mishlawi 2018).

Essay in situ: March 20, 2018, 6:32 a.m., Gouroud Street, Gemmayzeh, Beirut

This morning I heard a bird. One little bird with one little chirp, but a bird nevertheless.

Hearing birdsong back home may be unremarkable, but in Beirut it is notable. They say Beirut has no green spaces. And the city really does feel like one mass of concrete sometimes. Concrete and dust. Dust from the cement buildings, dust from the drilling, dust from the dusty lens through which one begins to view the world. What is the color of dust, come to think of it? And what is the color of Beirut? Does it settle into some kind of limestoneish, eggshellish ochre? Do the city's colors average out, psychogeographically,

into one dusty hue in people's minds? What does it mean to imagine the city you live in as a city of dust?

There it is again, the bird. It sings and in return it is honked at. That must be strange for a bird. They say that every species occupies its own acoustic niche, a frequency bandwidth it shares with other members of its species. The theory is that, as noise pollution increases, this acoustic niche becomes squeezed, full of other sounds. Eventually the species is forced out of its habitat because its members can no longer communicate with one another.

This one bird lives in a precarious acoustic niche here in Gemmayzeh. But still, it is here. So perhaps it adapts: it no longer communicates with other birds but with machines—car horns, drills, saws, screeching brakes, other high-pitched noisemakers. I wonder if it considers these acoustic companions its friends? Does a bird make friends with a car if the car is the only other occupant of its acoustic niche? Can a bird fall in love with a jackhammer?

8.3 The Right to Listen: *Silent Room*

In *Berlin Sonic Places* (2017) the soundscape artist and researcher Peter Cusack argues that there is no such thing as "the tone" of a city. Rather, he suggests that the acoustic city is comprised of a series of distinct "sonic places" that are seamlessly stitched together to make an irreducible, always-evolving assemblage. While the idea of hearing the city as an acoustic whole might be attractive in theory, this is not how urban soundscapes are experienced in practice: cities are simply too large for that. As people move through a city they encounter innumerable sonic places, which Cusack calls "the building blocks of the urban sound environment" (Cusack 2017, 4).

As a virtual newcomer in Beirut (I was born there but my family emigrated to Canada when I was three), I certainly heard distinct sonic places that were marked by social, cultural, economic, and religious differences, and were equally marked by the same kinds of architectural and urban features that one might expect to encounter in any city, such as highways or alleyways. If there *was* a "tone of the city," however, it seemed to me to be an intense mix of traffic and construction sounds that stuck to the city like a dense fog of acoustic smog. Construction work starts around 7:00 a.m. six days a week, and is audible across the city. The usual mix of traffic noises (cars, motorcycles, buses, etc.) is supplemented with the local habit of horn honking seemingly almost continuously while driving. Some drivers use their cars as informal taxis, honking to pedestrians to signal that they're offering cheap lifts; others engage in what seems like a perpetual dialogue with other drivers. Another pervasive sound is the hum of electrical generators, which are switched on for several hours a day due to planned power outages—a problem that, like the garbage crisis, serves as a powerful symbol of political paralysis for many Beirutis. Studies of environmental noise in Beirut have found

Figure 8.2
Photograph of *Silent Room* (2017) by Nathalie Harb. Photograph by Taim Karesly. Copyright © 2017 by
Taim Karesly. Used with the permission of Taim Karesly.

that, in most locations, average daytime environmental noise levels exceed 75 decibels, a
level at which sustained exposure can lead to hearing loss (Chaaban and Ayoub 1996; Korfali
and Massoud 2003).

In 2017 the Lebanese scenographer Nathalie Harb—working in collaboration with the
local sound designer Khaled Yassine, the architecture collective BÜF, and the acoustic con-
sultants 21dB—created *Silent Room*, a free, publicly accessible acoustic refuge (see figure 8.2).
Silent Room was an invitation to listen in a place where listening is often stressful and dif-
ficult. In its original manifestation it was installed in a parking lot at the intersection of
a highway, an industrial site, and a low-income neighborhood in Beirut.[8] Painted entirely
in pink, the structure was so improbable relative to its surroundings, a landscape wrought
in concrete and cement, that it might as well have been a flying pig. In order to enter the
space visitors climbed a ladder that led to a waiting room where a sign instructed them to
remove their shoes. Yassine's sound installation provided a just-audible soundtrack com-
posed of sounds captured in the city during the quietest hours of the night, around 4:00
a.m.: the sounds of air conditioners, water pumps, and electrical generators. Harb says, "We

chose these unpleasant sounds because, paradoxically, they're also comforting. They have a domestic, familiar quality" (Harb 2018a). Although the project is called *Silent Room*, Harb did not seek to create a space *devoid* of sound. Rather, her idea was to install quiet sounds, as well as wood, paint, fabric, and plants, to create a sensorially rich but muted environment. The interior of the structure was acoustically treated such that ambient noise levels were dampened to around 30 decibels. The city could still be heard, but at a distance. Harb says, "We decided to reduce the decibels to a comfortable level, as if the city is whispering" (Harb 2018b). Thus, *Silent Room* offered people an alternative sonic experience of their city as an imagined possibility.

Silent Room was a meditation not only on noise pollution, but also on the uneven ways in which noise affects the city's residents. Harb says, "Our cities are often configured in such a way that underprivileged communities are the most affected by higher noise pollution" (Harb 2017). For Harb, the unevenness of noise pollution thus represents a social injustice. "Urban segregation," she writes, "can be mapped through noise variations across the city."

Harb conceived *Silent Room* during the garbage crisis. While she herself had the means to escape this sensory overload, she was aware that this was an unimaginable luxury for many Beirutis, especially those who worked outdoors. She says, "I was thinking of people who could not be inside. Not everybody can be inside" (Harb 2018b). Harb imagines that *Silent Room* could one day become a kind of public utility for underprivileged neighborhoods, "like toilets." She stresses that access to such acoustic refuges should not be seen as a luxury but as "a necessity, something that's needed in urban planning."

Like the TAP intervention at Dalieh, *Silent Room* opened a window onto the ways in which official planning and reconstruction policies have failed Beirutis. While the Dalieh campaign addressed a growing lack—the dispossession of an urban commons, the devaluation of natural habitats—*Silent Room* addressed an overabundance (of noise) whose presence signals the failure of municipal authorities to protect civilians from preventable harms. Notably, both *Silent Room* and *The Invisible Soundtrack* invite people to listen: an everyday act that, in the context of a city that operates under what one person has called an "acoustic siege" (Wimmen 1999), can emerge as a kind of resistance, an alternative poetics of everyday city life.

In "Dissonance and Urban Discord" (2012) Nadim Mishlawi offers a nuanced reading of how noise has accumulated in Beirut. Mishlawi hears the city's overloaded soundscape not as a sign of urban renewal, but precisely as the result of political inertia. He argues that, while in many cities "noise pollution is a side effect of excessive urban development," in Beirut it is not a result of progress but rather "of paralysing stagnation" (Mishlawi 2012, 169). He writes, "The endless loop of the national anthem, the echoing of political speeches, the calls of equality from the lower classes, the tortured screams of thousands of massacred civilians, and the unresolved clash of opposing political factions, are all superimposed in a collage of

garbled nonsense. And this situation denies the possibility of rediscovering the only solution to overcoming noise pollution, that act which prevents a society from falling into such a dilemma to begin with: listening" (161–162).

Mishlawi understands listening as a civil right. He stresses that in Lebanon it is not political speech that has been repressed. Rather, he argues, "it is the right to listen that has been scandalously denied" (Mishlawi 2012, 166).

8.4 Hearing Shadows: *Concrete Sampling*

On the evening of March 29, 2014, a crowd gathered at the perimeter of a construction site in downtown Beirut. From the depths of the site there emerged a mellifluous mix of percussive sounds, voices, drones, recordings of environmental sounds, sampled music, and the sounds of construction work—hammering, banging, drilling, hitting, dragging. All of the sounds bounced off the walls and crevices of the cavernous construction site. The performance was the culmination of a months-long project, *Concrete Sampling (arrangement for derbekah and jackhammer)* (2014) by Joe Namy and Ilaria Lupo in collaboration with a construction crew of twenty-two boys and men aged sixteen to fifty, all of whom were Syrian nationals and refugees (see figure 8.3).

In Lebanon today, Syrian refugees live in abandoned and unfinished buildings, on land that has been repurposed for informal settlements, and in temporary shelters that include, for many construction workers, the construction sites themselves. Although Lebanon does not hold a national census, and has not done since the establishment of the modern Lebanese state in 1932, it is widely believed that Lebanon is host to approximately two million Syrian refugees as of this writing (in June 2018). This is a staggering number for a country with a total population of around six million. Approximately one in every three people living in Lebanon today is a refugee, and Lebanon hosts more refugees per capita than any other nation in the world (UNHCR 2018). In a national political context marred by failing infrastructure and ineffective governance, and in a region unsettled by near-continuous conflict, the status of Lebanon's newest refugee population is deeply uncertain. According to a 2018 report by Human Rights Watch, Syrian nationals in Lebanon face increasingly hostile attitudes from municipal authorities, with growing reports of discrimination, harassment, forced eviction, and expulsion (Human Rights Watch 2018). Most live a precarious existence. Homelessness, destitution, food scarcity, and lack of access to safe water are commonplace.

Lupo and Namy noticed that the sounds of construction work, much of it undertaken by Syrian refugees, had become a kind of "sonic landmark" in Beirut. They wanted to reorient this soundtrack of the city by using the tools of construction work as musical instruments, and by repositioning the construction site as a resonant space—as a kind of aural

(a)

(b)

Figure 8.3
Photographs of *Concrete Sampling* (2014) by Joe Namy and Ilaria Lupo. Reprinted with the permission of Joe Namy and Ilaria Lupo. Copyright © 2014 by Joe Namy and Ilaria Lupo.

architecture whose properties could be explored through performance. It was important that the performance be developed by the construction workers themselves, who, Namy said, had become a "common fixture in Lebanese society" yet remained "in the shadows of the city" (Namy, cited in MacGilp 2014). Indeed, it is a terrible irony that a profoundly disenfranchised population—refugees who typically have no home to which to return—are rebuilding a city that increasingly rejects them. Although construction work is pervasive, Namy remarks that there is little interaction between Beirutis and construction workers, most of whom "stay behind the walled fence of the site perimeter."

In preparation for *Concrete Sampling* Lupo and Namy studied construction sites in Beirut over a period of several months, making environmental recordings and speaking with workers and managers at various sites. Through Ashkal Alwan, a local arts organization that hosts vital artist development programs, they were introduced to the Lebanese architect Bernard Khoury, who granted them access to one of his construction sites. After discussing their idea with the construction workers and inviting them to participate in the project if they wished, and in return for compensation, Namy and Lupo returned to the site almost every day for two months to conduct rehearsals, which typically took place after the workers had finished twelve- or thirteen-hour shifts. Some rehearsals involved listening sessions during which Lupo and Namy played recordings of their favorite music and members of the construction crew shared theirs in return. On some days the group developed elements of the performance while on other days they simply gathered and talked. The process was improvisational and collaborative, focused on creating a group dynamic where, Lupo says, "every individual could find his voice in relation to the collective" (Lupo, cited in MacGlip 2014). Over the course of the project the construction site was alternately experienced as a work site, a shelter, an instrument, and a continuously evolving "aural architecture" (see Blesser and Salter 2007). It was equally reconfigured as a place that could connect the workers to other people in the city. Namy said of the performance that at first it "kind of felt like another rehearsal because we didn't notice the audience above." However, once the group heard the cheers of the audience, "we all looked up and the excitement level and focus just jumped 1,000 degrees, that was the moment when it all clicked" (Namy, cited in MacGilp 2014).

March 22, 2018, 9:15 a.m., Gouroud Street, Gemmayzeh, Beirut

I'm not sure how to bring up the subject of the war, or if I should bring it up at all. But it is a reality of this place, something that happened here that continues to shape what is happening today. The entire project of reconstruction is the war's most enduring repercussion, at least its most audible one. Through reconstruction, the devastation of war literally reverberates throughout the city.

8.5 Hearing Violence: *50cm Slab*

At Ashkal Alwan I met Mhamad Safa, an architect, musician, and artist who had recently embarked on a project examining noise legislation in Beirut. Safa's project—which was realized in part as a video installation titled *520,579 m2* (Safa 2018c)—was inspired by the observation that noise legislation in Beirut is unevenly enforced along socioeconomic lines. While noise from bars and nightclubs was heavily policed in areas frequented by locals, it was more permissible in areas frequented by tourists. Safa understood this kind of uneven enforcement of noise policy as "a sort of orchestration about who can [and can't] make sounds" (Safa 2018b). He was concerned that this unevenness particularly impacted vulnerable groups deemed "exceptional bodies" by the state, including construction workers, he told me, who are treated in such a way that they are deemed able to withstand higher levels of harmful noise than others. He said, "I started looking into the idea of the construction worker to explain this idea of orchestrated noise, and orchestrating it in relation to a specific person or body, and the idea that 'this person can handle noise, and this other person cannot handle noise'" (Safa 2018b). Safa was also interested in the idea that the construction site was in itself an exceptional site, since construction work is critical for the Lebanese economy. He said, "You cannot call the cops at 9 a.m. or 10 a.m. and say 'I can't handle this anymore, I have a sick, elderly person in my house and they can't handle the drilling.' They will tell you, 'It's a construction site. Millions of dollars have been poured into the project.' So, this site is an exception, and in this site, there are exceptional bodies that are subjected to these sounds. The different players are related through how much each of them is subjected to noise and how much each player can handle noise" (Safa 2018b).

Safa's idea that noise policy is differently enforced or even "orchestrated" along socioeconomic lines bears further examination. On the one hand, orchestration implies design; indeed, the concept of orchestration was central to R. Murray Schafer's conception of acoustic design. In a passage titled "Principles of Acoustic Design" in his landmark study, Schafer suggested that the acoustic designer should examine musical compositions in order to learn how soundscapes "may be altered, sped up, slowed down, thinned or thickened, weighted in favor of or against specific effects" (Schafer [1977] 1994, 344). He proposed that the aim of acoustic design should be "to learn how sounds may be rearranged so that all possible types may be heard to advantage—an art called orchestration" (344). In Safa's reading of noise management in Beirut, the idea of orchestration emerges in more nefarious ways. It evokes the uneven distribution of power, whether the power to make noise; the power to determine which bodies can be subjected to which levels and what kinds of noise; or the power (or lack thereof) to protect oneself from the harmful effects of noise.

Figure 8.4
Installation view of *50cm Slab* (2018) by Mhamad Safa at the *Points of Contact* exhibition curated by Helene Kazan at the Goethe-Institut Libanon, Beirut, January 27–March 10, 2018. Reprinted with the permission of Mhamad Safa. Copyright © 2018 by Mhamad Safa.

In 2018 Safa created *50cm Slab*, a sound installation that reflected on the experience of noise in conflict. It was originally presented as part of the *Points of Contact* exhibition curated by Helene Kazan at the Goethe-Institut Libanon in Beirut, from January 27 to March 10, 2018 (see figure 8.4). The exhibition grappled with the question "What are the points of contact between human bodies, the architecture of the lived built environment, and state and international governing forces?" (Kazan 2018). Safa's contribution was a harrowing meditation on this question, conceived in response to the 2006 Israel-Lebanon war, and in particular to the suspected use of thermobaric bombs by Israeli forces in Beirut. Thermobaric bombs, also known as vacuum bombs, draw oxygen from the surrounding air to create high-temperature explosions. The process of removing oxygen from the air causes extreme damage to architectural structures, and it also sucks the air out of victims' lungs. As part of a reconstruction

project, Safa visited a building that was suspected to have been destroyed by a thermobaric bomb. The entire structure had collapsed onto a 50 centimeter-thick slab of concrete that protected the basement. He wrote:

> In the 2006 war on Lebanon, the consultative council in the southern suburb was razed to the floor, where all its components were pulverized. Meanwhile, the underground floors were left intact, due to the protective nature of the thick concrete slab that was used on the ground floor. This prompted an engineer working for the Hezbollah affiliate reconstruction team (Jihad Al Bina'a) to claim that this building was hit by a thermobaric bomb, or as he put it, a "vacuum" bomb. . . .
>
> The thickness of the shielding slab in question was in fact implemented and used in all reconstruction works. The 50cm thick slab is no longer limited to its basic role of supporting the upper levels but gains a protective quality and turns into a shield for the lower [levels]. Apart from [its] practical nature . . . it represents the inevitable coming war—be it with Israel or some other foe—and affirms its devastating results. And so this operation restarts the normalization of the "state of exception" by invoking the idea of war in the very foundation of the structure. Hence, the exception becomes the norm. (Safa 2018a)

For *50cm Slab* Safa sonically recreated the experience of hearing a structure collapsing onto a fortified shelter. He used the Max/MSP programming language to generate randomized impact sounds and applied granular synthesis techniques to create extremely short "grains" from these sounds. The effect was one of short bursts of part-harmonic, part-enharmonic tones stochastically clustered and layered together, such that a single second might contain dozens of bursts of (mostly) high-pitched noises occurring at random. Inside the exhibition space these noises were projected from a pair of loudspeakers pointing directly at a metal sheet bent at a 90-degree angle. Listeners stood beneath this metal sheet in order to hear the noises as if they were being projected directly onto their heads. Safa noted that the experience of standing beneath the metal structure was so intense that many listeners, including himself, could only stand beneath it for a few seconds at a time.

8.6 Hearing Trauma

Beiruti artists have invented striking ways of processing acoustic and auditory trauma. During the 2006 Israel-Lebanon war the illustrator and musician Mazen Kerbaj famously recorded the track *Starry Night* on his balcony, what he described as "a minimalistic improvisation" between himself (on trumpet) and "the Israeli Air Force (bombs)" (Kerbaj 2006; see also Kerbaj 2017). For the installation *Arsenal* (2017), the composer and visual artist Cynthia Zaven disassembled an upright piano, lining up its hundreds of strings, keys, hammers, dampers, soundboard and other parts in a way that recalled an arsenal display. While many artists and composers have deconstructed or destroyed musical instruments—Zaven cites Fluxus artists' irreverent destruction of musical instruments as a way of signaling their break with the

Western musical avant-garde—Zaven's particular reconfiguration of the instrument spoke to the ways in which everyday objects can become weaponized through conflict (Zaven 2017). With the series *Public Hearing* (2018–ongoing) the artist Joan Baz invites Beirutis to share their experiences of trauma using voice memos, interviews, and found sounds. She writes that *Public Hearing 1* (2018), which focused on Beirutis' memories of car bombs, "began as an attempt to create space for us to remember [but] ended up becoming an oral record of our lived history and collective memory" (Baz 2018). *Public Hearing 2: dwelling upon dwelling* (2019) evolved as a series of videos in which participants were invited to "rebuild" their childhood homes by using toy blocks. In these videos, the participants' faces are not seen; only their voices are heard. Speakers' voices thus become anchors for personal experiences of that are nonetheless familiar, widely shared but almost never publicly discussed. In *Landline* (2019), a composition by the architect and musician Omaya Malaeb, Baz provides the voice of an urban wanderer who is marked by the sounds of her high heels clacking upon city streets. Speaking in Arabic, with a lilting, mellifluous voice, she says:

> Our dear listeners,
> Before we begin these exercises
> Exercises of goodness
> We need to remember together
> All the goodness
> That is around us.
> The goodness of the land
> The goodness of the soil
> The goodness of the air
> The goodness of the wind
> The goodness of the body
> The goodness of the mind
> The goodness of words
> The goodness of love. (Rafat Mazjoub, cited in Malaeb 2019)[9]

In Malaeb's composition this urban wanderer, whose movements create a steady rhythmic counterpoint to the chaotic soundscapes of everyday city life in Beirut, makes peace with the noise-city in order to transcend it. She invites us to listen to the city *through her*. In doing so, we hear the city—one so often represented as a city in disrepair—re-embodied in a figure of goodness and love.

8.7 Hearing the Acoustic City

In *The Culture of Cities* (1970) Lewis Mumford described the war-metropolis as "an anti-civilizing agent: a non-city" (Mumford [1938] 1970, 278). In Beirut, the sonic practices of

artists, activists, musicians, and architects have emerged from the ruins of what some might call a non-city, but not as a way of "re-civilizing" it. The very idea of a civilizing mission would be profoundly off-putting for obvious reasons. Rather, projects like *The Invisible Soundtrack*, *Silent Room*, *Concrete Sampling*, *50cm Slab*, *Public Hearing*, and *Landline* draw attention to the invisible processes that have kept Beirut in perpetual upheaval. Through attention to the acoustic city they give form to systemic problems such as corrupt redevelopment policy, the privatization of public space, and uneven law enforcement; individual and collective experiences of trauma and conflict; and, equally, the diminishment of the rights and dignities that shape civic life: the right to work safely, the right to citizenship, the right to protest, the right to gather, the right to remember, the right to speak, and the right to listen.

As such these sonic practices articulate a new paradigm for the acoustic city. They are not so concerned with improving urban soundscapes, or with articulating acoustic design as an alternative mode of urban design, as much as they are with revealing deeper truths about the city. We might therefore consider such practices not as ways of revivifying city spaces through art, but in a forensic capacity: as evidence of the processes that shape cities, and of the myriad local and transnational forces that come to bear upon the city dweller.[10] By becoming attuned to the modes of listening they suggest, we become newly aware of what has happened, and what is happening, in the city. And, by listening in this way, we reorient our understanding not only of our surroundings, but equally of ourselves, finding new points of hearing and new perspectives through which to listen.

9 Epilogue

This book has traced a listening path from the body to the city and back. When Somerville Scott Alison coined the term "bin-aural" it was in connection to studies that aimed to collapse the distance between the two ears and the two chambers of the human heart. Time and again he put the ear-pieces of the differential stethoscope in his ears and held its two trumpets to the chest, listening for evidence of disease. Within this three-dimensional mode of listening he was acoustically transported into the spaces of the body as if the body were an aural architecture. He listened for how sounds were reflected inside the body; how they interacted with tissues and organs as if the body were a building made of reflective and absorptive surfaces. He inhabited this space through listening.

Listening to the city—or putting listeners into dialogue with the city, as the projects discussed in chapter 8 do—might seem to be a wholly different kind of gesture. And yet these projects similarly offer alternative ways of understanding the world, by attending and listening to sounds as they are manifested in relation to space. The spaces themselves have exploded: they can be as large as a building, a neighborhood, or even a city; and some have been shaped by the literal explosions of conflict and warfare. Listening to such spaces in a city such as Beirut—one in which listening itself has been repressed—is undeniably a political as well as a physical and sensorial act.

The methods for "hearing space" discussed in this book are enormously varied. They include plugging headphones into the façade of a building in order to hear its materiality; listening while submerged under water in order to investigate the propagation of sound; chasing elusive and mesmerizing echoes—even, in one story, to the point of death; appreciating sacred music only through its reflections and reverberations in an architecturally distinct church; observing sounds through scientific instruments like the homophone and pseudophone in order to better understand auditory space perception; listening to faraway music, theater, and opera transmitted over telephone wires in three-dimensional auditory relief; listening through sound location technologies during warfare, as a means of survival; being

engulfed by spatial music; taking soundwalks and listening walks; mapping the soundscapes of cities; using noise meters and mobile phones to measure the noise levels of a site; "hearing architecture"; and listening in a city where listening can be a dangerous prospect. In these different listening contexts, the idea of "space" is equally varied, as are the ways in which space is constituted, sensed, navigated, imagined, and understood.

This historical variety is in itself remarkable. The examples in this book make clear that, for centuries, people have listened to space not only as a way of understanding its characteristics or dimensions, but as a way of probing deeper truths. When Francis Bacon listened for echoes in a ruined chapel he found evidence of the divine. When Samuel Morland listened to the voice projected through the speaking trumpet he concluded that sound's effects were beyond human comprehension, since they are ultimately transmitted not only to a physical location, but, he believed, to the soul. When Omaya Malaeb's urban wanderer speaks to other inhabitants of the noise-city, it is to offer them hope in a place that can seem hopeless.

It is these deeper truths that are at once the most difficult to articulate but that unite these varied gestures, emerging as they do from different cultural, sociopolitical, geographical, and historical contexts. Some are gestures of delight—in the sensations and promises of new technologies, for example, as in BTL's experiments with stereo reproduction, or in Edgard Varèse's dream of a spatial music. Others are gestures of defiance and resistance, as in Rebecca Belmore's installation of a megaphone in the Rocky Mountains. Still others are gestures of survival, as in the case of soldiers who listened to war machines that attacked at night, under the cover of clouds.

One of the themes to emerge from this history is the influence of war on sonic cultures. War has certainly transformed the soundscapes of innumerable places, and it has led to countless scientific and technological advances in sound and acoustics. How these wartime advances have shaped sonic cultures more broadly, however, has not been as widely studied and is not always immediately apparent. We find evidence of this influence in several chapters—for example, in the stereo sound recording and reproduction technologies that developed directly as a result of military research in sound location during the First World War; and in the rise of applied methods of psychoacoustics that emerged in the 1940s, again, directly as an outgrowth of the Second World War.

For this reason, it seemed important to return to a context and environment that was distinctly shaped by war for the chapter on sonic urbanism. I have a personal connection to Beirut, given that my family fled the Lebanese civil war when I was young. When I returned to the city decades later, it was originally to research sound art in a post-conflict context—a project that also interested me in relation to Belfast, which, like Beirut, also has a vibrant sound art scene (Ouzounian 2013). In setting out for Beirut I thought I had some idea of how people might speak about the war in relation to sound and listening. For many years I heard

stories from friends and relatives about how those who lived through the war had become intimately familiar with the sounds of airplanes, guns, bombs, and other technologies of war; and I learned about the terror that many people experienced while listening in such a context. What I had not anticipated was that, first, many people in Beirut do not view their city as a post-conflict city but rather as one that perpetually exists in and between different states of conflict; and second, not only is war acoustically manifested in the presence of sounds, but equally in their absence—in the hollowness and acoustic reflectiveness of ruined and abandoned architectures that remain long after a war is technically over. In 2018, as part of his project *City of Impulse*, the architect and sound artist Merijn Royaards made sound recordings in one such abandoned building in Beirut, locally known as "The Egg": a brutalist, egg-shaped, multistory former cinema house in the city center. He made impulse noises (sharp, impulse-like sounds) in it, as acousticians do when they calculate the reverberation time of an architectural space; and he listened to the city as it was filtered through The Egg, thinking of the building as a kind of mixing board for the city. Hardly a year later, this once-abandoned space has become reoccupied by thousands of protesters who are making a case for unity in a country that has been deeply scarred by division and sectarianism. Their voices gain literal and symbolic power as they gather and fill the echoic chambers of The Egg, a space whose reverberation time is so long that individual voices are already difficult, if not impossible, to distinguish.

The chosen case studies in this book mark key episodes in the evolution of the understanding of sound and space. However, the histories described here are all ongoing, and in some cases rapidly evolving; their unfinished nature begs for another return and another perspective, if not many others. My own subjective listening to a city undergoing rapid transformation is a small part of this process.

Finally, this account has been an attempt to capture a sliver of the enormous variety of thought and experience vis-à-vis *stereophonica*: spatial sonic phenomena, where "space" is understood not in absolute terms but as something that is socially, culturally, and politically produced. It has thus given historical form to something that has been described as incomprehensible, unknowable, ineffable—beyond the realm of physics and philosophy. While this project has been concerned with recovering historical knowledge, I hope it has also retained a sense of the wonderment at what has seemed, for so many, to be an illusion; something perplexing, mesmerizing, overwhelming, exhilarating. To hear a world in a sound.

Notes

1 Introduction

1. The opening three examples respectively refer to: *BUG* (2008–ongoing), a permanent installation by the artist Mark Bain in a building designed by the architects Arno Brandlhuber, Brandlhuber+Emde, ERA, and Burlon at Brunnenstrasse 9 in Berlin's Mitte district, as part of a project supported by the Tuned City urban sound initiative (Tuned City 2008); *Vex* (2017), a London home designed by the architects Steve Chance and Wendy de Silva—who form the architecture firm Chance de Silva—in collaboration with the musician Robin Rimbaud, aka Scanner (Chance de Silva 2017); and *Silent Room* by Nathalie Harb, who collaborated with the architecture firm BÜF Architecture, the acousticians 21dB, and the musician Khaled Yassine (Harb 2017).

2. The second group of examples refer to Signe Lidén's sound essay "Robert Revisited" from her series *Wave Forms and Tunnel Visions III* (Lidén 2015); Sam Auinger's *Listening Sites in Bonn* (2010) (Auinger 2010); and Christina Kubisch's *Electrical Walks* series, ongoing since 2004.

3. See, for example, "acoustic space" (Carpenter and McLuhan 1960); "aural architecture" (Blesser and Salter 2007); "soundscape" (Schafer [1977] 1994; Thompson 2002); "aural landscape" (Thompson 2002); "auditory landscape" (Corbin 1998); and "acoustic territory" (LaBelle 2010).

4. Peirce describes this catalog as having been prepared "with the greatest care from the Catalogue of Dr. [Thomas] Young, in his Lectures on Natural Philosophy and from an examination of every volume of the Memoirs of the Academies of Paris, Turin, Berlin, Petersburgh, Göttingen, Philadelphia, Boston, of the Philosophical Transactions of London, Edinburgh, Dublin, Cambridge, the Journal de Physique by [François] Rosier, the Journal Polytechnique, Annales des Mathematiques, various Catalogues and Journals, and the works of [Daniel] Bernoulli, [Jean le Rond] D'Alembert, [Augustin-Louis] Cauchy &c" (Peirce 1836, iv). In other words, we can consider it to be as comprehensive a bibliography as any of its time.

5. In *Philosophiae naturalis principia mathematica* (Newton 1687), commonly known as the *Principia*, Newton established mathematical principles of sound wave propagation by observing principles of wave motion and oscillation in other materials, for example of water rising and falling in pipes, or a pendulum swinging in air. He suggested that sounds, arising from "tremulous bodies," were nothing other than "pulses of the air propagated through it," a fact, he claimed, that could be confirmed by

"the tremors which sounds, if they be loud and deep, excite in the bodies near them, as we experience in the sounds of drums" (cited and translated in Chandrasekhar 1995, 591). See Hunt (1978, 148–161) for a discussion of Newton's contribution to the wave theory of sound and the historical controversies surrounding his speed-of-sound calculations.

6. Charles Curtis cautions that contemporary discourses on "spatialized sound" generally overlook "the simple fact that sound, considered as energy that travels in waves, is inherently spatial" (Curtis 2009, 108). He writes, "The term itself . . . is jarring, suggesting that sound is in need of having this done to it. A confusion appears to have set in" (108). The confusion that Curtis identifies is a relatively recent one whereby sound is characterized as "spatialized" only when it is reproduced via multichannel sound systems, whereas, as Curtis writes, sound itself, when considered in the physical sense, is already spatial.

7. Lamarck suggested that sound and noise constituted an "invisible fluid" that "surrounds us everywhere, in which, consequently, we find ourselves constantly immersed" (Lamarck 1799, 398; my translation). See Rodgers 2016 for a study of wave and water metaphors in acoustics and audio technologies, which Rodgers interprets through the lens of feminist theory.

8. Francis Bacon described sound as a *"Trembling Medium,"* likening it to smoke (Bacon 1627, III.264, 59; emphasis in original), and identified a number of forms of *"Audibles,"* including "Articulate Voices, Tones, Songs and Quaverings" (III.258, 59; emphasis in original).

9. Bacon wrote, "The *Repercussion of Sounds,* (which we call Eccho), is a great Argument of the *Spiritual Essence of Sounds.* For if it were Corporeal, the Repercussion should be created in the same manner, and by like instruments, with the original Sound" (Bacon 1627, III.287, 62–63; emphasis in original).

10. Kip Lornell writes, "Antiphony has graced black American music since slavery and its contemporary use recalls prayer and church services, railroad gandy-dancers (track layers), and blues singers" (Lornell 2012, xix).

11. In *"Musik in Raum"* Karlheinz Stockhausen suggested that there had been many examples of spatial effects throughout the history of Western art music, including the poly-choric, antiphonal works of the Italian Renaissance; echo effects in Baroque music; and even the principle of repetition of two-, four-, and eight-bar phrases in Classical forms. Still, he argued that these spatial effects had "as little as possible in common with the present-day situation," referring to multichannel electronic and electroacoustic music (Stockhausen [1958] 1961, 68).

12. Morland wrote that voices "make spherical Undulations in the Air. . . . But what manner of Images or Species such Percussions make; with such an infinity of distinctions and varieties? and how they fly about like Atoms in the Air? and are to be found in each point of the Medium? (and anon vanish into nothing?) and by what stupendious agility they are conveyed to the Soul? and how that does to receive so many millions of messages from without? and to dispatch and send out as many more from within? and that in so short a space of time? the more we torment our thoughts about it, the less we understand it, and are forced to confess our Ignorance" (Morland 1672, 7).

13. As such, Morland's illustration conformed with definitions of sound that circulated in Western cultures since at least the time of Aristotle. In Aristotle's *De Anima (On the Soul),* which dates from around 350 BC, sound is already described as "a kind of movement of the air" (*DA* II.8 420b11, translated by W.

S. Hett in Aristotle 1957, 117). Mark Johnstone remarks, "The air that has been moved is said to 'reverberate' inside a hollow object, to 'bounce' back, to 'rebound', to be capable of 'dispersing', to 'vibrate'" (Johnstone 2013, 634). Aristotle developed a distinctly spatial conception of sound, one that was rooted in ideas of movement, displacement, reflection, and reverberation (see Burnyeat 1995; Johnstone 2013).

14. In 1684 the English clergyman and philosopher Narcissus Marsh, who referred to Morland's speaking trumpet in his "Doctrine of Sounds," wrote that just as microscopes and magnifying glasses aided the eye in perceiving objects that were otherwise invisible, "So *Microphones* . . . may be contriv'd [such] that they shall render the most minute Sound in nature distinctly *Audible*, by *Magnifying* it to an unconceivable loudness" (Marsh 1684, 482; emphasis in original). Chladni wrote, "An ear trumpet is, so to speak, a reverse megaphone, arranged so that all the action of the sound that is made on a larger surface concentrates in the auditory canal of people who are hard of hearing" (Chladni [1809] 2015, 153).

15. On the development of architectural acoustics, see, for example, Thompson 2002; Blesser and Salter 2007; Howard and Moretti 2009; Atkinson 2016; and Guillebaud and Lavandier 2019.

2 The Rise of the Binaural Listener

1. Melissa Dixon (2016) examines the Enchanted Lyre in relation to nineteenth-century cultural fantasies around enchantment, supernatural presence, and disembodiment, situating Wheatstone's demonstration within Victorian traditions of spectacular science as well as nineteenth-century experiments in acoustics concerned with the materialization and visualization of sound.

2. In "New Experiments on Sound" Wheatstone drew parallels between his experiments on mechanical oscillation and Chladni's experiments from the late 1780s, in which Chladni bowed metal plates that had sand lightly sprinkled onto them, thereby revealing nodal patterns. He likewise drew attention to Ørsted's more recent experiments from 1810, which investigated similar principles using Lycopodion, a fine powder. Chladni's acoustic figures were first published in his 1787 treatise *Entdeckungen über die Theorie des Klanges* (*Discoveries in the Theory of Sound*). Wheatstone would later analyze and refine Chladni's work, revealing further patterns where the unaided eye could find none (Wheatstone 1833).

3. In its time the Enchanted Lyre was described as a kind of "telephone" (Mills 2009, 144). More recently it has been characterized as a kind of "telemusic" (Joy 2009, 475).

4. The differential stethoscope has also been called the "double stethoscope" (Théberge, Devine, and Everrett 2015, 276).

5. Alison wrote, "This remarkable separation of the components of a sound may be effected also when the sounding bodies are enclosed in a box capable of transmitting sound, or when separated from us by the interposition of materials capable of conducting sound; and by successive trials and comparisons of intensity at different places, and by a process of exclusion of those parts which fail to cause sensation, the respective positions of two adjacent sounding bodies may be predicated" (Alison 1858, 206).

6. Théberge, Devine, and Everrett (2015, 24) characterize Steinhauser's statement as an exaggeration. Indeed, Steinhauser was aware of Lord Rayleigh's and Sylvanus P. Thompson's studies on binaural audition, which he referenced in his own article.

7. This passage in *Scientific American* is attributed to "M. Hospitalier" in an article from *L'Électricien* from 1881. The writer in question is Édouard Hospitalier (see E. H. 1881).

8. Tyler Whitney suggests that the théâtrophone "transported listeners into the spaces of the opera hall or to other distant performances" (Whitney 2013, 233). "But," he writes, "the sounds on the other end also extended outward and ultimately entered into the listener's head. Singer and listener each moved toward the other, using the spaces of the stereophonic telephone as a complex conduit, shuffling between the performance hall and internal spaces of the body" (233–234).

9. In 1896–1898 Matataro Matsumoto conducted experiments that made use of a similar rotating chair apparatus at the Yale Psychological Laboratory (Matsumoto 1897). Matsumoto indicates that these experiments were conducted according to statistical methods established by William Thierry Preyer (1887), but that the rotating chair apparatus was used as an alternative to Preyer's "sound helmet" (Matsumoto 1897, 1; see also Brech 2015, 76–78). Pierce (1901) describes this sound helmet as "a sort of cap made of wire . . . from which projected 'pointers' several inches in length. These pointers were arranged symmetrically over the surface of the helmet [in] twenty-six different directions. Sounds were given at the extremities of these pointers and the subject was required to give his judgement of the position of any sound in terms of the positional designations agreed upon" (Pierce 1901, 37). Matsumoto (1897) and Pierce (1901) both acknowledge the influence of Ernst Heinrich Weber and Eduard Weber's work on sound localization, in particular the idea that the outer ear and sensations on the eardrum are both involved in determining the direction of sounds (see Pierce 1901, 23–24; see also E. H. Weber (1846, 1849) and E. F. Weber (1851). See Hui (2013) for a discussion of Ernst Heinrich Weber's influential role in psychophysical studies of sound sensation in the nineteenth century.

10. Pierce suggested that an effect approximating that of intracranial sounds could be produced by loudly singing "oo" or "mm" with closed lips. He wrote, "The successive stopping of one and both ears will cause the sound to wander up first to the closed ear and then to a point within the head" (Pierce 1901, 125).

3 Powers of Hearing

1. In order to produce "The End of the War," a series of six microphones were set in a row near the front lines. The sound of a gunshot arrived at each of the microphones at slightly different times. By calculating these time intervals and applying a process of triangulation, the position of enemy guns could be identified (see Trowbridge 1919).

2. The caption for "The End of the War" in *America's Munitions* indicated that "the two minutes on either side of the exact armistice hour have been cut from the strip to emphasize the contrast" (Crowell 1919, frontispiece).

3. It was a similar story with underwater acoustics and submarine detection (see Bruton and Coleman 2016, 251).

4. Tucker's hot-wire microphone had a built-in filter that responded only to the sounds of gun reports. Tucker was originally posted to the Experimental Sound Ranging Station at Kemmell Hill, Belgium,

where he served under the command of Sir William Lawrence Bragg. For more on Tucker's work in sound ranging see Van der Kloot 2005 and Wittje 2016.

5. See the archival collection *Miscellaneous Wartime (WWI) Collection of Chiefly Reports*. MS2019. Science Museum Library and Archives, Wroughton, England.

6. The department was also sometimes referred to as *l'Etablissement central du matériel de la radiotélégraphie militaire*; or simply *Télegraphie militaire*. In English language documents it is sometimes referred to as "Central Establishment for Material of the Military Telegraph."

7. Lewis Pyenson writes, "Wireless, which provided the precise time signals that were essential for mapping, was the domain of the Army's communications branch, whose resident expert was Gustave-Auguste Ferrié. . . . Soon after he made captain in 1897, he was transferred to the central office of military telegraphy. In 1898 he began experimenting with Hertzian waves, and the following year he assisted Guglielmo Marconi in sending wireless signals between England and France. The Ministry of War lost no time in having Ferrié organize a military radiotelegraphic service; over the next 30 years Ferrié directed the service's expanding fortunes" (Pyenson 1996, 145).

8. According to Baillaud, Perrin had an entire group of researchers to whom he could have entrusted the problem of tracking aircraft through their sounds, "but it was [Perrin] himself who undertook to solve it" (Baillaud 1980, 129; my translation). Baillaud writes that he therefore found himself "involuntarily in competition with one of the most famous French scientists, a future member of the Institute [of France] (1923), a future Nobel Prize winner in Physics (1926), and a future minister (Under-Secretary of State 1936–37 and 1938)" (129).

9. John R. Innes remarked of sound ranging, for example, that "it was the French who first took it up; and it was the French who first tried it out, and, if in the end the British system proved itself superior to the French system, much of the credit for this must go to the French for their pioneer work and for the ready assistance they rendered when the British Army first took the job in hand" (Innes 1935, 141).

10. This document is an English translation, issued by the U.S. War Department, of a French military manual that was originally produced by the ECMT.

11. Baillaud writes, "I was told that this was the first time that a parabolic mirror was used for *locating* sources other than light sources. It's possible; the idea was adopted in the case of radar and in radio telescopes" (Baillaud 1980, 133n1; emphasis in original).

12. Raviv Ganchrow (2009) gives a detailed account of the acoustic paraboloid and its long-range correlate, the sound mirror, focusing on their development and use in Britain. He makes the compelling argument that sound mirrors, particularly when used in conjunction with imaging technologies, demarcated a "paradigmatic shift in perceptual relations" (73). He writes, "A subtext to the development of [sound] mirrors is the shift in observational methods away from the optic model of the telescope (wherein the eye is seen to extend into a 'stable' landscape) to the radiant model of interferometry (wherein a point of observation becomes the anchor in an otherwise fluctuant zone of wave fronts)" (73).

13. Baillaud wrote, "The first application of the principle of binaural audition was made in early 1915 by the Radiotélégraphie Militaire, for listening to subterranean sounds (General Ferrié and Mr. Jouaust)" (Baillaud 1922, 60, my translation). We also find in a technical report issued by the U.S. Bureau of Mines that "French physicists are credited with [the geophone's] invention" (Ilsley, Freeman, and Zellers 1928, 4).

14. Baillaud also referred to Lord Rayleigh's experiments, writing, "Lord Rayleigh was the first to show the role played by the difference in phase of sound waves arriving at the two ears in sensing the direction of the sound focus" (Baillaud 1922, 59; my translation).

15. Wittje traces Hornbostel and Wertheimer's sound locator to a device developed by Wolfgang Köhler, who had worked on binaural audition at the Psychological Institute in Berlin before the war (Wittje 2016, 75).

16. Sterne writes, "Audile technique emerged as a distinctively modern set of practical orientations toward listening. As a way of knowing and interacting with the world, it amounted to the reconstruction of listening in science, medicine, bureaucracy, and industry. It helped constitute these fields" (Sterne 2003, 95).

4 Sound and Music in Three Dimensions

1. In 1933, "Bell System" was used to designate an organization that comprised the American Telephone and Telegraph Company (AT&T) and twenty-four regional operating companies. The Western Electric Company served as the manufacturing and purchasing department of the Bell System (American Telephone and Telegraph Company 1933).

2. As H. D. Arnold, director of research at BTL, wrote in his introduction to Fletcher's landmark study, the study of hearing should encompass not only an understanding of speech but also of music, because "if we attempt to divide the study [of hearing] between speech and music we come upon the difficulty that speech conveys information by intonation as well as by articulate syllables; and this makes it infeasible to set a definite boundary between them" (Arnold 1929, xiii).

3. "Head receivers" referred to two telephone receivers that listeners held to their ears. In effect, they were proto-headphones.

4. As a result of these recording tests, Arthur C. Keller and Irad S. Rafuse of the Instrument Transmissions group made several breakthroughs in stereophonic recording, including single-groove stereo playback. Some of these stereo recordings were publicly released in the album *Early Hi-Fi* (Bell Telephone Laboratories 1979b). For an account of these developments, see Keller, Vernon, and Rafuse 1938; Keller 1981; and McGinn 1983.

5. The total attendance at the Bell System exhibit was estimated at around 6,350,000 (Smith 1934, 5). With regard to the Oscar Show, AT&T estimated that "about 4,500,000 persons stopped to observe the [Oscar] show and close to 600,000 actually heard the demonstration" (6).

6. The reviews in the *Philadelphia Inquirer* and the *New York Times* were on the occasion of a preview performance of the Philadelphia-Washington demonstration. The preview performance took place in

the Academy of Music in Philadelphia on April 12, 1933. During this performance the orchestra played in a sound-proof room, while the audience was seated in the auditorium.

7. In his 1937 study *Toward a New Music: Music and Electricity*, Carlos Chavez wrote, "Electrical musical transmission radically alters the role of the conductor. He no longer fixes the balance of the orchestral sound solely in relation to the personal capacities of his players. Both before and during the performance he will regulate the amplification, using the control panel to obtain the musical result he wishes" (Chavez 1937, 84).

8. A short version of the program can be found in "Stereophonic Recordings of Enhanced Music" 1940a, 258–259. However, archival copies of the program show a different (and longer) program, summarized here.

9. BTL would not be able to take advantage of the commercial boom in stereo sound. According to a press release, "While the Bell System had virtually ceased activities in the entertainment industry by the 1940s, a 1956 agreement with the U.S. government officially ended involvement of the Bell System in activities other than telecommunications" (Bell Telephone Laboratories 1979a, 5).

10. These remarks are from a review in the *New York Times* of another demonstration of stereo sound by Fletcher and BTL scientists, given on the occasion of an annual convention of the American Institute of Electrical Engineers, on January 24, 1934. This demonstration was given at the Engineering Societies' Building at 29 West 39th Street in New York City ("'Solidified' Music Shakes a Building" 1934, 15).

11. BTL's experiments in binaural and stereo sound inspired composers including Edgard Varèse, who between 1932 and 1936 repeatedly (and unsuccessfully) applied for a Guggenheim Fellowship to collaborate with Fletcher at BTL. Varèse wrote of the desire to "to prove to [the technicians of different organizations] the necessity of a closer collaboration between composer and scientist" (Wen-Chung 1966, 2).

5 Psycho-Acoustics

1. Both of the opening quotes in chapter 5 are from Kaempffert 1940.

2. Alternative theories at the time held that the sounds were the result of building noise (e.g., bad engineering) or surveillance technologies gone awry. More recently, it has been suggested that the sounds were unintentionally caused by acoustic interference through the use of surveillance technologies (Yan, Fu, and Xu 2018)—or crickets.

3. Harold Burris-Meyer is the subject of a recent biography by Juliette Volcler, *Contrôle: Comment s'inventa l'art de la manipulation sonore* (2017). His work is also mentioned in histories of Muzak (Lanza 1994; Jones 2005) and studies of sonic deception and sonic warfare (Holt 2004; Goodman 2010).

4. The National Defense Research Committee (NDRC) was established in June 1940 by Executive Order of the President in order to coordinate military scientific research at a national level and across the various branches of the U.S. military. One of the six executive members appointed to the NDRC was Frank B. Jewett, who by then was president of both BTL and the National Academy of Sciences. In 1941 the NDRC was subsumed into the Office of Scientific Research and Development (OSRD).

5. For relevant studies on Muzak, see Jones and Schumacher 1992; Lanza 1994; Suisman 2009; Kassabian 2013; Vanel 2013; Clark and Lyons 2014; and Anderson 2015.

6. Beranek, a recent PhD graduate who had yet to secure his first permanent academic post, thus found himself at the head of a massive operation, the EAL. A second laboratory, PAL, was soon established in the basement of Memorial Hall at Harvard, with Stanley S. Stevens in charge. Beranek's group initially studied the reduction of noise in combat vehicles, while Stevens's group initially studied the effects of noise on psychomotor efficiency. Over the course of the war, the groups would study such phenomena as noise generation, noise reduction, and the design of intercom and radio systems, earphones, microphones, and other devices for military communications (see Beranek 2008 and Rosenzweig and Stone 1948).

6 From a Poetics to a Politics of Space

1. Studies by Lander and Lexier (1990); Kahn and Whitehead (1992); Augaitis and Lander (1994); Wishart (1996); Kahn (1999); Schulz (2002); Drobnick (2004); LaBelle (2004; 2006; 2010); Licht (2007); Kim-Cohen (2009); and Voegelin (2010) have made significant contributions to the historical and theoretical understanding of sound art. Much of the academic literature on this subject, however, remains focused on composition, recording, transmission, and performance practices, with installation practices receiving relatively less attention by historians and critics. Writings by artists, exhibition catalogs, and artist monographs are a key resource, and make up the bulk of the literature on sound installation art.

2. A version of this chapter first appeared in the volume *Music Sound and Space: Transformations of Public and Private Experience* (2013), ed. Georgina Born. I am grateful to Born for her advice on that chapter, and to my dissertation advisers George Lewis, Jann Pasler, and Anthony Davis for their guidance on my PhD dissertation "Sound Art and Spatial Practices: Situating Sound Installation Art Since 1958" (Ouzounian 2008).

3. *Poème électronique* was the name given to Varèse's composition as well as to the larger multimedia project by Le Corbusier, Xenakis, Varèse, and others. Xenakis, a self-taught composer who worked as an architectural assistant in Le Corbusier's Paris studio, designed the outer shell of the building based on very basic sketches by Le Corbusier. Xenakis's designs, which featured hyperbolic paraboloid curves, are considered to be the first of their kind in architecture.

4. Marc Trieb writes, "The recording was made on one track, reserving the second and third tracks for 'reverberation and stereophonic effects.' A second tape, with fifteen tracks, was used to control the distribution of the sounds among the several hundred speakers positioned throughout the building. The tracks were 35 mm wide, punched with the same perforations as cinematic film. Each of the tapes was scanned on its own playback machine (with up to fifteen playback heads); each unit was duplicated, yielding a total of four playback machines in the control room. Twenty amplifiers, each with 120 watts, powered the production" (1996, 203).

5. The *pupitre d'espace* was also called *pupitre de relief* or *potentiomètre d'espace*. It has been variously translated into English as "relief desk," "space console," and "spatialization desk."

6. Stockhausen wrote of *Gesang der Jünglinge*, "I attempted to form the direction and movement of sound in space, and to make them accessible as a dimension for musical experience" (Stockhausen [1958] 1961, 68).

7. In 1958 the GRMC would be renamed Groupe de Recherches Musicales (GRM).

8. Brant himself would say, "What I'd like to do ideally is leave the audience free, go any place, as in a picture gallery. And I see nothing vague about this. What this means is that what they hear takes in every element from any position of the house, but of course always in a different proportion" (cited in Brooke 2014).

9. These Event scores are reprinted in *The Fluxus Workbook* (Friedman 1990).

10. Young was associated with Fluxus in its early stages and organized concerts of experimental music at Ono's loft during this period.

7 Mapping the Acoustic City

1. These reports are compiled as part of the project "London's Pulse: Medical Officer of Health reports 1848–1972," by the Wellcome Collection. See https://wellcomelibrary.org/moh/.

2. See Barkhausen 1926; Bakos and Kagan 1932; Lübcke 1938; Kösters, Beirreth, and Kemper 1938; and Meister 1956, 1957.

3. The phon is a unit of measure for the perceived loudness of sounds (Bijsterveld 2008; Heller 2015). Bijsterveld writes that at the first meeting of the International Committee on Acoustics (ICA) in 1937, a decision was undertaken to "work with two different units, the decibel and the phon. [The ICA] defined the decibel as the unit expressing the intensity of sound, and the phon, a unit of German origin, as the unit expressing the level of equivalent loudness" (Bijsterveld 2008, 106).

4. Whereas the decibel (dB) scale accounts for sound intensity, the A-weighted decibel (dbA) scale is weighted to account for the relative loudness perceived by the human ear, since the ear is less sensitive to low frequencies.

5. See 49 US. Code § 47507: "Nonadmissibility of noise exposure map and related information as evidence" https://www.law.cornell.edu/uscode/text/49/47507.

6. The developers of SONYC write that the SONYC system "includes a hybrid, distributed network of sensors and citizens for large-scale noise reporting. . . . Information from the network flows through a cyberinfrastructure that analyzes, retrieves and visualizes data to facilitate the identification of important patterns of noise pollution: a noise 'mission control' center of sorts, intended for decision-makers at city agencies to strategically deploy the human resources at their disposal to act on the physical world" (https://wp.nyu.edu/sonyc/).

7. Noise maps historically have portrayed a bird's-eye view, but with new mapping and visualization technologies, noise maps can also show street-level representations of noise levels, allowing users to "zoom in" and "zoom out" dynamically on a digital map.

8 Hearing the Acoustic City

1. During my visits to Beirut I kept a journal, containing what I thought of as "essays in situ" (in effect, site-specific essays) on sonic environments I encountered there. I include a few of those entries in this chapter. This chapter draws on conversations with local artists, theorists, architects, urban designers, and curators, as well as with fellow visitors to the city. They include Amanda Abi Khalil, Haig Aivazian, Howayda Al-Harithy, Annelise Andersen, Joan Baz, John Bingham-Hall, Nathalie Harb, Lea Kayrouz, Omaya Malaeb, Nadim Mishlawi, Joe Namy, Ibrahim Nehme, Elisabetta Pietrostefani, Merijn Royaards, Mhamad Safa, Youmna Saba, Richard Sennett, Christabel Stirling, Sasha Ussef, and Cynthia Zaven. I'm grateful to them for our conversations, ongoing dialogue, and collaborations.

2. See, for example, Thompson 2002; Picker 2003; Thibaud 2003; Augoyard and Torgue 2005; Back 2007; Bull 2007; Kang 2007; Peterson 2010; LaBelle 2010; Baker 2011; Birdsall 2012; Bijsterveld 2013; Belgiojoso 2014; Gandy and Nilsen 2014; Wissmann 2014; Boutin 2015; Atkinson 2016; Lacey 2016; Ouzounian and Lappin 2016; Cusack 2017.

3. See http://www.tunedcity.net/.

4. In *Expulsions* (2014) Saskia Sassen describes the "subterranean trends" and the deeper systemic dynamics that shape contemporary globalized economies, often to brutal effect. She draws attention to trends that are "hard to see when we think with our familiar geopolitical, economic, and social markers" (Sassen 2014, 6).

5. In *Divided Cities* (2009) Jon Calame and Esther Charlesworth argue that urban division is "typically the product of external forces acting on a city with the intent to protect it, save it, claim it, demoralize it, or enlist it in a larger struggle from which it cannot benefit" (Calame and Charlesworth 2009, 8).

6. *Urban Sound and the Politics of Memory* was cohosted by Recomposing the City, a research group I direct with the architect Sarah Lappin, and Theatrum Mundi, an organization dedicated to the crafts of city-making founded by Richard Sennett and directed by John Bingham-Hall. The program was supported by a research grant from the Arts & Humanities Research Council of the UK, as part of the project "Hearing Trouble: Sound Art in Post-Conflict Cities" (AH/M008037/1), developed in collaboration with the architect Sarah Lappin. *Urban Sound and the Politics of Memory* facilitated opportunities for exchange between sound artists and built environment practitioners and theorists from Lebanon and the UK (see Theatrum Mundi 2018 and Recomposing the City 2019).

7. *The Invisible Soundtrack* and several other projects discussed in this chapter—including *Silent Room*, *50cm Slab*, *Public Hearing 2*, and *Landline*—are documented as part of an edition of collected works, *Acoustic Cities: London and Beirut*, that I curated with John Bingham-Hall (see Various Artists 2019).

8. *Silent Room* was first presented as part of Beirut Design Week in 2017. It has since been presented in London, as part of London Design Biennale (2018); and in Beirut as part of *La Semaine du Son au Liban* in 2019.

9. The text quoted here was written by Raafat Mazjoub for Omaya Malaeb's *Landline* (Malaeb 2019); it is translated from the original Arabic by Malaeb. This is an excerpt from a longer work. Used with the permission of Omaya Malaeb.

10. Although I apply the concept differently in this chapter, the idea of "forensic listening" owes much to the work of Forensic Architecture (FA), an architectural research agency based at Goldsmiths, University of London. The agency uses spatial and media analysis to investigate cases of human rights violations (Weizman 2017). "Forensic architecture" is also the name of a research methodology that FA has developed, and refers to "the production and presentation of architectural evidence—relating to buildings, urban environments—within legal and political processes" (Forensic Architecture 2019). The Beiruti artist Lawrence Abu Hamdan has been an important proponent of forensic architecture in the sound art world, in particular through his forensic investigations of audio recordings, and his analyses of "earwitness" testimonies and other sonic evidence used in legal cases (Abu Hamdan 2019).

References

Archival Resources

AT&T Archives and History Center, Warren, New Jersey.

Churchill Archives Centre, University of Cambridge, Cambridge, England.

Paul D. Fleck Library and Archives, Banff Center, Banff, Alberta, Canada.

Archives & Special Collections, Samuel C. Williams Library, Stevens Institute of Technology, Hoboken, New Jersey.

Science Museum Library and Archives, Wroughton, England.

San Francisco Museum of Modern Art (SFMOMA) Library and Archives, San Francisco, California.

Works Cited

Abu Hamdan, Lawrence. 2019. Artist website. Accessed May 25, 2019. http://lawrenceabuhamdan.com/.

Ackermann, Rudolph, and Frederic Shoberl. 1821. "Musical Intelligence: The Enchanted Lyre." *Ackermann's Repository of Arts, Literature, Fashions, Manufactures, &c.*, The Second Series 12 (69): 173–175.

Ader, Clément. 1882. "Telephonic Transmission of Sound from Theaters." US patent no. 257,453, filed January 13, 1882, and issued May 9, 1882.

"Advance Is Shown in Music Recordings." 1931. *New York Times*, December 10, 1931.

Alison, S. Scott. 1858. "On the Differential Stethophone, and Some New Phenomena Observed by It." *Proceedings of the Royal Society of London* 9 (1857–1859): 196–209.

Alison, S. Scott. 1861. *The Physical Examination of the Chest in Pulmonary Consumption and Its Intercurrent Diseases*. London: John Churchill.

Allen, Henry B. 1940. Letter from Henry B. Allen to Frank B. Jewett. Unpublished letter, 1 page, April 10, 1940. Frank B. Jewett files 74-10-01-05. AT&T Archives and History Center.

American Telephone and Telegraph Company. 1933. *The Bell System: Its Organization and Service as Exhibited at a Century of Progress Exposition*. American Telephone and Telegraph Company.

Anderson, Paul Allen. 2015. "Neo-Muzak and the Business of Mood." *Critical Inquiry* 41 (4): 811–840.

Antrim, Doron K. 1943. "Music in Industry." *Musical Quarterly* 29 (3): 275–290.

Aristotle. 1957. *Aristotle On the Soul, Parva Naturalia, On Breath*. Trans. W. S. Hett. Loeb Classical Library. Cambridge, MA; London: Harvard University Press.

Arnold, H. D. 1929. "Introduction." In *Speech and Hearing*, Harvey Fletcher, xi–xv. New York: D. Van Nostrand Company.

Arnold, H. D. 1932. "Philadelphia Tests of the High Quality Reproduction of Orchestral Music." Unpublished manuscript, 12 pages, March 9, 1932. H. D. Arnold Papers, Location 80-02-03, AT&T Archives and History Center.

Atallah, Antoine. 2017. *Panoramic Beirut*. Beirut: Plan BEY.

Atkinson, Niall. 2016. *The Noisy Renaissance: Sound, Architecture, and Florentine Urban Life*. University Park: Penn State University Press.

Augaitis, Diana, and Dan Lander, eds. 1994. *Radio Rethink: Art, Sound and Transmission*. Banff: Walter Phillips Gallery.

Augoyard, Jean-François, and Henry Torgue. 2005. *Sonic Experience: A Guide to Everyday Sounds*. Trans. Andra McCartney and David Paquette. Montréal: McGill-Queen's University Press.

Auinger, Sam. 2010. *Listening Sites in Bonn*. Accessed May 25, 2019. http://www.samauinger.de/Data /other/hoerorte/hoer_orte_bonn_english.pdf.

Babbage, Charles. 1864. *Passages from The Life of a Philosopher*. London: Longman, Green, Longman, Roberts, & Green.

Back, Les. 2007. *The Art of Listening*. Oxford: Berg.

Bacon, Francis. 1627. *Sylva Sylvarum; Or, a Natural History in Ten Centuries*. Ten vols. London: William Rawley.

Baillaud, René. 1922. "Le Problème du repérage des aéronefs au son." *Revue du génie militaire* Tome L, 55–97. Nancy-Paris-Strasbourg: Librairie Militaire Berger-Levrault.

Baillaud, René. 1980. *Souvenirs d'un astronome (1908–1977)*. Rodez: Imprimerie Carrère.

Bain, Alexander. 1855. *The Senses and the Intellect*. London: John W. Parker and Son.

Baker, Geoffrey. 2011. *Music and Urban Society in Colonial Latin America*. Cambridge: Cambridge University Press.

Bakos, G., and S. Kagan. 1932. "Geräusch- und Lärmmessungen." *Zeitschr. V.D.I.* 76 (7): 145–150.

Barbieri, Patrizio. 2004. "The Speaking Trumpet: Developments of Della Porta's 'Ear Spectacles' (1589–1967)." Trans. Hugh Ward-Perkins. *Studi Musicali* 33 (1): 205–248.

Barkhausen, H. 1926. "Ein neuer Schallmesser für die Praxis." *Zeitschrift fur Technische Physik* 7:599–601.

Barnett, Lincoln. 1963. "Interview with Harvey Fletcher." Unpublished manuscript, 17 pages. Location 85-01-01-04, Sound Recording, Stokowski and Bell Laboratories, AT&T Archives and History Center.

Battah, Habib. 2015. "A City without a Shore: Rem Koolhaas, Dalieh and the Paving of Beirut's Coast." *The Guardian*, March 17, 2015. Accessed May 25, 2019. https://www.theguardian.com/cities/2015/mar/17/rem-koolhaas-dalieh-beirut-shore-coast.

Baxter, James Phinney. 1946. *Scientists Against Time*. Boston: Little, Brown and Company.

Baz, Joan. 2018. *Public Hearing 1*. Accessed May 24, 2019. https://www.joanbaz.com/public-hearing-1.

Belgiojoso, Ricciarda. 2014. *Constructing Urban Space with Sounds and Music*. Surrey, UK; Burlington, VT: Ashgate Publishing.

Bell, Alexander Graham. 1880. "Experiments Relating to Binaural Audition." *American Journal of Otology* 2 (3): 169–179.

Bell Telephone Laboratories. 1979a. "Stokowski Q&As." Press release, 9 pages. AT&T Archives and History Center.

Bell Telephone Laboratories. 1979b. *Early Hi-Fi: Wide Range and Stereo Recordings Made by Bell Telephone Laboratories in the 1930s; Leopold Stokowski Conducting the Philadelphia Orchestra, 1931–1932*. New York: Bell Telephone Laboratories, Inc.

Belmore, Rebecca. 1996. *Ayum-ee-aawach Oomama-mowan: Speaking to Their Mother*. Accessed May 25, 2019. http://www.rebeccabelmore.com/exhibit/Speaking-to-Their-Mother.html.

Beranek, Leo L. 1949. *Acoustic Measurements*. New York: John Wiley & Sons.

Beranek, Leo L. 1967. "Street and Air Traffic Noise—And What We Can Do About It." *UNESCO Courier* (July 1967): 12–18.

Beranek, Leo L. 2008. *Riding the Waves: A Life in Sound, Science, and Industry*. Cambridge, MA: MIT Press.

Beranek, Leo L., and Harvey P. Sleeper, Jr. 1946. "The Design of Anechoic Sound Chambers." *Journal of the Acoustical Society of America* 18 (1): 140–150.

Beuving, Margreet, and Paul de Vos. 2004. *IMAGINE—Improved Methods for the Assessment of the Generic Impact of Noise in the Environment*. Utrecht: AEA Technology Rail BV.

Beuys, Joseph. 1990. *Joseph Beuys in America: Energy Plan for the Western Man*. New York: Four Walls Eight Windows.

Bijsterveld, Karin. 2008. *Mechanical Sound: Technology, Culture, and Public Problems of Noise in the Twentieth Century*. Cambridge, MA: MIT Press.

Bijsterveld, Karin, ed. 2013. *Soundscapes of the Urban Past: Staged Sound as Mediated Cultural Heritage*. Bielefeld: Transcript Verlag.

Birdsall, Carolyn. 2012. *Nazi Soundscapes: Sound, Technology and Urban Space in Germany, 1933–1945.* Amsterdam: Amsterdam University Press.

Bishop, Dwight E., and Richard Horonjeff. 1969. "Application of Noise-Exposure Forecast Contours to Noise-Reduction Tradeoff Studies." *Journal of the Acoustical Society of America* 46 (1A): 85.

Blauert, Jens. 1983. *Spatial Hearing: The Psychophysics of Human Sound Localization.* Cambridge, MA: MIT Press.

Blesser, Barry, and Linda-Ruth Salter. 2007. *Spaces Speak, Are You Listening? Experiencing Aural Architecture.* Cambridge, MA: MIT Press.

Bloor, David. 2000. "Whatever Happened to 'Social constructiveness?'" In *Bartlett, Culture and Cognition,* ed. Akiko Saito, 194–215. Hove: Psychology Press.

Böhme, Gernot. 2000. "Acoustic Atmospheres: A Contribution to the Study of Ecological Aesthetics." *Soundscape: The Journal of Acoustic Ecology* 1 (1): 14–18.

bonn hoeren. *urban sound art/stadt klangkunst.* Accessed May 25, 2019. https://www.bonnhoeren.de/.

Born, Georgina. 1995. *Rationalizing Culture: IRCAM, Boulez, and the Institutionalization of the Musical Avant-Garde.* Berkeley: University of California Press.

Born, Georgina. 2013. "Introduction—Music, Sound and Space: Transformations of Public and Private Experience." In *Music, Sound and Space: Transformations of Public and Private Experience,* ed. Georgina Born, 15–85. Cambridge: Cambridge University Press.

Boutin, Aimée. 2015. *City of Noise: Sound and Nineteenth-Century Paris.* Urbana: University of Illinois Press.

Bragg, Sir William. 1921. *The World of Sound: Six Lectures Delivered Before a Juvenile Auditory at the Royal Institution, Christmas, 1919.* 2nd ed. London: G. Bell and Sons Ltd.

Brandlhuber, Arno, and Markus Emde. 2008. "Noise Control: Interview with Arno Brandlhuber and Markus Emde." In *Tuned City: Zwischen Klang- und Raumspekulation/Tuned City: Between Sound and Space Speculation,* ed. Doris Kleilein, Anne Kockelkorn, Gesine Pagels, and Carsten Stabenow, 165–170. Berlin: KOOKbooks.

Brant, Henry. 1967. "Space as an Essential Aspect of Musical Composition." In *Contemporary Composers on Contemporary Music,* ed. Elliott Schwartz and Barney Childs, 221–242. New York: Holt, Rinehart and Winston.

Brech, Martha. 2015. *Der hörbare Raum: Entdeckung, Erforschung und musikalische Gestaltung mit analoger Technologie.* Bielefeld: Transcript.

Brooke, Nick. 2014. "Henry Brant and the History of 'Spatial Music.'" Accessed May 25, 2019. http://roomtone.bennington.edu/exhibit.php.

Brown, Carolyn. 2007. *Chance and Circumstance: Twenty Years with Cage and Cunningham.* New York: Knopf.

Brown, Edward F., E. B. Dennis Jr., Jean Henry, and G. Edward Pendray, eds. 1930. *City Noise*. New York: Noise Abatement Commission, Department of Health, City of New York.

Bruton, Elizabeth, and Paul Coleman. 2016. "Listening in the Dark: Audio Surveillance, Communication Technologies, and the Submarine Threat during the First World War." *History and Technology* 32 (3): 245–268.

Bull, Michael. 2007. *Sound Moves: iPod Culture and Urban Experience*. London: Routledge.

Burnyeat, Myles. 1995. "How Much Happens When Aristotle Sees Red and Hears Middle C? Remarks on *De Anima* 2. 7–8." In *Essays on Aristotle's De Anima*, ed. Martha C. Nussbaum and Amelie Oksenberg Rorty, 421–434. Oxford: Clarendon Press.

Burris-Meyer, Harold. 1934a. Press release. "The Stevens Dramatic Society Announces a Demonstration of a Technique for the Application of Controlled Sound to the Legitimate Stage on May Fourth and Fifth." Harold Burris-Meyer Papers, Box 3, Folder 1, Samuel C. Williams Library, Stevens Institute of Technology.

Burris-Meyer, Harold. 1934b. "Introductory Remarks for the Stevens Sound Show." 3 pages. Harold Burris-Meyer Papers, Box 3, Folder 1, Samuel C. Williams Library, Stevens Institute of Technology.

Burris-Meyer, Harold. 1935a. "The Dramatic Use of Controlled Sound." *Journal of the Acoustical Society of America* 7 (1): 74.

Burris-Meyer, Harold. 1935b. "'Controlled Sound' for Modern Theatres." *Radio-Craft* (September 1935): 157, 185.

Burris-Meyer, Harold. 1940a. "Sound for the Theater." *Journal of the Acoustical Society of America* 11 (3): 380.

Burris-Meyer, Harold. 1940b. "Sound Control Apparatus for Theater." *Journal of the Acoustical Society of America* 12 (1): 122–126.

Burris-Meyer, Harold. 1941a. "Introductory Remarks for the Second Sound Show." 3 pages. Samuel C. Williams Library at the Stevens Institute of Technology. Harold Burris-Meyer Papers, Box 3. Samuel C. Williams Library, Stevens Institute of Technology.

Burris-Meyer, Harold. 1941b. "Theatrical Uses of the Remade Voice, Subsonics and Reverberation Control." *Journal of the Acoustical Society of America* 13 (1): 16–19.

Burris-Meyer, Harold. 1941c. "The Control of Acoustic Conditions on the Concert Stage." *Journal of the Acoustical Society of America* 12 (3): 335–337.

Burris-Meyer, Harold. 1943. "Music in Industry." *Scientific American* 169 (6): 262–264.

Burris-Meyer, Harold. 1957. "Psycho-Acoustics Applied and Misapplied." *Journal of the Acoustical Society of America* 29 (1): 176–177.

Burris-Meyer, Harold. 1964. "Acoustics and People." *Journal of the Acoustical Society of America* 36 (5): 1043.

Burris-Meyer, Harold, and Edward C. Cole. 1949. *Theatres & Auditoriums*. New York: Reinhold.

Burris-Meyer, Harold, and Vincent Mallory. 1950. "Sound in the Theater. II." *Journal of the Acoustical Society of America* 22 (2): 256–259.

Burris-Meyer, Harold, and Vincent Mallory. 1959. *Sound in the Theatre*. Mineola, NY: Radio Magazines.

Burris-Meyer, Harold, and Vincent Mallory. 1960. "Psycho-Acoustics Applied and Misapplied." *Journal of the Acoustical Society of America* 32 (12): 1568–1574.

Burris-Meyer, Harold, Theodore W. Forbes, and W. L. Woolf. 1942. *Effect of Sound on Man and Means for Producing Such Sound*. OSRD Report 1255. Washington, DC: Applied Psychology Panel, NDRC.

Bush, Vannevar. 1946. "Foreword." In *Scientists Against Time*, James P. Baxter, vii–ix. Boston: Little, Brown and Company.

Bush, Vannevar, and James B. Conant. 1946. "NDRC Foreword." In *Summary Technical Report of Division 17, NDRC. Volume 2: Compasses, Odographs, Combat Acoustics, and Sonic Deception*, ed. Chas. E. Waring, v. Washington, DC: War Department.

Calame, Jon, and Esther Charlesworth. 2009. *Divided Cities: Belfast, Beirut, Jerusalem, Mostar, and Nicosia*. Philadelphia: University of Pennsylvania Press.

Cardinell, Richmond L. 1946. "Music in Industry—War Baby Grows Up." *Music Journal* 4 (1): 36–53.

Cardinell, Richmond L., and Harold Burris-Meyer. 1947. "Music in Industry Today." *Journal of the Acoustical Society of America* 19 (4): 547–549.

Cardinell, Richmond L., and Glenn C. Henry. 1944. *Guide to Industrial Sound*. Washington, DC: Office of Production Research and Development of the War Production Board.

Carlton, Jack. 2002. "Recollections of a Unit 6 Beach Jumper: Training and Action Experiences in World War II." Accessed May 25, 2019. http://www.beachjumpers.com/History/1940sJC.htm.

Carpenter, Edmund, and Marshall McLuhan. 1960. "Acoustic Space." In *Explorations in Communication: An Anthology*, ed. Edmund Carpenter and Marshall McLuhan, 65–70. Boston: Beacon.

Ceraso, Steph. 2010. "The Site of Sound: Mapping Audio." Humanities, Arts, Science and Technology Alliance and Collaboratory (HASTAC), October 5, 2010. Accessed May 25, 2019. http://www.hastac.org/blogs/stephceraso/sight-sound-mapping-audio.

Chaaban, Farid, and George Ayoub. 1996. *Database of Air and Noise Pollution in Lebanon*. Beirut: National Council for Scientific Research.

Chance de Silva. 2017. "Vex—New Concrete House in London." Accessed November 28, 2019. http://s479488183.websitehome.co.uk/vex/.

Chandrasekhar, Subrahmanyan. 1995. *Newton's Principia for the Common Reader*. Oxford: Clarendon Press.

Chavez, Carlos. 1937. *Toward a New Music: Music and Electricity*. Trans. Herbert Weinstock. New York: W. W. Norton & Co., Inc.

Chicago and the World's Fair, 1933. 1933. Chicago: Fred Husum Publishing Company.

Chladni, Ernst Florens Friedrich. 1787. *Entdeckungen über die Theorie des Klanges.* Leipzig: Weidmanns, Erben und Reich.

Chladni, Ernst Florens Friedrich. [1809] 2015. *Treatise on Acoustics: The First Comprehensive English Translation of E. F. F. Chladni's Traité d'Acoustique.* Cham: Springer International Publishing.

Clark, Paul W., and Laurence A. Lyons. 2014. *George Owen Squier: U.S. Army General, Inventor, Aviation Pioneer, Founder of Muzak.* Jefferson, NC: McFarland & Company, Inc.

Connor, Steven. 2000. *Dumbstruck: A Cultural History of Ventriloquism.* Oxford: Oxford University Press.

Corbin, Alain. 1998. *Village Bells: Sound and Meaning in the Nineteenth-Century French Countryside.* New York: Columbia University Press.

Cosgrove, Denis, ed. 1999. *Mappings.* London: Reaktion Books Ltd.

Crary, Jonathan. 1990. *Techniques of the Observer: On Vision and Modernity in the Nineteenth Century.* Cambridge, MA: MIT Press.

Crowell, Benedict. 1919. *America's Munitions 1917–1918.* Washington, DC: Government Printing Office.

Curran, Henry H. 1935. "Curran Calls New York Too Patient About Noise." *New York Times*, September 15, 1935.

Curtin, Adrian. 2014. *Avant-Garde Theatre Sound: Staging Sonic Modernity.* New York: Palgrave MacMillan.

Curtis, Charles. 2009. "Incomprehensible Space." *OASE* 78:105–115.

Cusack, Peter. 2017. *Berlin Sonic Places: A Brief Guide.* Berlin: Wolke Verlag.

Cusick, Suzanne G. 2008. "'You Are in a Place That Is out of the World . . .': Music in the Detention Camps of the 'Global War on Terror.'" *Journal of the Society for American Music* 2 (1): 1–26.

Cusick, Suzanne G. 2013. "Towards An Acoustemology of Detention in the 'Global War on Terror.'" In *Music, Sound and Space: Transformations of Public and Private Experience*, ed. Georgina Born, 275–291. Cambridge: Cambridge University Press.

Daughtry, J. Martin. 2015. *Listening to War: Sound, Music, Trauma and Survival in Wartime Iraq.* New York: Oxford University Press.

de la Motte-Haber, Helga. 1998. "*Ton-Raüme-Felder-Objekte*/Sound-Spaces-Fields-Objects." In *Ton, Raum = Sound, Space*, Bernhard Leitner. Ostfildern-Ruit: Cantz. Accessed May 25, 2019. https://www.bernhardleitner.at/texts.

de la Motte-Haber, Helga. 1999. "Space-Environment-Shared World: Robin Minard's Sound Installations." In *Robin Minard: Silent Music, Between Sound Art and Acoustic Design*, ed. Bernd Schulz, 34–56. Heidelberg: Kehrer.

des Jardins, Gregory, ed. 1994. *Max Neuhaus, Sound Works, Volume 1: Inscription.* Ostfildern: Hatje Cantz Verlag.

D'Hondt, Ellie, Matthias Stevens, and An Jacobs. 2012. "Participatory Noise Mapping Works! An Evalua-tion of Participatory Sensing as an Alternative to Standard Techniques for Environmental Monitoring." *Pervasive and Mobile Computing* 9 (5): 681–694.

Dixon, Melissa. 2016. "Charles Wheatstone's Enchanted Lyre and the Spectacle of Sound." In *Sound Knowledge: Music and Science in London, 1789–1851*, ed. James Q. Davies and Ellen Lockhart, 129–148. Chicago: University of Chicago Press.

Downes, Edward. 1958. "Rebel from Way Back: Varese, Composer of Electronic Works, Likes Music That Explodes in Space." *New York Times*, November 16, 1958.

Drieskens, Barbara, Frank Mermier, and Heiko Wimmen, eds. 2008. *Cities of the South: Citizenship and Exclusion in the 21st Century*. London: Saqi Books.

Drobnick, Jim, ed. 2004. *Aural Cultures*. Toronto: YYZ Books.

Edwards, Stanley R. 1933. "Telephone Exhibit at Century of Progress." *Telephony* 105 (June 10, 1933): 8–9.

Egger, Max. 1898. "De l'orientation auditive: Un cas de destruction unilatérale de l'appareil vestibulaire avec conservation de l'appareil cochléaire." *Comptes rendus hebdomadaires des séances et mémoires de la Société de biologie* 50:740–742.

E. H. [Édouard Hospitalier]. 1881. "L'Exposition d'électricité. Auditions téléphoniques théâtrales sys-tème Ader." *La Nature: Revue des sciences et de leurs applications aux arts et à l'industrie* 9 (434) (September 24, 1881): 257–260.

Eisenberg, Andrew. 2015. "Space." In *Keywords in Sound*, ed. David Novack and Matt Sakakeeny, 193–207. Durham and London: Duke University Press.

Elliot, John. [1780] 2013. *Philosophical Observations on the Senses of Vision and Hearing*. Cambridge: Cam-bridge University Press.

Ely, Hiram B. 1926. "Sound Locators: Their Functions and Limitations." *The Coast Artillery Journal* 65 (2): 123–131.

"'Ether Wave' in Orchestra." 1929. *New York Times*, April 30, 1929.

European Commission. 2002. Directive 2002/49/EC of the European Parliament and of the Council. Assessment and Management of Environmental Noise. *Official Journal of the European Communities*, L 189/12-L 189/25.

Eustachius, Bartholomaeus. 1563. *Sanctoseverinatis Medici ac Philosophi Opuscula Anatomica. Quorum numerum & argumenta auersa pagina indicabit*. Venetiis: Vicentius Luchinus.

Fabricius ab Aquapendente, Hieronymus. 1600. *De visione, voce, auditu*. Venetiis: Per Franciscum Bolzettam.

Fantel, Hans. 1979. "Stokowski—A Pioneer of Sonic Splendor." *New York Times*, December 9, 1979.

Fantel, Hans. 1981. "100 Years Ago: The Beginning of Stereo." *New York Times*, January 4, 1981.

Farneth, David. 1996. "La Monte Young—Marian Zazeela: Ultra Modern Minimalists." *Metrobeat.* Accessed May 25, 2019. http://melafoundation.org/farneth.htm.

Fast, Heidi. 2006. Invitation to *A Nightsong Action*, unpublished.

Fast, Heidi. 2007. Artist statement, unpublished.

Fast, Heidi. 2008. Interview with the author, unpublished.

Fauser, Annegret. 2005. *Musical Encounters at the 1889 Paris World's Fair.* Rochester: University of Rochester Press.

Federal Aviation Administration (FAA). 2019. Airport Noise and Land Use Information, including Noise Exposure Maps (NEMs). Accessed May 25, 2019. https://www.faa.gov/airports/environmental/airport_noise/noise_exposure_maps/.

Feiereisen, Florence, and Alexandra Merley Hill, eds. 2012. *Germany in the Loud Twentieth Century: An Introduction.* Oxford: Oxford University Press.

Fernández, Belén. 2015. "Public Space Is Disappearing in Beirut." *Al Jazeera America*, May 14, 2015. Accessed May 25, 2019. http://america.aljazeera.com/opinions/2015/5/public-space-is-disappearing-in-beirut.html.

Fletcher, Harvey. 1929. *Speech and Hearing.* New York: D. Van Nostrand Company.

Fletcher, Harvey. 1933. "An Acoustic Illusion Telephonically Achieved." *Bell Laboratories Record* 11 (10): 286–289.

Fletcher, Harvey. 1934. "Auditory Perspective—Basic Requirements." *Electrical Engineering* 53 (1): 9–11.

Fletcher, Harvey. 1939. "The Acoustical Society of America. Its Aims and Trends." *Journal of the Acoustical Society of America* 11 (1): 13–14.

Fletcher, Harvey. 1940a. "Stereophonic Recording." Introductory remarks at Carnegie Hall demonstration of stereophonic recordings. 2 pages. AT&T Archives and History Center.

Fletcher, Harvey. 1940b. "Stereophonic Reproduction from Film." *Bell Laboratories Record* 18 (9) (May 1940): 260–265.

Fletcher, Harvey. 1941. "The Stereophonic Sound Film System—General Theory." *Journal of the Acoustical Society of America* 13 (2): 89–99.

Fletcher, Harvey. 1947. "An Institute of Musical Science—A Suggestion." *Journal of the Acoustical Society of America* 19 (4): 722.

Floyd, M. K. 1973. *A Bibliography of Noise 1965–1970.* Troy, NY: Whitson Publishing Company.

Foley, Suzanne. 1981. *Space, Time, Sound: Conceptual Art in the San Francisco Bay Area, the 1970s.* San Francisco: San Francisco Museum of Modern Art.

Forensic Architecture. 2019. "About Forensic Architecture." Accessed May 25, 2019. https://forensic-architecture.org/about/agency.

Fox, Terry. 1972. "Program notes for *Action for a Tower Room*," unpublished.

Fox, Terry. 1982. *Metaphorical Instruments*. Berlin: daadgalerie.

Free, E. E. 1926. "How Noisy Is New York?" *The Forum* 75 (2): xxi–xxiv.

Free, E. E. [1928] 1930. "*The Forum's* Second Report on City Noise." In *City Noise*, ed. Edward F. Brown, E. B. Dennis, Jr., Jean Henry, and G. Edward Pendray, 276–285. New York: Noise Abatement Commission, Department of Health, City of New York.

Free, E. E. 1933. "Noise Measurement." *Review of Scientific Instruments* 4 (7): 368–372.

Friedman, Ken, ed. 1990. *Fluxus Performance Workbook*. Trondheim, Norway: G. Nordø.

Friedman, Ken, ed. 1998. *The Fluxus Reader*. New York: Academy Editions.

Galt, Rogers H. 1930. "Results of Noise Surveys Part 1: Noise Out-of-Doors." *Journal of the Acoustical Society of America* 2 (1): 30–58.

Ganchrow, Raviv. 2009. "Perspectives on Sound-Space: The Story of Acoustic Defense." *Leonardo Music Journal* 19:71–75.

Gandy, Matthew, and BJ Nilsen. 2014. *The Acoustic City*. Berlin: Jovis.

Ganz, Cheryl R. 2008. *The 1933 Chicago World's Fair: A Century of Progress*. Urbana: University of Illinois Press.

Gernsback, Hugo. 1958. "400 Loudspeakers." *Radio-Electronics* (October 1958): 46–47.

Gifford, Walter S. 1933. Telegraph to Frank Jewett, April 25, 1933. F.B. Jewett Papers, Location 72-08-02, Box 20, Series 1, General, AT&T Archives and History Center.

Gilbreth, Frank B. 1911. *Motion Study: A Method for Increasing the Efficiency of the Workman*. New York: Van Nostrand.

Goodfriend, Lewis S. 1985. "Burris-Meyer, Harold. 1902–1985." *Journal of the Acoustical Society of America* 77 (5): 1963.

Goodman, Steve. 2010. *Sonic Warfare: Sound, Affect, and the Ecology of Fear*. Cambridge, MA: MIT Press.

Gradenwitz, Peter. 1953. "Experiments in Sound; Ten-Day Demonstration in Paris of the Latest in 'Musique Concrete.'" *New York Times*, August 9, 1953.

Guillebaud, Christine, and Catherine Lavandier, eds. 2019. *Worship Sound Spaces: Architecture, Acoustics and Anthropology*. Oxon and New York: Routledge.

Hamilton, Jon. 2019. "Doubts Rise about Evidence That U.S. Diplomats in Cuba Were Attacked." National Public Radio, March 25, 2019. Accessed May 25, 2019. https://www.npr.org/sections/health-shots/2019/03/25/704903613/doubts-rise-about-evidence-that-u-s-diplomats-in-cuba-were-attacked.

Harb, Nathalie. 2017. "Silent Room." Accessed May 25, 2019. https://archello.com/project/silent-room.

Harb, Nathalie. 2018a. "Sound & Safe." Public lecture. The Bartlett School of Architecture, University College London, July 12, 2018.

Harb, Nathalie. 2018b. Interview with the author, unpublished.

Heller, Michael C. 2015. "Between Silence and Pain: Loudness and the Affective Encounter." *Sound Studies* 1 (1): 40–58.

Helmholtz, Hermann von. 1863. *Die Lehre von den Tonempfindungen als physiologische Grundlage für die Theorie der Musik*. Braunschweig: F. Vieweg und Sohn.

Herschel, John Frederick William. 1830. *Treatises on Physical Astronomy, Light and Sound. Contributed to the Encyclopaedia Metropolitana*. London and Glasgow: Richard Griffin and Company.

Higgins, Hannah. 2002. *Fluxus Experience*. Berkeley: University of California Press.

Hildebrand, James L. 1970. "Noise Pollution: An Introduction to the Problem and an Outline for Future Legal Research." *Columbia Law Review* 70 (4): 652–692.

Hill, Archibald Vivian. 1918. "The History of the Anti-Aircraft Experimental Section." Unpublished report. Churchill Archives Centre, The Papers of Professor A. V. Hill, AVHL.

Hill, Archibald Vivian. 1922. *Theory and Use of Anti-Aircraft Sound-Locators*. The War Office. London: Harrison and Sons.

Hoffmann, Christoph. 1994. "Wissenschaft und Militär: Das Berliner Psychologische Institut und der 1. Weltkrieg." *Psychologie und Geschichte* 5 (3/4): 261–285.

Holt, Thaddeus. 2004. *The Deceivers: Allied Military Deception in the Second World War*. New York: Scribner.

Hornbostel, Erich Moritz von, and Max Wertheimer. 1923. "Method and Means for Determining the Direction of Sounds." US patent no. 1,467,545, filed March 8, 1920, and issued September 11, 1923.

Horonjeff, Richard D., and Allan P. Paul. 1970. "Digital Computer Program for Calculating Noise Exposure Forecast Contours." *Journal of the Acoustical Society of America* 47 (1A): 111.

Hosokawa, Shuhei. 1984. "The Walkman Effect." *Popular Music* 4:165–180.

Howard, Deborah, and Laura Moretti. 2009. *Sound and Space in Renaissance Venice: Architecture, Music, Acoustics*. New Haven and London: Yale University Press.

Hui, Alexandra. 2013. *The Psychophysical Ear: Musical Experiments, Experimental Sounds, 1840–1910*. Cambridge, MA: MIT Press.

Human Rights Watch. 2018. *"Our Homes Are Not for Strangers": Mass Evictions by Lebanese Municipalities*. Report, April 20, 2018. Accessed May 25, 2019. https://www.hrw.org/report/2018/04/20/our-homes-are-not-strangers/mass-evictions-syrian-refugees-lebanese-municipalities.

Hunt, Frederick Vinton. 1978. *Origins in Acoustics: The Science of Sound from Antiquity to the Age of Newton*. New Haven: Yale University Press.

Ilsley, L. C., H. B. Freeman, and D. H. Zellers. 1928. *Technical Paper 433: Experiments in Underground Communication Through Earth Strata*. Washington, DC: U.S. Bureau of Mines.

"Inaudible Sounds Affect Mental Processes." 1935. *Toronto Mail-Empire*, March 13, 1935.

Innes, John R., ed. 1935. *Flash Spotters and Sound Rangers: How They Lived, Worked and Fought in the Great War*. London: George Allen & Unwin Ltd.

Jewett, Frank B. 1933a. "Perfect Quality and Auditory Perspective in the Transmission and Reproduction of Music." *Science*, New Series 77 (2002) (May 12, 1933): 435–440.

Jewett, Frank B. 1933b. Memorandum for Mr. W. S. Gifford, April 28, 1933. Unpublished memorandum, 1 page. F. B. Jewett Papers, Location 72-08-02, Box 20, Series 1, General, AT&T Archives and History Center.

Jewett, Frank B. 1933c. "A New Achievement in the Transmission of Music." Unpublished manuscript, 11 pages. F. B. Jewett Papers, Location 72-08-02, Box 20, Series 1, General, AT&T Archives and History Center.

Jewett, Frank B. 1934. "Science and Industry." *Scientific Monthly* 38 (4): 301–302.

Jewett, Frank B. 1940. "Demonstration of Stereophonic Recordings. Introductory Remarks by Doctor Frank B. Jewett." Press release, Bell Telephone Laboratories, April 9, 1940. 3 pages. Location 154-04-01-01, AT&T Archives and History Center.

Johnstone, Mark A. 2013. "Aristotle on Sounds." *British Journal for the History of Philosophy* 21 (4): 631–648.

Jones, Keith. 2005. "Music in Factories: A Twentieth-Century Technique for Control of the Productive Self." *Social & Cultural Geography* 6 (5): 723–744.

Jones, Simon C., and Thomas G. Schumacher. 1992. "Muzak: On Functional Music and Power." *Critical Studies in Mass Communication* 9 (2): 156–169.

Joy, Jérôme. 2009. "Networked Music and Soundart Timeline (NMSAT). Excerpts of Part One: Ancient and Modern History, Anticipatory Literature, and Technical Developments References." *Contemporary Music Review* 28 (4–5): 449–490.

Kaempffert, Waldemar. 1933. "New Tone Quality by Wire Achieved." *New York Times*, April 13, 1933.

Kaempffert, Waldemar. 1940. "Science in the News; Thunder Behind the Footlights." *New York Times*, June 2, 1940.

Kafka, George, Sophie Lovell, and Fiona Shipwright, eds. 2019. *Sonic Urbanism*. London: Theatrum Mundi.

Kahn, Douglas. 1999. *Noise Water Meat: A History of Sound in the Arts*. Cambridge, MA: MIT Press.

Kahn, Douglas, and Gregory Whitehead, eds. 1992. *Wireless Imagination: Sound, Radio, and the Avant-Garde*. Cambridge, MA: MIT Press.

Kang, Jian. 2007. *Urban Sound Environment*. London; New York: Taylor & Francis.

Kanjo, Eiman 2010. "NoiseSPY: A Real-Time Mobile Phone Platform for Urban Noise Monitoring and Mapping." *Mobile Networks and Applications* 15 (4): 562–574.

Kassabian, Anahid. 2013. *Ubiquitous Listening: Affect, Attention, and Distributed Subjectivity*. Berkeley: University of California Press.

Kazan, Helene. 2018. *Points of Contact* event announcement. Goethe-Institut Libanon. Accessed May 25, 2019. https://www.goethe.de/ins/lb/en/m/ver.cfm?fuseaction=events.detail&event_id=21132768.

Keller, Arthur C. 1981. "Early Hi-Fi and Stereo Recording at Bell Laboratories (1931–1932)." *Journal of the Audio Engineering Society* 29 (4): 274–280.

Keller, Arthur C., Mount Vernon, and Irad S. Rafuse. "Sound Recording and Reproducing System." US patent no. 2,114,471, filed June 20, 1936, and issued April 19, 1938.

Kerbaj, Mazen. 2006. *Starry Night* (excerpt). Audio recording. Soundcloud. Accessed May 25, 2019. https://soundcloud.com/mazenkerbaj/starry-night-excerpt-631-min.

Kerbaj, Mazen. 2017. *Beirut Won't Cry*. Seattle: Fantagraphics Books.

Khalil, Amanda Abi. 2018. Interview with the author, unpublished.

Kim-Cohen, Seth. 2009. *In the Blink of an Ear: Toward a Non-Cochlear Sonic Art*. New York: Continuum.

Kimmelman, Michael. 2015. "Dear Architects: Sound Matters." *New York Times*, December 29, 2015.

Kircher, Athanasius. 1650. *Musurgia Universalis, sive Ars magna consoni et dissoni*. Romae: Typis Ludovici Grignani.

Kircher, Athanasius. 1673. *Phonurgia Nova, sive Conjugium mechanico-physicum artis & naturae paranympha phonosophia concinnatum*. Campidonae: Rudolphum Dreherr.

Kneisel, Christian, Matthias Osterwold, and Georg Weckwerth. 1996. "zur einführung." In *Klangkunst/Sound Art*, ed. Helga de la Motte-Haber, 6–11. Munich: Prestel-Verlag.

Korfali, Samira Ibrahim, and May Massoud. 2003. "Assessment of Community Noise Problem in Greater Beirut Area, Lebanon." *Environmental Monitoring and Assessment* 84 (3): 203–218.

Kösters, H., W. Bierreth, and A. Kemper. 1938. "Lautstärken-Karte eines Berliner Stadtbezirkes." *Akustische Zeitschrift* 3: 310–313.

Kryter, Karl D. 1959. "Scaling Human Reaction to Sound from Aircraft." *Journal of the Acoustical Society of America* 31 (11): 1415–1429.

Kryter, Karl D. 1960. "The Meaning and Measurement of Perceived Noise Level." *Noise Control* 6 (5): 12–27.

Kryter, Karl D. 1970. *The Effects of Noise on Man*. New York and London: Academic Press.

LaBelle, Brandon. 2004. *Site Specific Sound*. Frankfurt: Errant Bodies Press/Selektion with Ground Fault Recordings.

LaBelle, Brandon. 2006. *Background Noise: Perspectives on Sound Art*. New York: Continuum International.

LaBelle, Brandon. 2010. *Acoustic Territories: Sound Culture and Everyday Life*. New York; London: Continuum.

Lacey, Jordan. 2016. *Sonic Rupture: A Practice-led Approach to Urban Soundscape Design*. New York: Bloomsbury Academic.

Ladd, George Trumbull. 1894. *Psychology, Descriptive and Explanatory: A Treatise of the Phenomena, Laws, and Development of Human Mental Life*. New York: Charles Scribner.

Lamarck, Jean-Baptiste. 1799. "Mémoire, sur la matière du son." *Journal de Physique, de Chimie, d'Histoire Naturelle et des Arts* 49:397–412.

Lander, Dan, and Micah Lexier, eds. 1990. *Sound by Artists*. Toronto: Art Metropole; Banff: Walter Phillips Gallery.

Lanza, Joseph. 1994. *Elevator Music. A Surreal History of Muzak, Easy-Listening, and Other Moodsong*. New York: St Martin's Press.

Lavine, Abraham Lincoln. 1921. *Circuits of Victory*. Garden City, NY: Doubleday, Page & Company.

Le CRESSON. 2019. *Le Centre de recherche sur l'espace sonore et l'environnement urbain*. Accessed May 25, 2019. http://aau.archi.fr/cresson/.

Lefebvre, Henri. [1974] 1991. *The Production of Space*. Trans. Donald Nicholson-Smith. London: Blackwell.

Leitner, Bernhard. 1973. "Immaterial Arching." Accessed May 25, 2019. https://soundartarchive.net/WORKS-details.php?recordID=1215.

Leitner, Bernhard. 1978. *Ton, Raum = Sound, Space*. New York: New York University Press.

Leitner, Bernhard. 2003. *KOPFRAÜME/HEADSCAPES*. Compact Disc. Karlsruhe: Edition ZKM; Ostfildern: Hatje Cantz.

Licht, Alan. 2007. *Sound Art: Beyond Music, Between Categories*. New York: Rizzoli International Publications.

Lidén, Signe. 2015. *Wave Forms and Tunnel Visions III: Robert Revisited*. Accessed May 25, 2019. https://signeliden.com/?p=1901.

Lippard, Lucy R. 1973. *Six Years: The Dematerialization of the Art Object from 1966 to 1972*. New York: Praeger.

Lippard, Lucy R. 1997. *The Lure of the Local: Senses of Place in a Multicentered Society*. New York: New Press.

Lipps, Theodor. 1883. *Grundtatsachen des Seelenlebens*. Bonn: Verlag von Max Cohen & Sohn.

Logan, Mrs. John A. 1912. "Mrs. Isaac L. Rice, 1860–." In *The Part Taken by Women in American History*, ed. Mrs. John A. Logan. Wilmington, DE: The Perry-Nalle Publishing Company. Accessed May 25, 2019. http://www.ahgp.org/women/mrs_isaac_l_rice_1860.html.

"London Noises Mapped." 1934. *New York Times*, March 18, 1934.

Lornell, Kip. 2012. *Exploring American Folk Music: Ethnic, Grassroots, and Regional Traditions in the United States*. Jackson: University Press of Mississippi.

Lübcke, E. 1938. "Geräuschbekämpfung bei elektrischen Maschinen und Geräten." *ETZ* 29:765–770.

Lupo, Ilaria, and Joe Namy. 2014. "Concrete Sampling (Arrangement for derbekah and jackhammer)." Accessed May 25, 2019. http://ashkalalwan.org/events/concrete-sampling-a-performance-by-ilario-lupo -and-joe-namy/.

MacGilp, Ali. 2014. "Interview with Ilaria Lupo and Joe Namy about Their Recent Project *Concrete Sampling (arrangement for derbekah and jackhammer)*." *Artvehicle* 66. Accessed May 25, 2019. http://www .artvehicle.com/interview/43.

Mach, Ernst. 1901. "On Physiological, as Distinguished from Geometrical, Space." *The Monist* 11 (3): 321–338.

Maisonneuve, Nicholas, Matthias Stevens, Maria E. Niessen, Peter Hanappe, and Luc Steels. 2009. "Citizen Noise Pollution Monitoring." In *dg.o '09: Proceedings of the 10th International Digital Government Research Conference. Social Networks: Making Connections between Citizens, Data and Government*, ed. Soon Ae Chun, Rodrigo Sandoval, and Priscilla Regan, 96–103. Los Angeles: Digital Government Society of North America.

Maisonneuve, Nicholas, Matthias Stevens, and Luc Steels. 2009. "Measure and Map Noise Pollution with Your Mobile Phone." In *Proceedings of DIY for CHI, Workshop Held at the ACM SIGCHI Conference on Human Factors in Computing Systems (CHI 2009)*, 78–82.

Malaeb, Omaya. 2019. *Landline*. Audio recording. Accessed May 25, 2019. https://www.optophono .com/acousticcitieslondonbeirut.

Mallory, Vincent. 1940. *Stevens Sound Control System: Data on Design, Construction, Operation and Maintenance*. Hoboken, NJ: Stevens Institute of Technology.

Manning, Peter. 2006. "The Significance of *Techné* in Understanding the Art and Practice of Electroacoustic Composition." *Organised Sound* 11 (1): 81–90.

Mansell, James G. 2016. *The Age of Noise in Britain: Hearing Modernity*. Urbana: University of Illinois Press.

Mansell, James G. 2017. "'A Chamber of Noise Horrors': Sound, Technology, and the Museum." *Journal of the Science Museum* 7 (Spring 2017). Accessed May 25, 2019. http://journal.sciencemuseum.ac.uk /browse/issue-07/chamber-of-noise-horrors/.

Marcelin, André Jules. 1926. "Apparatus for Indicating the Course of Aircraft." US patent no. 1,593,089, filed February 1, 1924, and issued July 20, 1926.

Marsh, Narcissus. 1684. "An Introductory Essay to the Doctrine of Sounds, Containing Some Proposals for the Improvement of Acousticks." *Philosophical Transactions of the Royal Society* 14:472–488.

Martial. [86–103 AD] 1865. *The Epigrams of Martial, Translated into English Prose*. Bohn's Classical Library. London: Bell & Daldy.

Martin, Linton. 1933. "Themes and Variations." *Philadelphia Inquirer*, April 16, 1933.

Matsumoto, Matataro. 1897. "Researches on Acoustic Space." In *Studies from the Yale Psychological Laboratory*, ed. Edward W. Scripture, 1–75. New Haven: Yale University.

Mayer, Alfred Marshall. 1879. "Experimental Researches in the Determination of the Forms of Acoustic Wave-Surfaces, Leading to the Invention of the Topophone, an Instrument to Determine the Direction of a Source of Sound." *American Journal of Otology* 1:282–286.

Mayer, Alfred Marshall. 1880. "Topophone." US patent no. 224,199, filed September 30, 1879, and issued February 3, 1880.

Mayor of London. 2004. *Sounder City: The Mayor's Ambient Noise Strategy*. London: Greater London Authority. Accessed March 25, 2019. https://www.london.gov.uk/sites/default/files/mayors_noise _strategy.pdf.

McCafferty, Conor. 2019. "Urban Sound Mapping in Sound Art and Built Environment Practice." PhD dissertation. School of Arts, English and Languages, Queen's University Belfast.

McCartney, Andra. 2004. "Soundscape Works, Listening and the Touch of Sound." In *Aural Cultures*, ed. Jim Drobnick, 179–185. Toronto: YYZ Books.

McConnell, F. H. 1941. "Riveting to Rhythm." *New York Times*, August 31, 1941.

McGinn, Robert E. 1983. "Stokowski and the Bell Telephone Laboratories: Collaboration in the Development of High-Fidelity Sound Reproduction." *Technology and Culture* 24 (1): 38–75.

McKenzie, Dan. 1916. *The City of Din: A Tirade Against Noise*. London: Adlard & Son, Bartholomew Press.

Meireles, Matilde. 2013. *X Marks the Spot*. Accessed May 25, 2019. http://matildemeireles.com/portfolio /xmsbelfast.

Meister, F. J. 1956. "Traffic Noise in West Germany, Evaluation of Noise Levels and Experience in Noise Control." *Journal of the Acoustical Society of America* 28 (4): 783.

Meister, F. J. 1957. "Measurements of Traffic Noise in West Germany." *Journal of the Acoustical Society of America* 29 (1): 81–84.

Mersenne, Marin. 1636. *Harmonie universelle, contenant la théorie et la pratique de la musique*. Paris: Sebastien Cramoisy.

Mills, Mara. 2009. "When Mobile Communication Technologies Were New." *Endeavour* 33 (4): 140–146.

Mills, John. 1936. "Auditory Perspective." *Scientific Monthly* 42 (2): 137–141.

Minard, Robin. 1996. *Sound Installation Art*. Graz: Institut für Elektronische Musik.

Mishlawi, Nadim. 2012. "Dissonance and Urban Discord." *New Soundtrack* 2 (2): 159–167.

Mishlawi, Nadim. 2018. Panel Discussion on Sonic Urbanism, Sursock Museum, Beirut, March 23, 2018. Accessed May 25, 2019. https://sursock.museum/content/sonic-urbanism.

Morland, Samuel. 1672. *Tuba Stentoro-Phonica: An Instrument of Excellent Use as Well at Sea as at Land.* London: W. Godbid.

Mumford, Lewis. [1938] 1970. *The Culture of Cities.* London: Secker & Warburg.

Münsterberg, Hugo, and Arthur Henry Pierce. 1894. "The Localization of Sound." *Psychological Review* 1 (5): 441–495.

"Music: Productive Melody." 1942. *TIME*, November 2, 1942.

Musschenbroek, Pieter van. [1734] 1739. *Elementa physicae conscripta in usus academicos.* Lugduni Batavorum: Samuel Luchtmans. Translated in 1739 as *Essai de Physique.* Leyden: Samuel Luchtmans.

Nemo. 1889. "Le Théâtre par Téléphone à l'Exposition." *Le Figaro*, July 2, 1889.

Neuhaus, Max. 1988. "LISTEN." Accessed May 25, 2019. http://www.maxneuhaus.info/soundworks/vectors/walks/LISTEN/.

Neuhaus, Max. 1990. *Elusive Sources and "Like" Spaces.* Turin: Galleria Giorgio Persano.

Neuhaus, Max, and Ulrich Loock. 1990. "A Conversation Between Max Neuhaus and Ulrich Loock, Milan, March 25, 1990." In *Elusive Sources and "Like" Spaces*, Max Neuhaus. Turin: Galleria Giorgio Persano.

Newton, Isaac. 1687. *Philosophiae naturalis principia mathematica.* London: Jussu Societatis Regiae ac Typis Josephi Streater.

Nichols, Herbert. 1893. "The Psychological Laboratory at Harvard." *McClure's Magazine* 1 (5): 399–409.

"Noisiest Spot Here 6th Av. at 34th St." 1926. *New York Times*, January 16, 1926.

"Of Sound, Fury, and Stevens Tech." 1941. *New York Times*, July 20, 1941.

Ørsted, Hans Christian. [1810] 2014. "Experiments on Acoustic Figures." In *Selected Scientific Works of Hans Christian Ørsted*, trans. and ed. Karen Jelved, Andrew D. Jackson, and Ole Knudsen, 264–281. Princeton: Princeton University Press.

"Oscar 'Steals the Show' at A Century of Progress." 1933. *Bell Telephone News* 23 (7): 5–6.

Osterwold, Matthias. 1998. "Terry Fox: Economy of Means-Density of Meanings." In *Works with Sound/Arbeiten mit Klang*, Terry Fox, 17–30. Heidelberg: Kehrer.

Ouellette, Fernand. 1968. *Edgard Varèse.* New York: Orion Press.

Ouzounian, Gascia. 2006. "Embodied Sound: Aural Architectures and the Body." *Contemporary Music Review* 25 (1–2): 69–79.

Ouzounian, Gascia. 2008. "Sound Art and Spatial Practices: Situating Sound Installation Art Since 1958." PhD dissertation. Department of Music, University of California, San Diego.

Ouzounian, Gascia. 2013. "Recomposing the City: A Survey of Recent Sound Art in Belfast." *Organised Sound* 23:47–54.

Ouzounian, Gascia. 2014. "Acoustic Mapping." In *The Acoustic City*, ed. Matthew Gandy and BJ Nilsen, 165–174. Berlin: Jovis.

Ouzounian, Gascia, and Sarah Lappin. 2016. "New Directions in Urban Sound Art." *Journal of Sonic Studies* 11. Accessed December 3, 2019. https://www.researchcatalogue.net/view/236505/236507.

Pallasmaa, Juhani. [1996] 2012. *The Eyes of the Skin: Architecture and the Senses*. Chichester: John Wiley & Sons Ltd.

Palombini, Carlos. 1993. "Pierre Schaeffer, 1953: Towards an Experimental Music." *Music & Letters* 74 (4): 542–557.

Parsons, William Barclay. 1920. *The American Engineers in France*. New York and London: D. Appleton and Company.

Parton, Lemuel F. 1935. "Who's News Today." *Cincinnati Times-Star*, May 1, 1935.

Peirce, Benjamin. 1836. "A Catalogue of Works Relating to Sound." In *An Elementary Treatise on Sound; Being the Second Volume of a Course on Natural Philosophy, Designed for the Use of High Schools and Colleges*, ed. Benjamin Peirce, xi–lvi. Boston: James Munroe and Company.

Penrose, [first name unknown]. 1940. Letter to Frank B. Jewett, April 9, 1940. AT&T Archives and History Center.

Perrin, Jean, and Georges-Émile-Henri Gobel. "Appareil amplificateur pour la transmission du son." French patent no. FR509,877, filed May 26, 1919, and issued 26 August, 1920.

Peterson, Marina. 2010. *Sound, Space, and the City: Civic Performance in Downtown Los Angeles*. Philadelphia: University of Pennsylvania Press.

Pick, Herbert L. 2008. "History of Research on Blindness and Brain Plasticity." In *Blindness and Brain Plasticity in Navigation and Object Perception*, ed. John J. Rieser, Daniel H. Ashmead, Ford Ebner, and Anne L. Corn, 26–33. New York: Taylor & Francis.

Picker, John M. 2003. *Victorian Soundscapes*. Oxford: Oxford University Press.

Pierce, Arthur Henry. 1901. *Studies in Auditory and Visual Space Perception*. London and Bombay: Longmans, Green & Co.

Pisano, Giusy. 2012. "The Théâtrophone, an Anachronistic Hybrid Experiment or One of the First Immobile Traveler Devices?" In *A Companion to Early Cinema*, ed. André Gaudreault, Nicolas Dulac, and Santiago Hidalgo, 80–98. Chichester: Wiley-Blackwell.

Preyer, William Thierry. 1887. "Die Wahrnehmung der Schallrichtung mittelst der Bogengänge." *Pflügers Archiv* 40: 586-622.

Potter, Robert D. 1935. "Synthetic Thrills for Theater Audiences of the Future." *Newark Ledger*, August 4, 1935.

Poullin, Jacques. [1954] 1957. "The Application of Recording Techniques to the Production of New Musical Materials and Forms. Applications to 'Musique Concrete.'" Ottawa: National Research Council of Canada. Technical Translation TT-646. Trans. D. A. Sinclair from the original in *L'Onde Électrique* 34 (324): 282–291.

Psychological Laboratory of Harvard University. 1893. Cambridge, MA: Harvard University.

Pyenson, Lewis. 1996. "On the Military and Exact Sciences in France." In *National Military Establishments and the Advancement of Science and Technology: Studies in 20th Century History*, ed. Paul Forman and José M. Sánchez-Ron, 135–152. Dordrecht; London: Kluwer Academic.

Radau, Rodolphe. 1870. *Wonders of Acoustics, or, the Phenomena of Sound*. Paris: L. Hachette et cie.

Radovac, Lilian. 2014. "The Muted City: New York, Noise Control and the Reconfiguration of Urban Space." PhD dissertation. Department of Art History and Communication Studies. McGill University, Montreal.

Rankin, William. 2005. "Noise, Mapping, and the Architecture of Statistics." In *93rd ACSA Annual Meeting Proceedings, The Art of Architecture/The Science of Architecture*, 371–384. Washington, DC: Association of Collegiate Schools of Architecture.

Rasmussen, Steen Eiler. [1957] 1962. *Experiencing Architecture*. First paperback ed. Cambridge, MA: MIT Press. (First Danish ed. 1957; first English ed. 1959, trans. Eve Wendt. London: Chapman & Hall.)

Rawes, Ian. 2019. "Unhealthy Noise." *London Sound Survey*. Accessed May 25, 2019. https://www .soundsurvey.org.uk/index.php/history/unhealthy_noise/null/440.

Rawlinson, Alfred. 1923. *The Defence of London 1915–1918*. 2nd ed. London and New York: Andrew Melrose Ltd.

Rayleigh, Lord. 1875. "On Our Perception of the Direction of a Source of Sound." *Proceedings of the Musical Association* 2:75–84.

Rayleigh, Lord. 1907. "On Our Perception of Sound Direction." *The London, Edinburgh, and Dublin Philosophical Magazine and Journal of Science* 13 (74): 347–363.

Recomposing the City. 2019. Research. Accessed May 25, 2019. http://www.recomposingthecity.org /research.

"Reproduction of Music by New Methods." 1933. *Science* 77 (1999): 6.

"Revenue Cutters May Chase the Tooters: Agitators Against River Noises Make Great Headway." 1905. *New York Times*, December 28, 1905.

R. H. O. 1946. "Giant Loud Speakers." *Journal of the Franklin Institute* 241 (4): 310–311.

Rickard, Jolene. 2005. "Rebecca Belmore: Performing Power." Accessed May 25, 2019. http://www .rebeccabelmore.com/assets/Performing_Power.pdf.

Ripley, Colin. 2006. "In the Place of Sound: Architecture | Music | Acoustics." In *Proceedings of Architecture | Music | Acoustics*, ed. Colin Ripley, 1–3. Toronto: Ryerson Embodied Architecture Lab.

Rodgers, Tara. 2016. "Toward a Feminist Epistemology of Sound: Refiguring Waves in Audio-Technical Discourse." In *Engaging the World: Thinking after Irigaray*, ed. Mary C. Rawlinson, 203–222. Albany: State University of New York Press.

Rosen, George. 1974. "A Backward Glance at Noise Pollution." *Public Health Then and Now* 64 (5): 514–517.

Rosenzweig, Mark R., and Geraldine Stone. 1948. "Wartime Research in Psycho-Acoustics." *Review of Educational Research* 18 (6): 642–654.

Ross, David. 1992. "Introduction." In *Terry Fox: Articulations (Labyrinth/Text Works)*, Terry Fox. Philadelphia: Moore College of Art.

Roth, Allen J. 1958. "Sonic Boom: A New Legal Problem." *American Bar Association Journal* 44 (3): 216–220, 276.

Rueb, Emily S. 2016. "To Create a Quieter City, They're Recording the Sounds of New York." *New York Times*, November 6, 2016.

Russolo, Luigi. [1913] 1986. "The Art of Noises: Futurist Manifesto." In *The Art of Noises*, Luigi Russolo, 23–31. Translated from Italian; introduction by Barclay Brown. Monographs in Musicology, No. 6. New York: Pendragon Press.

Safa, Mhamad. 2018a. Unpublished text on *50cm Slab* from *Points of Contact* exhibition, January 27–March 10, 2018, Goethe-Institut Libanon, Beirut.

Safa, Mhamad. 2018b. Interview with the author, unpublished.

Safa, Mhamad. 2018c. *520,579 m2*. Video. Accessed December 3, 2019. https://vimeo.com/303132962.

Sassen, Saskia. 2014. *Expulsions: Brutality and Complexity in the Global Economy*. Cambridge, MA: The Belknap Press of Harvard University.

Saunders, John Cunningham. 1806. *The Anatomy of the Human Ear, &c.* London: Richard Phillips.

Scarpa, Antonio. 1789. *Anatomicae Disquisitiones de Auditu et Olfactu*. Ticini: Petri Galeatii.

Schafer, Raymond Murray. 1970. *The Book of Noise*. Wellington, NZ: Price Milburn & Co., Ltd.

Schafer, Raymond Murray, ed. 1973a. *The Vancouver Soundscape*. Burnaby, BC: World Soundscape Project, Sonic Research Studio, Department of Communication, Simon Fraser University.

Schafer, Raymond Murray, ed. 1973b. *The Music of the Environment*. Wien: Universal Edition.

Schafer, Raymond Murray. [1977] 1994. *The Soundscape: Our Sonic Environment and the Tuning of the World*. Rochester, VT: Destiny Books.

Schafer, Raymond Murray, ed. 1977a. *European Sound Diary*. No. 3, The Music of the Environment Series. Vancouver: A.R.C. Publications; World Soundscape Project, Simon Fraser University.

Schafer, Raymond Murray, ed. 1977b. *Five Village Soundscapes*. No. 4, The Music of the Environment Series. Vancouver: A.R.C. Publications; World Soundscape Project, Simon Fraser University.

Schiavon, Martina. 2015. "Phonotelemetry: Sound-ranging Techniques in World War I." *Lettera Matematica* 3 (1): 27–41.

Schulz, Bernd. 2002. "The Whole Corporeality of Hearing: An Interview with Bernhard Leitner." In *Resonanzen: Aspekte der Klangkunst*, ed. Bernd Schulz, 81–88. Heidelberg: Kehrer.

Schwartz, Hillel. 2011. *Making Noise: from Babel to the Big Bang & Beyond*. Brooklyn, NY: Zone Books.

"Science Makes Jitters Real, Adding to Horrors of Stage." 1935. *New York Times*, February 24, 1935.

"Science Remakes the Human Voice." 1941. *New York Times*, April 20, 1941.

"Scientists Mapping World Fair Display." 1930. *New York Times*, July 6, 1930.

Seiffarth, Carsten. 2012. *bonn hoeren: urban sound art/stadt klangkunst 2010–2012*. Trans. Julia Schweizer. Bonn: Beethovenstiftung für Kunst und Kultur der Bundesstadt Bonn.

Shore, Charles. 1980. "Kinds of Art That Vanish as They Are Being Done." *Oakland Tribune*, January 13, 1980.

Sickert, Otto G. 1940. Letter to Frank B. Jewett, April 11, 1940. AT&T Archives and History Center.

Smith, C. Theodore. 1934. "Exhibiting Telephone Progress at the World's Fair." *Bell Telephone Quarterly* 13 (1): 3–22.

Smith, Peter Andrey. 2013. "The Society for the Suppression of Unnecessary Noise." *New Yorker*, January 11, 2013. Accessed March 25, 2019. https://www.newyorker.com/culture/culture-desk/the-society-for-the-suppression-of-unnecessary-noise.

Snow, W. B. 1934. "Auditory Perspective." *Bell Laboratories Record* 12 (7): 194–198.

Soemmerring, Samuel Thomas von. 1806. *Icones Organi Auditus Humani*. Frankfurt: Varrentrapp and Wenner.

"'Solidified' Music Shakes a Building." 1934. *New York Times*, January 25, 1934.

"Sound Control Possibilities in Theater Cited." 1935. *New York Herald Tribune*, April 30, 1935.

"Sound Harnessed for Stage Effect." 1935. *New York Times*, April 30, 1935.

"Sound Waves 'Rock' Carnegie Hall as Enhanced Music Is Played." 1940. *New York Times*, April 10, 1940.

Southworth, Michael. 1969. "The Sonic Environment of Cities." *Environment & Behavior* 1 (1): 49–70.

Spurlock, James William. 2007. "The Bell Telephone Laboratories and the Military-Industrial Complex: The Jewett-Buckley Years, 1925–1951." PhD dissertation, The George Washington University.

Stedman, Michael. 2017. *What Did World War One Sound Like?* BBC. Accessed May 25, 2019. http://www.bbc.co.uk/guides/zwg72hv.

Stein, Max, and Julian Stein. 2008–ongoing. Montréal Sound Map. Accessed May 25, 2019. https://www.montrealsoundmap.com/.

Steinhauser, Anton. 1879. "The Theory of Binaural Audition. A Contribution to the Theory of Sound." Translated and communicated by Prof. Silvanus P. Thompson. *London, Edinburgh, and Dublin Philosophical Magazine and Journal of Science* 7 (42): 181–197.

"Stereophonic Music—A Historical Note." 1940. Press release by Bell Telephone Laboratories, April 1940, 4 pages. Location 154-04-01-01, AT&T Archives and History Center.

"Stereophonic Recordings of Enhanced Music." 1940a. *Bell Laboratories Record* 18 (9) (May 1940): 258–259.

"Stereophonic Recordings of Enhanced Music." 1940b. *Nature* 146 (3692) (August 3, 1940): 174.

Sterne, Jonathan. 2003. *The Audible Past: Cultural Origins of Sound Reproduction.* Durham: Duke University Press.

Stockhausen, Karlheinz. [1958] 1961. "Music in Space." Trans. Ruth Koenig. *Die Reihe 5 (Reports-Analyses)*: 67–82.

Stokley, James. 1941. "Sounds in the Air." *Science News-Letter* 39 (20): 314–316.

"Stokowski Asks Aid in Hiding Orchestra." 1926. *New York Times*, October 28, 1926.

"Stokowski Has a Surprise." 1930. *New York Times*, August 31, 1930.

"Stokowski Receives Broadcasting Medal." 1931. *New York Times*, November 3, 1931.

"Stokowski Seeks True Tone Colors." 1932. *New York Times*, October 26, 1932.

"Stokowski to Study Radio." 1929. *New York Times*, December 9, 1929.

Stokowski, Leopold. 1931. Letter to H. D. Arnold, December 14, 1931. H. D. Arnold Papers, Location 80-02-03-27, Arnold-Stokowski Correspondence 1930–1932, AT&T Archives and History Center.

Stokowski, Leopold. 1932. "New Horizons in Music." *Journal of the Acoustical Society of America* 4:11–19.

Stokowski, Leopold. 1940. "Statement of Doctor Leopold Stokowski at the Stereophonic Demonstration at Carnegie Hall," April 9, 1940. Location 154-04-01-01, AT&T Archives and History Center.

Styhre, Alexander. 2012. "Sound, Silence, Music: Organizing Audible Work Settings." *Culture and Organization* 13 (1): 22–41.

Suisman, David. 2009. *Selling Sounds: The Commercial Revolution in American Music.* Cambridge, MA: Harvard University Press.

"Supersonic 'Boom' Carpet." 1967. *UNESCO Courier* (July 1967): 17–19.

Teruggi, Daniel. 2007. "Technology and *Musique concrète*: The Technical Developments of the Groupe de Recherches Musicales and Their Implication in Musical Composition." *Organised Sound* 12 (3): 213–231.

"Thar She Blows." 1940. *New York Herald Tribune*, April 10, 1940.

Theatrum Mundi. 2018. "Urban Sound and the Politics of Memory." Accessed May 25, 2019. https://theatrum-mundi.org/programme/urban-sound-and-the-politics-of-memory/.

Théberge, Paul, Kyle Devine, and Tom Everrett. 2015. *Living Stereo: Histories and Cultures of Multichannel Sound*. New York: Bloomsbury Academic.

"The End of the War." 1919. *Journal of Electricity* 43 (10): 441.

"The Super-Orchestra." 1933. *New York Herald Tribune*, April 14, 1933.

"The Telephone." 1876. *New York Times*, March 22, 1876.

"The Telephone at the Paris Opera." 1881. *Scientific American* 45 (27) (December 31, 1881): 422–423.

Thibaud, Jean-Paul. 2003. "The Sonic Composition of the City." In *The Auditory Culture Reader*, ed. Michael Bull and Les Back, 329–342. Oxford: Berg.

Thomas, William. 2015. *Rational Action: The Sciences of Policy in Britain and America, 1940–1960*. Cambridge, MA: MIT Press.

Thompson, Emily. 2002. *The Soundscape of Modernity: Architectural Acoustics and the Culture of Listening in America, 1900–1933*. Cambridge, MA: MIT Press.

Thompson, Sylvanus P. 1877. "On Binaural Audition." *London, Edinburgh, and Dublin Philosophical Magazine and Journal of Science* 4 (25): 274–276.

Thompson, Sylvanus P. 1878. "Phenomena of Binaural Audition—Part II." *London, Edinburgh, and Dublin Philosophical Magazine and Journal of Science* 6 (38): 383–391.

Thompson, Sylvanus P. 1879. "The Pseudophone." *London, Edinburgh, and Dublin Philosophical Magazine and Journal of Science* 8 (50): 385–390.

Titchener, Edward Bradford. 1896. *An Outline of Psychology*. New York: Macmillan.

Tod, David. 1832. *The Anatomy and Physiology of the Organ of Hearing, &c*. London: Longman, Rees, Orme, Brown, Green, and Longman.

Tournès, Ludovic. 2004. "The Landscape of Sound in the Nineteenth and Twentieth Centuries." *Contemporary European History* 13 (4): 493–504.

Townsend-Gault, Charlotte. 2002. "Have We Ever Been Good?" In *Rebecca Belmore: The Named and the Unnamed*. Exhibition catalogue. Vancouver: Morris and Helen Belkin Art Gallery, University of British Columbia. Accessed May 25, 2019. http://www.ccca.ca/c/writing/t/townsend-gault/tgault013t.html.

Trieb, Marc. 1996. *Space Calculated in Seconds: The Philips Pavilion, Le Corbusier, Edgard Varèse*. Princeton: Princeton University Press.

Trowbridge, Augustus. 1919. "Sound and Flash Ranging." *Science*, New Series 49 (1274): 521–523.

Truax, Barry, ed. 1978. *Handbook for Acoustic Ecology*. No. 5, The Music of the Environment Series. Vancouver: A.R.C. Publications; World Soundscape Project, Simon Fraser University.

Truax, Barry. 1999. "Noise Exposure Forecast." In *Handbook for Acoustic Ecology*, ed. Barry Truax. CD-ROM edition. No. 5, The Music of the Environment Series. Burnaby, BC: Cambridge Street Publishing. Accessed May 25, 2019. https://www.sfu.ca/sonic-studio-webdav/handbook/Noise_Exposure_Forecast.html.

Tschirhart, Peter Louis. 2013. "Sound Maps and the Representation of Audible Space." PhD dissertation. Department of Music, University of Virginia.

Tuned City. 2008. "BUG: Installation by Mark Bain in cooperation with b&k, Arno Brandlhuber." Accessed May 25, 2019. http://www.tunedcity.net/?page_id=191.

Tyndall, John. 1867. *Sound, A Course of Eight Lectures Delivered at the Royal Institution of Great Britain.* New York: D. Appleton and Company.

UNHCR. 2018. "Operational Portal: Refugee Situations. Syria Regional Refugee Response." Accessed May 25, 2019. https://data2.unhcr.org/en/situations/syria/location/71.

Urbantschitsch, Victor. 1881. "Zur Lehre von der Schallempfindung." *Pflügers Archiv* 24:574–595.

Urbantschitsch, Victor. 1883. "Über die Wechselwirkungen der innerhalb eines Sinnesgebietes gesetzten Erregungen." *Pflügers Archiv* 31:280–309.

U.S. Congress. 1994. U.S. Code § 47507. Nonadmissibility of noise exposure map and related information as evidence. Public Law 103–272, §1(e), July 5, 1994, 108 Stat. 1287. Accessed May 25, 2019. https://www.law.cornell.edu/uscode/text/49/47507.

U.S. Department of Defense. 1935. *Historical Film, No. 1132.* U.S. Department of Defense. Department of the Army. Office of the Chief Signal Officer. Accessed May 25, 2019. https://www.youtube.com/watch?v=YvcIy9kDV6g.

U.S. Embassy in Cuba. 2017. Senior State Department Officials: Special Briefing, September 29, 2017. Accessed May 25, 2019. https://cu.usembassy.gov/senior-state-department-officials-cuba/.

Van der Kloot, William. 2005. "Lawrence Bragg's Role in the Development of Sound-Ranging in World War I." *Notes & Records of the Royal Society of London* 59 (3): 273–284.

Van Drie, Melissa. 2015. "Hearing through the Théâtrophone: Socially Constructed Spaces and Embodied Listening in Late Nineteenth-Century French Theatre." *Sound Effects* 5 (1): 74–90.

Vanel, Hervé. 2013. *Triple Entendre: Furniture Music, Muzak, Muzak-Plus.* Urbana: University of Illinois Press.

Varèse, Edgard. [1936] 1966. "New Instruments and New Music." In "The Liberation of Sound," ed. and ann. Chou Wen-chung, *Perspectives of New Music* 5 (1) (1966): 11–12.

Varèse, Edgard. [1959] 1998. "Spatial Music." In *Contemporary Composers on Contemporary Music,* ed. Elliott Schwartz and Barney Childs, 169–173. New York: Da Capo Press.

Varèse, Edgard. [1936] 2004. "New Instruments and New Music." In *Audio Culture: Readings in Modern Music,* ed. Christoph Cox and Daniel Warner, 17–21. London: Continuum.

Varèse, Edgard. [1962] 1966. "The Electronic Medium." In "The Liberation of Sound," ed. and ann. Chou Wen-chung, *Perspectives of New Music* 5 (1) (1966): 17–19.

Various Artists. 2019. *Acoustic Cities: London and Beirut.* Optophono. Accessed May 25, 2019. https://www.optophono.com/acousticcitieslondonbeirut.

Venturi, Giovanni Battista. 1796. "Analyse des sentiments et des idées; Considérations sur la connaissance de l'étendue que nous donne le sens de l'ouïe." *Magasin encyclopedique, ou journal des sciences, des lettres et des arts* 3 (1): 29–37.

Vieth, Leonard. 1946. "Polly Gets the Japs." *Bell Laboratories Record* 24 (8): 305–307.

Voegelin, Salomé. 2010. *Listening to Noise and Silence: Towards a Philosophy of Sound Art*. New York: Continuum.

Volcler, Juliette. 2017. *Contrôle. Comment s'inventa l'art de la manipulation sonore*. Paris: La Découverte.

Wade, Nicholas J., and Diana Deutsch. 2008. "Binaural Hearing—Before and After the Stethophone." *Acoustics Today* 4 (3): 16–27.

Wainwright, Oliver. 2015. "Is Beirut's Glitzy Downtown Development All That It Seems?" *The Guardian*, January 22, 2015. Accessed May 25, 2019. https://www.theguardian.com/cities/2015/jan/22/beirut-lebanon-glitzy-downtown-redevelopment-gucci-prada.

War Department. 1917a. *Note on the Listening Apparatus for Aircraft made by the Military Telegraph Service*. Trans. and ed. from the original French at the Army War College. Washington, DC: Government Printing Office.

War Department. 1917b. *Provisional Note on the Acoustic Goniometer Military Telegraph Type 1; Including an Extract on the Use of Searchlights; and Note on the Application of the Acoustic Goniometer to Firing by Sound and to the Orientation of Searchlights*. Trans. and ed. from the original French at the Army War College. War Department Document No. 690. Washington, DC: Government Printing Office.

War Department. 1917c. *Report on the Perception of Subterranean Sounds and the Plotting of Subterranean Work by Sound; Methods and Instruments Prescribed by the Military Telegraph Service; Translation of a French official document of June, 1916*. Trans. and ed. from the original French at the Army War College. War Department Document No. 646. Washington, DC: Government Printing Office.

Ward, Archibald. 1918. "Report to Director A.A. Experimental M.I.D. from Lieut. A. Ward R.A.F." Unpublished report, July 27, 1918. Science Museum Archives, Wroughton, UK, MS 2019/21.

Weber, Eduard F. 1851. "Über den Mechanismus des Gehörorgans" *Berichte über die Verhandlungen der Königlich Sächsischen Gesellschaft der Wissenschaften zu Leipzig. Mathematisch-Physische Classe* (1851): 29–31.

Weber, Ernst Heinrich. 1846. "Der Tastsinn und das Gemeingefühl." In *Handwörterbuch der Physiologie mit Rücksicht auf physiologische Pathologie Vol. 3 Abt. 2*, ed. Rudolph Wagner, 481–588. Braunschweig: Vieweg.

Weber, Ernst Heinrich. 1849. "Über die Umstände, durch welche man geleitet wird manche Empfindungen auf äussere Objecte zu beziehen." *Berichte über die Verhandlungen der Königlich Sächsischen Gesellschaft der Wissenschaften zu Leipzig. Zweiter Band. Aus dem Jahre 1848*: 226–237.

Weizman, Eyal. 2017. *Forensic Architecture: Violence at the Threshold of Detectability*. New York: Zone Books.

Wellcome Collection. 2019. "London's Pulse: Medical Officer of Health reports 1848–1972." Accessed May 25, 2019. https://wellcomelibrary.org/moh/.

Wen-chung, Chou. 1966. "Open Rather Than Bounded." *Perspectives of New Music* 5 (1) (1966): 1–6.

Westerkamp, Hildegard. 1974. Soundwalking. *Sound Heritage* 3 (4). Accessed May 25, 2019. https://www.sfu.ca/~westerka/writings%20page/articles%20pages/soundwalking.html.

Weyl, Charles. 1931. "The Art of Recording." *Disques* (May 1931): 111–115.

Wheatstone, Charles. [1823] 1879. "New Experiments on Sound." In *The Scientific Papers of Sir Charles Wheatstone, D.C.L., F.R.S.*, 1–13. London: Taylor and Francis.

Wheatstone, Charles. [1827] 1879. "Experiments on Audition." In *The Scientific Papers of Sir Charles Wheatstone, D.C.L., F.R.S.*, 30–35. London: Taylor and Francis.

Wheatstone, Charles. [1831] 1879. "On the Transmission of Musical Sounds through Solid Linear Conductors, and on Their Subsequent Reciprocation." In *The Scientific Papers of Sir Charles Wheatstone, D.C.L., F.R.S.*, 223–238. London: Taylor and Francis.

Wheatstone, Charles. 1833. "On the Figures Obtained by Strewing Sand on Vibrating Surfaces, Commonly Called Acoustic Figures." *Philosophical Transactions of the Royal Society of London* 123:593–634.

Wheatstone, Charles. 1838. "Contributions to the Physiology of Vision—Part the First. On Some Remarkable, and Hitherto Unobserved, Phenomena of Binocular Vision." *Philosophical Transactions of the Royal Society of London* 128:371–394.

Wheatstone, Charles. 1852. "Contributions to the Physiology of Vision—Part the Second, &c." *Philosophical Transactions of the Royal Society of London* 142:1–17.

Wheatstone Collection. 2018. Wheatstone Collection, King's College London. Accessed May 25, 2019. http://www.kcl.ac.uk/library/archivespec/special-collections/Individualcollections/wheatstone.aspx.

Whitney, Tyler. 2013. "Spaces of the Ear: Literature, Media, and the Science of Sound 1870–1930." PhD dissertation. Graduate School of Arts and Sciences, Columbia University.

Wimmen, Heiko. 1999. "In Beirut, Noise Pollution Isn't Just Once a Year." *Daily Star Lebanon*, January 5. Accessed May 25, 2019. http://www.dailystar.com.lb/News/Lebanon-News/1999/Jan-05/33089-in-beirut-noise-pollution-isnt-just-once-a-year.ashx.

Wishart, Trevor. 1996. *On Sonic Art*. Amsterdam: Harwood Academic Publishers.

Wissmann, Torsten. 2014. *Geographies of Urban Sound*. Farnham, UK: Ashgate Publishing.

Wittje, Roland. 2016. *The Age of Electroacoustics: Transforming Science and Sound*. Cambridge, MA: MIT Press.

Wolfle, Dael, ed. 1946. *Human Factors in Military Efficiency-Training and Equipment*. Summary Technical Report of the Applied Psychology Panel, NDRC, Volume 2. Washington, DC: Applied Psychology Panel, National Defense Research Committee.

"Woman Starts a War on Tooting River Tugs." 1905. *New York Times*, December 10, 1905.

Wynne, Shirley W. 1930. "New York City's Noise Abatement Commission." *Journal of the Acoustical Society of America* 2 (1): 12–17.

Xenakis, Iannis. 1958. "Notes sur un 'geste électronique.'" In *Le Poème électronique Le Corbusier*, ed. Jean Petit, 226–231. Paris: Les Éditions de Minuit.

Xenakis, Iannis. 2008. *Music and Architecture: Architectural Projects, Texts, and Realizations.* Compilation, translation, and commentary by Sharon Kanach. Hillsdale, NY: Pendragon Press.

Yan, Chen, Kevin Fu, and Wenyuan Xu. 2018. "On Cuba, Diplomats, Ultrasound, and Intermodulation Distortion." *Computers in Biology and Medicine* 104:250–266.

Young, La Monte. 1969. "Notes on Continuous Periodic Composite Sound Waveform Environment Realizations." *Aspen* 8. Accessed May 25, 2019. http://www.ubu.com/aspen/aspen8/waveform.html.

Young, La Monte, and Marian Zazeela. [1964] 2000. "Notes on the Theatre of Eternal Music and *The Tortoise, His Dreams and Journeys.*" Accessed May 25, 2019. http://www.melafoundation.org/theatre.pdf.

Young, La Monte, and Marian Zazeela. 2016. "Dream House: Seven+Eight Years of Sound and Light." Accessed May 25, 2019. http://melafoundation.org/DHpressFY16.html.

Zaven, Cynthia. 2017. *Arsenal.* Accessed May 25, 2019. http://www.cynthiazaven.com/installations -experimental-works.

Zimmer, Carl. 2017. "A 'Sonic Attack' on Diplomats in Cuba? These Scientists Doubt It." *New York Times*, October 5, 2017.

Zimmerman, David. 1997. "Tucker's Acoustical Mirrors: Aircraft Detection before Radar." *War & Society* 15 (1): 73–99.

Index

The letter *f* following a page number denotes a figure.